CW00550425

After Effects
for **Designers**

Graphic and

Interactive Design

in Motion

After Effects for Designers

Graphic and
Interactive Design
in Motion

Chris Jackson

Routledge
Taylor & Francis Group

NEW YORK AND LONDON

First published 2018
by Routledge
711 Third Avenue, New York, NY 10017

and by Routledge
2 Park Square, Milton Park, Abingdon, Oxon OX14 4RN

Routledge is an imprint of the Taylor & Francis Group, an informa business

Library of Congress Cataloging in Publication Data
Names: Jackson, Chris (Chris B.), author.
Title: After effects for designers : graphic and interactive design in motion / Chris Jackson.
Description: New York : Routledge, Taylor & Francis Group, 2018. | Includes index.
Identifiers: LCCN 2017037206 (print) | LCCN 2017042232 (ebook) | ISBN 9781315186283
(E-book) | ISBN 9781138735866 (hardback) | ISBN 9781138735873 (pbk.)
Subjects: LCSH: Adobe After effects. | Computer animation.
Classification: LCC TR897.72.A335 (ebook) | LCC TR897.72.A335 J33 2018 (print) | DDC 006.6/96--dc23
LC record available at https://lccn.loc.gov/2017037206

ISBN: 978-1-138-73586-6 (hbk)
ISBN: 978-1-138-73587-3 (pbk)
ISBN: 978-1-315-18628-3 (ebk)

Typeset in Avenir Next
Publisher's Note: This book has been prepared from camera-ready copy provided by the author.

Visit the companion website: **www.routledge.com/cw/jackson**

Table of Contents

Introduction vii

Chapter 1 **Elements of Motion Design** 1

Chapter 2 **Creating a Motion Design Project in After Effects** 33

Chapter 3 **Typography in Motion** 71

Chapter 4 **Logos in Motion** 111

Chapter 5 **User Interface (UI) Design in Motion** 155

Chapter 6 **Information in Motion** 195

Chapter 7 **Title Sequences in Motion** 233

Chapter 8 **3D Space in Motion** 273

Chapter 9 **Moving Forward in Motion Design** 301

Index 311

Introduction

Welcome to *After Effects for Designers*. This book explores practical and creative projects in motion design. With Adobe After Effects, artists and designers can develop and implement time-based designs that go beyond print and static imagery. This chapter discusses the overall structure of the book and its primary audience, artists and designers.

What is This Book About?

Written for designers, *After Effects for Designers* balances the design aspects with related techniques. This includes composition and layout, visual hierarchy, typography, motion principles, 3D media integration, and compositing with live-action. The book is designed to walk the reader through project-based case studies that effectively enhance their motion design skills.

Each chapter contains unique project exercises that offer timesaving practical tips, and hands-on design techniques. Each chapter exercise provides step-by-step instructions and tips for the reader to use in conceptualizing and visualizing creative solutions to their own motion design projects. Digital files for each chapter exercise will be available to download through Routledge's website. These files will include After Effects, Photoshop, Illustrator, CINEMA 4D, QuickTime video and audio files.

Who Should Read This Book?

The primary audience for this book is artists and designers. These readers can be professionals in the workforce, students, educators, or anyone interested in creatively designing, animating, and distributing motion design projects.

Book Layout Conventions

To help you get the most out of this book, let's look at the layout conventions used in the chapters.

- Words in **bold** within the main text refer to keywords, names of files, and folders.
- Menu selections are presented like this: **File > Place**.
- Supplemental information to the text that sheds light on a procedure or offers miscellaneous options available to you in a side column.

All of the chapter exercise files are provided to readers at the following URL: *www.routledge.com/cw/jackson*. Chapter exercises have their own compressed (zip) file. Inside each folder you will find the material needed to complete each exercise. Completed versions for every exercise are provided.

All of the material inside this book and accompanying digital files are copyright protected. They are included only for your learning and experimentation. Please respect the copyright. We encourage you to use your own artwork and experiment with each exercise. This is not an exact science. The specific values given in this book are suggestions. If you want to experiment, by all means, do so. That is the best way to learn.

About the Author

Chris Jackson is a computer graphics designer, professor, and Associate Dean for the College of Imaging Arts and Sciences at Rochester Institute of Technology (RIT). Before joining the RIT faculty, Chris was a new media designer with Eastman KODAK Company, creating and delivering online instructional training. He continues to be an animator, designer, developer, and consultant for global corporations. He lectures and conducts workshops relating to interactive design and motion graphics.

Chris's professional work has received over 25 distinguished national and international awards for online communication. His areas of research include user's experience design, 2D character animation, digital storytelling and interactive design for children. Chris continues to publish and present his research and professional work at Adobe MAX, ACM SIGGRAPH and the Society for Technical Communication (STC). Chris is author of *After Effects and CINEMA 4D Lite* (Focal Press, September 2014), *Flash + After Effects* (Focal Press, August 2010), *Flash Cinematic Techniques* (Focal Press, January 2010), and co-author of *Flash 3D: Animation, Interactivity and Games* (Focal Press, October 2006).

For Instructors

After Effects for Designers provides hands-on exercises that clearly demonstrate core features in Adobe products. As instructors, I know you appreciate the hard work and effort that goes into creating lessons and examples for your courses. I hope you find the information and exercises useful and can adapt them for your own classes.

All that I ask is for your help and cooperation in protecting the copyright of this book. If an instructor or student distributes copies of the source files to anyone who has not purchased the book, they are violating the copyright protection. Reproducing pages from this book or duplicating any part of the source files is also a copyright infringement. If you own the book, you can adapt the exercises using your own footage and artwork without infringing copyright. Thank you for your cooperation!

Credits

Special thanks goes to Darryl Marshall, Scott Bessey, and Steve Gallo. I would also like to thank the following people for their contributions:

- Lizzy Liz, *Tree Hill Vines Landscape,* Chapter 1 *pixabay.com/en/tree-hill-vines-landscape-mood-207584/*

- Suju, *Sunset,* Chapter 3 *pixabay.com/en/sunset-red-sky-sun-afterglow-988556/*

- Brand H, *Sunset Drone Flight,* Chapter 4 *www.youtube.com/watch?v=ujg-Lo1ayAo*

- Lorenzo Cafaro, *Map,* Chapter 6 *www.pexels.com/photo/adventure-city-country-destination-240834/*

- Stocksnap, *Road,* Chapter 6 *www.pexels.com/photo/road-clouds-street-path-480269/*

- Video Background, *Spring Flowers 1 - Cherry Blossom,* Chapter 6 *https://goo.gl/Gbb7jd*

- Ghost Presenter, *Grayscale Photo of Gray Man Statue,* Chapter 7 *www.pexels.com/photo/cloudy-statue-beard-cemetery-96446/*

- Ghost Presenter, *Gray Statue,* Chapter 7: *www.pexels.com/photo/black-and-white-statue-beard-black-white-96939/*

- Omar Alnahi, *Eyes Portrait,* Chapter 7 *www.pexels.com/photo/eyes-portrait-person-girl-18495/*

- The 5th, *Watch Knife and Pocket Watches on Able,* Chapter 7 *www.pexels.com/photo/antique-camera-classic-clock-179911/*

- Pixabay, *Antique Art,* Chapter 7 *www.pexels.com/photo/abstract-ancient-antique-art-235985/*

- Pixabay, *Train Railway on Forest,* Chapter 7 *www.pexels.com/photo/night-building-forest-trees-42263/*

- Pixabay, *Scenic View of Desert Landscape,* Chapter 7 *www.pexels.com/photo/scenic-view-of-desert-landscape-against-dramatic-sky-326149/*

- Tookapic, *Night Television,* Chapter 7 *www.pexels.com/photo/night-television-tv-video-8158/*

- Stocksnap, *Forest,* Chapter 8 *www.pexels.com/photo/forest-woods-trees-house-488851/*

- Invisible Power, *Landscape Mountain Forest,* Chapter 8 *pixabay.com/en/videos/snowy-landscape-mountains-forest-7419/*

- Beachfront B-Roll, *Waves Crashing - Close,* Chapter 9 *http://goo.gl/cpQK06*

1

Elements of Motion Design

Motion design can be viewed as a marriage between graphic design and animation. It is much more than that. The added element of time redefines how designers use color, imagery, and typography to express ideas, communicate information, and visually tell stories. This chapter explores the fundamental elements that make motion design effective.

At the completion of this chapter, you will be able to describe:

- Motion design and where it is used
- Design and animation principles
- Cinematic storytelling techniques
- Broadcast terminology and limitations

What is Motion Design?

Motion design, also referred to as motion graphics and mograph, is a fusion of art, design, animation, filmmaking and the imagination of the designer. Understanding the key ingredients that make motion design effective is crucial. It helps to start with a good foundation in art and design. Knowing how to compose visual elements to provide clarity and vision is essential.

Adding the element of time gives life to art, typography, logos, data, user interfaces, presentations, and spaces. This is how motion design differentiates itself from typical animation. It often incorporates abstract shapes, such as logos, for commercial or promotional purposes. Motion design projects are generally short pieces of time-based media used in broadcast, film, and entertainment, not full-length movies.

Motion enhances communication using the most efficient, yet artistic, means possible. It should also evoke an emotional response to make a real connection with the viewer. Motion design projects blend visual and audible elements together to produce an emotional impact on an audience, leaving them inspired to think about the message being communicated to them.

Motion design integrates art, design, animation, and filmmaking techniques.

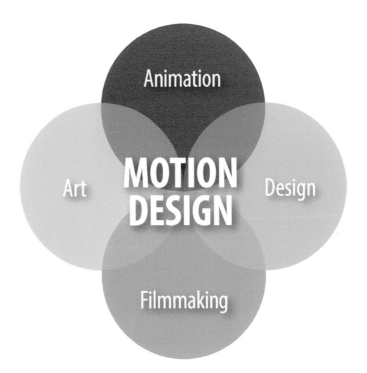

Examples of Motion Design Projects

Motion design projects include animated logos, explainer videos, user interface transitions, television channel identification (TV idents and stings), and film titles. With the web, live events, TV, and films, the platforms for motion design are becoming unlimited. Below are some examples of different types of motion design projects.

Example of motion design projects include: logo animation, film title design, animated infographics,and television advertisement and channel branding.

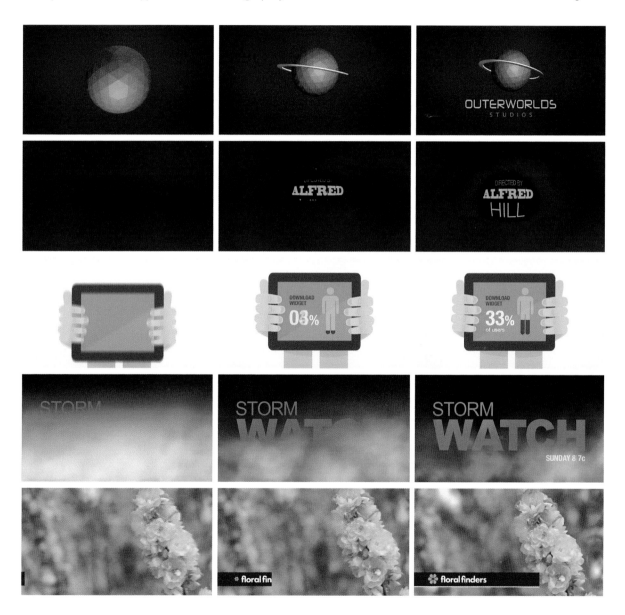

Design Principles

A successful design, whether static or in motion, does not take away from the content on the page or screen. Instead, it enhances the user experience by engaging the users and communicating content visually. Design principles are the building blocks used to create a motion design project. They focus on the aesthetics by strategically implementing images, colors, fonts, and other elements.

The key design principles to incorporate into a project include:

Alignment
- Creates order and a visual connection between elements on the screen.

Balance
- Eye seeks symmetrical, or formal balance
- Asymmetrical, or informal balance adds more interest
- Overall abstract composition still feels balanced even though there are differences in size, space, etc.

Contrast
- The juxtaposition of different elements used to create emphasis in a composition

Design principles include:

1. Alignment
2. Symmetrical balance
3. Asymmetrical balance
4. Contrast
5. Hierarchy
6. Proximity

Hierarchy
- The structuring of elements within a composition
to visually show priority in the content

Proximity
- Creates relationships between elements to form a focal point
- How elements within a composition are grouped as a single unit

Repetition
- Used to establish consistency and create a visual rhythm

Similarity
- Elements appear to be similar due to visual properties
such as size, shape, and color

Emphasis
- Creates a focal point in the composition
- Applied to an object to differentiate it from others
- Scale, shape, and color are commonly used to create emphasis

Space
- Includes the distance between, around, above, and below elements
- Both positive and negative spaces are important factors
to be considered in a composition

7

8

9

Design principles include:

7. Repetition

8. Similarity

9. Emphasis using shape

10. Emphasis using color

11. Negative space created by shapes

12. Space with overlapping shapes

10

11

12

Adding the Element of Time

Animation is an illusion. It is a representation of movement or change in time. Learning animation skills and principles help bring digital content and graphical user interfaces to life. Animation is not a new concept, but designers are now, more than ever, incorporating motion as an integral component in communication.

The Illusion of Movement

In film, a **frame** is a single still image. The illusion of movement occurs when frames are shown in rapid succession. This is often referred to as **persistence of vision**. This phenomenon takes place in the eye where a frame's afterimage is thought to persist for approximately 1/25th of a second on the retina. This afterimage is overlapped by the next frame's image and we interpret it as continuous movement.

Persistence of vision is an optical illusion of movement.

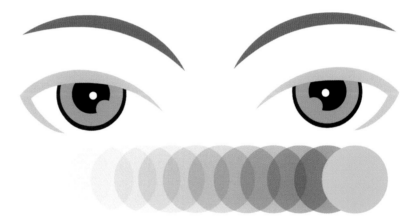

Animation Principles

Understanding realistic movements that occur in our world, such as gravity, and cause and effect relationships can enhance the design principles in communicating complex ideas and concepts. Animation can assist with the visual hierarchy through how objects enter or exit the screen, or into focus. In the 1930s, Walt Disney published a set of twelve animation principles that provided established guidelines for traditional animators. These animation principles are still employed today in motion design projects.

Solid Drawing

This principle focuses on the appearance of an object and its potential for movement. It provides a tangible link to three-dimensional real things that can react to falling, pushing, spinning, or dragging. Solidity helps separate the interactive UI elements from the static content.

Solid drawing gives an object a three-dimensional look.

Squash and Stretch

This movement shows an object's mass and flexibility as it moves. An important concept to remember is that an object's volume does not change when it is squashed or stretched. In user interface (UI) motion design, squash and stretch is used to provide feedback when a button is clicked, tapped, or hovered over.

Squash and stretch shows an object's mass and flexibility.

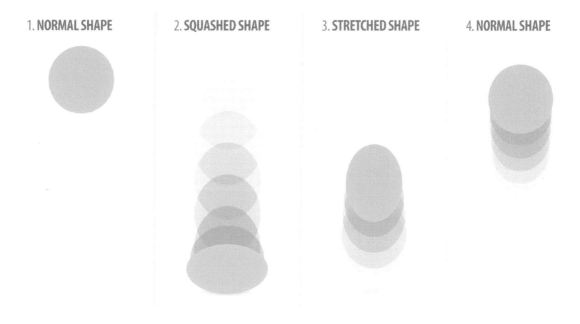

1. **NORMAL SHAPE** 2. **SQUASHED SHAPE** 3. **STRETCHED SHAPE** 4. **NORMAL SHAPE**

Anticipation

This action alerts the user to a movement that is about to occur. Anticipation is a subtle contrary movement just before the main move, such as a small backward motion occurring before an object moves forward. It provides a clue to the movement that follows, and without it the movement can appear unexpected and even jarring to the viewer.

Anticipation alerts the user to the main animation that is about to occur.

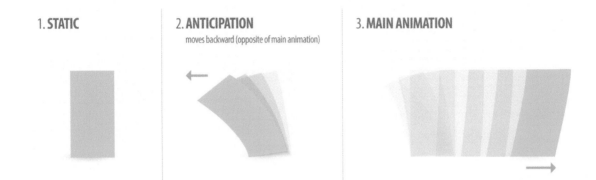

1. STATIC

2. ANTICIPATION
moves backward (opposite of main animation)

3. MAIN ANIMATION

Follow-through and Overlapping Action

Follow-through shows an object bounce or wiggle at the end of its motion, as if attached to a spring. Overlapping action observes that parts of an object do not move at the same time. These parts move at different speeds and require extra time to catch up to the main movement. This delay in time is often referred to as drag.

Follow-through and overlapping actions demonstrate that all parts of an object do not come to rest at the same time.

1. MAIN ANIMATION
individual parts lag behind as the main object moves forward

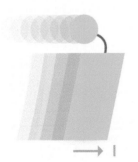

2. OVERLAPPING ACTION
the offset in time until all parts of an object catch up to the main motion

3. FOLLOW-THROUGH
individual parts of an object continue to move after the main object stops

Arcs

This movement mimics the slight circular path that objects tend to move along in our world. As humans, we do not move in straight lines. Using arcs provides consistent and predictable motion to graphical elements and makes the movements not seem robotic. Think of the trajectory of an object, such as a ball, as it's thrown.

Arcs mimic the trajectory of an object as it would move in our world.

ARCS

Slow-In and Slow-Out

Objects in our world gradually accelerate into motion or gradually decelerate out of motion. Think about when a driver puts his foot on the gas pedal. The car does not instantly move at the speed limit; it gradually accelerates over time as it travels down the road. Stepping on the brakes gradually decelerates the car's movement over time.

Slow-in and slow-out gradually change the speed of an object over time. This creates more realistic movement.

LINEAR MOTION
Object moves at a constant rate of speed from frame to frame

SLOW-IN
Object moves faster at the beginning of the animation and decelerates in speed at the end of the animation

Fast · Slow (In)

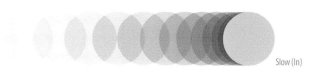

SLOW-OUT
Object moves slower at the beginning of the animation and accelerates in speed at the end of the animation

Slow (Out) · Fast

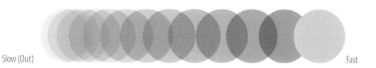

Staging

Staging refers to how objects are positioned in a frame to help visually communicate a story. It directs the audience's attention toward the most important elements in a scene. For motion design project, designers need to picture how the individual frames will communicate a message. It is similar to the job of a cinematographer in the filmmaking industry.

The staging of the box on the left is weak as it maintains a rather flat composition. Think about how lighting and different camera angles (right box staging) can impact the overall visual communication and storytelling.

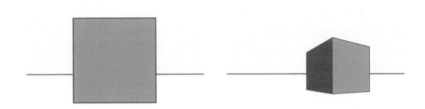

Cinematic Storytelling Techniques

Another critical element in motion design is the ability to show, not tell, a story. **Cinematography** is the art and technology of motion picture photography. It is the cinematographer's artistic vision and imagination that helps frame a scene viewed through a camera lens and bring that image to the screen. In film, the art of cinematography includes:

- Composing the actors and props within a scene
- Establishing a visual "look" and "mood" for the story
- Lighting the scene and actors

The visuals must reinforce the story's narrative or meet the audience's expectations. For each scene in a film, the cinematographer needs to visually answer the following questions that audience members ask:

- What is going on?
- Who is involved?
- How should I feel?

What are a Frame, a Shot, and a Scene?

As mentioned previously, a **frame** is a single still image. A **shot** is whatever the camera is looking at a particular moment in time. It is a continuous view filmed by one camera without interruption. Once the camera shows another viewpoint, it is considered another shot. Multiple shots in a given location make up a **scene**. A series of scenes makes up the whole picture.

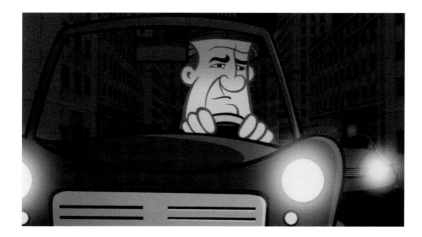

A frame is a single still image and equals one twenty-fourth of a second in film.

 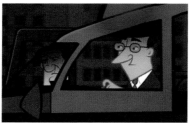

A shot is a series of frames filmed from one vantage point without interruption.

A scene is a series of shots that depicts action in a single location at a particular moment in time.

Camera Shots

Carefully planned camera shots and angles can greatly impact the emotional reaction from your audience. The three most common camera shots used are the long shot, medium shot, and close-up. The long shot and close-up can also have extremes that can visually heighten the drama and tension in a story.

An **extreme long shot** (ELS) shows the vastness of an area or setting. It is typically used to frame the setting at the beginning or ending of a story. Any characters shown in an extreme long shot would appear quite small. This can be an effective visual tool in generating an emotional response from your audience.

An extreme long shot can place characters in the middle of a vast forest. The composition not only amplifies the environment's scale but the characters' isolation from civilization.

With the setting established, a **long shot** (LS) is used to frame the action. This shot shows the place, the characters, and the action. A character is shown complete from head to toe and given enough space to move around in the frame.

A long shot frames the action in the story. It also provides enough space for the characters to move around in.

A **medium shot** (MS) frames the characters from the waist or knees up. The character's gestures and facial expressions are shown with just enough background to establish the setting. It is the most common shot used in film and television. It draws the audience in closer, making the story more personal for them.

A medium shot frames the character from the waist or knees up and captures the character's gestures.

In a **close-up** (CU), a character's head and shoulders are shown. This shot invites the audience to become a participant in the story by visually coming face-to-face with the characters. They can see and hopefully feel the emotions of the character.

A close-up shot reveals the character's emotional state and is used for dialogue.

Close-ups can also reveal private information to the audience or emphasize symbols within the shot. For more dramatic effect, use an **extreme close-up** (ECU). This shot focuses the audience's attention on whatever is significant in the shot. Like a painter, the way in which you frame the space has a direct effect on your audience. Always try to introduce variety by using different types of camera shots.

Camera Angles

Positioning the camera determines the point of view from which the audience will see the shot. It is the camera angle that makes a shot dynamic. Changing the camera's height and angle, with respect to the subject, affects the emotional impact of the shot. It is a film technique that is used to create specific effects or moods.

In a **high angle shot**, the camera is placed above the horizon line tilted down to view the subject. This camera angle can be used in conjunction with an extreme long shot to frame an aesthetically pleasing landscape. If combined with a medium shot, the high angle can create a sense of insignificance or vulnerability in the character shown.

In an **eye-level shot**, the camera is at the eye-level of an observer of average height. This angle creates a fairly neutral shot. This camera angle looks directly into the character's eyes. As a result, the audience identifies with the character as an equal.

In a **low angle shot**, the camera is below eye-level and often tilted up to view the subject. This camera angle creates a sense of awe and superiority. Strong characters shown from a low angle seem to have more power as they dominate the frame.

A carefully chosen camera angle can change the dynamics of the subject in the frame.

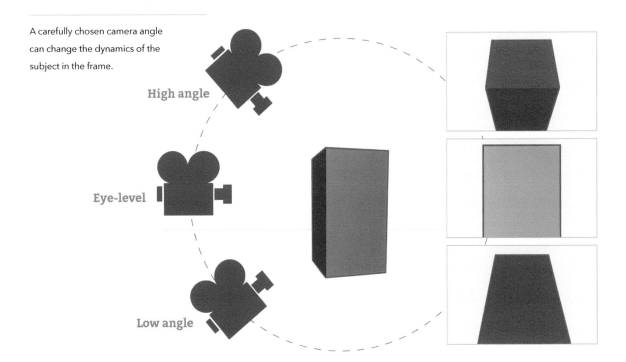

High angle

Eye-level

Low angle

Cinematographers sometimes choose to tilt the camera slightly. This is referred to as a **Dutch angle** or **canted** shot. In this shot the vertical axis of the camera is at an angle to the vertical axis of the subject. It creates a sense of being off balanced or insecure.

A Dutch angle shot creates a sense of being off balanced or insecure.

A **bird's-eye view** takes the high angle shot to the extreme. The camera is positioned directly overhead the action. Examples of the bird's-eye view in film include looking down on buildings in a city or following a car driving on a road.

The opposite of a bird's-eye view is a **worm's-eye** view. The camera is placed low on the ground and tilted upward. A worm's-eye view is used to make the audience look up to something or to make an object look tall, strong and mighty.

A worm's-eye view is an extreme low-angle shot used often to emphasize an object's strength or domination in the scene.

Camera Movements

Shots can also be defined by the movement of the camera. Camera movements are used to focus the audience's attention and involve them in the scene they are watching. Let's discuss some common camera movements used in film.

A **pan** (P) shot rotates the camera horizontally from left to right or right to left, similar to moving your head from side to side. Pans are used for establishing shots, where the camera pans across the horizon of a landscape. A **tilt** (T) is a pan in the vertical direction, up or down. It is most commonly used to reveal a tall building or a person.

A panning shot is typically used to establish a location or setting.

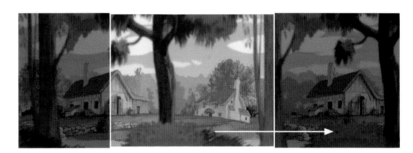

Cameras can also travel from one place to another within a single shot. This is called a **tracking shot** (TS). The camera tracks or follows along with the subject. A tracking shot can also be applied when the subject matter stays in one place and the camera moves in relation to it. The camera can move forward, called a **truck in**, or backward, called a **truck out**. This type of tracking movement adds depth to the shot.

Zooming is an optical effect that magnifies the image. Perspective is not affected because the foreground and background are magnified equally. All of these camera techniques can be used to effectively tell your story.

Tracking adds depth to a shot while a zoom magnifies the foreground and background equally.

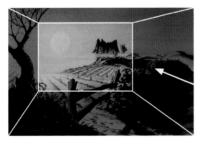

The Rule of Thirds

As a designer, you must keep the audience visually interested in the scene. The imagery should encourage an audience to scan the frame, seeking out what is most important. The **Rule of Thirds** is a compositional guideline that can help. The concept behind it is to divide the frame horizontally and vertically into thirds. The image is divided into nine equal parts by four straight lines. The important compositional element is positioned at the intersection of two lines.

Any one of the four points of intersection highlighted is a strong place for a point of interest in the frame.

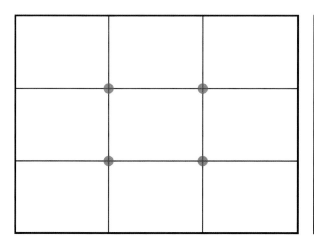

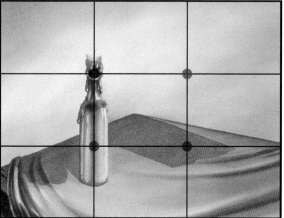

The horizon line, if visible, should never be in the center of the frame where it divides the composition in half. If the frame is split into two equal halves, there is no tension generated. The composition appears weak and uninteresting to the audience. Each half of the frame visually communicates different emotional connotations.

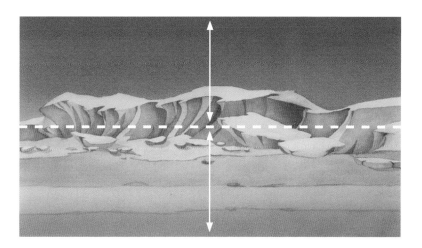

A symmetrical composition created by placing the horizon line in the center of the frame is often considered weak and generates no tension.

The top half of a composition implies a feeling of freedom, aspiration or accomplishment. Characters placed in the top half of a composition dominate the shot. The bottom half suggests a heavier, oppressed feeling. Characters placed in the lower half of a composition look and feel dominated or constrained. Try to balance the elements of the composition. Clarity is essential.

The top half of the composition provides dominance for the cyclist. The open sky provides breathing space to ride in.

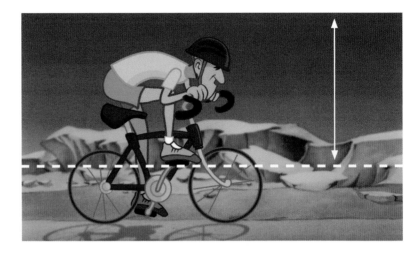

Positioning the cyclist in the bottom half of the composition visually constrains him by the mountains.

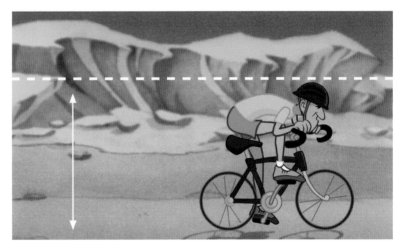

Drawing the Line

Design elements such as line, shape, color, and value are used together to form a composition. Lines are the most basic element of design. They imply movement and direct the viewer's eye within a frame. Lines can be horizontal, vertical, or diagonal.

Each line orientation generates a different psychological and emotional reaction from the audience.

- Horizontal lines convey a sense of stability, restfulness, or calm.
- Vertical lines imply strength and power.
- Diagonal lines suggest motion.

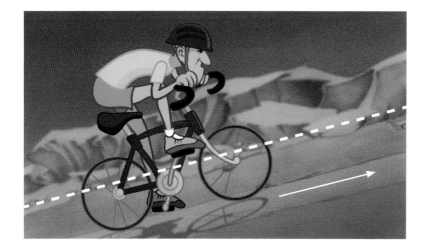

Tilting the flat horizon diagonally changes the cyclist's peaceful ride into an uphill adventure. The diagonal line ascending from left to right implies a movement that is more physical to follow than a flat line.

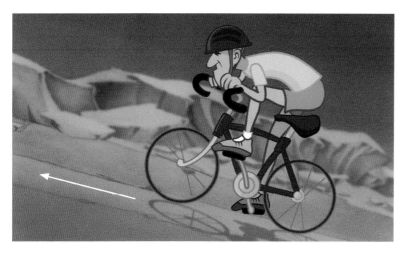

Flipping the composition horizontally makes the journey appear even more difficult. In addition to fighting gravity, the diagonal line goes against how we read from left to right requiring more focus and attention.

Lines provide a visual pathway for the viewer's eye to follow. Implied lines come in all forms. This is often referred to as **leading lines** in a frame. When designing your composition, have something lead to the subject from near a bottom corner, like a road, path, fence, or line of trees to help the eye find the way to the center of interest.

Leading lines help the audience find the center of interest.

The Line of Action

Cinematographers can create almost any spatial relationship between the elements in the shot through clever camera positions, angles, and composition. What about time? Editors achieve this cinematic illusion by editing a movie together after the film has been shot. The goal is to establish continuity from shot to shot. Continuity can be achieved by understanding screen direction, the line of action, and applying the 180° rule.

Screen direction refers to the direction of movement, or the direction a character is facing within the frame. Too many shots filmed from too many different camera angles can create problems with continuity in screen direction. If a character's position moves forward in one shot and then changes to a move backwards in the next shot, the continuity of the picture is disrupted and the audience is confused.

A scene showing two people having a conversation in a restaurant might consist of three basic shots: a medium shot showing both of them seated at the table and two close-ups, one for each person. These shots orient the viewer to the space and how the characters occupy it. In order to shoot the scene and edit each shot together effectively it is important to understand the **180° rule**. The primary rule is to pick one side of the line of action and stay on it throughout the scene.

This scene shows three individual shots of a conversation between two characters. Notice that something is awkward about the editing of the shots.

The second shot of the woman changes in screen direction. She appears to be talking to the back of the man's head. This is called reversed screen direction.

The **line of action** is an imaginary line that determines the direction your characters and objects face when viewed through a camera. When you cross the line of action, you reverse the screen direction of everything captured through the camera, even though the characters or objects have not moved an inch.

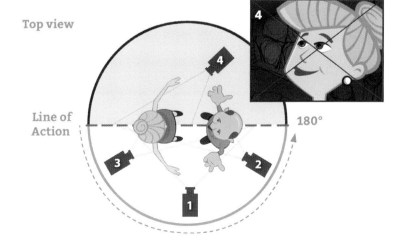

The overview diagram shows the mismatch in continuity achieved through camera 4. Choose camera shots on one side of the 180° line of action.

Cutting and Continuity

The rhythm of a scene is determined by the length and frequency of its shots and the movement within each shot. A **cut** is one shot that allows you to easily change the length and/or order of the scene. Cutaways serve to enhance the story.

Any shot can act as a cutaway, as long as it relates to and reinforces the main action. The goal in editing a scene is that you want the audience to presume that time and space has been uninterrupted. So how do you cut and still preserve continuity?

- **Cut on the Action:** Audiences will naturally follow movement on the screen. If a movement begins in one shot and ends in the next, the viewer's eye will follow along without becoming disoriented.

The cut on the action happens as the man raises his arm to read the letter. As the letter comes into view, a new close up shot is immediately shown.

- **Match Cut:** This cut compositionally matches the shapes and movement between shots. Almost any kind of movement from opening a door to sitting down can be effectively shown using a match cut.

- **Clean Entrances and Exits:** If a character is featured in two successive shots in different locations, the cut needs to have a clean entrance and exit. When a character exits the frame, hold the empty frame for a second or two. Then show the second background location empty before the character enters the frame. The audience will accept that he had time to travel to the different location in the following shot.

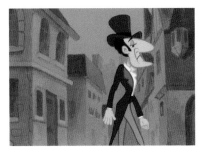 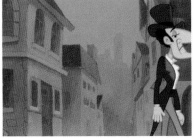

- **Jump Cut:** This is an abrupt transition from one shot to another. This type of cut is used sparingly to build suspense. One type of jump cut is called a **cut-in** and is used to focus the audience's attention immediately on the action. The cut-in shot narrows the audience's view point in the scene. This is accomplished by using a close-up shot of something already within the frame.

- **Crosscut:** This is also called parallel editing and cuts back and forth between events happening in different locations. A common example of crosscutting is a phone conversation. Two characters are shown on their phone in their location. The back and forth editing implies that the two events are occurring simultaneously.

Director Alfred Hitchcock shocked his audiences by cutting in with quick jump cuts to highlight a suspenseful moment.

A classic film example of crosscutting happens in the *Perils of Pauline*, a silent film episodic serial from 1914. In the film, the villain ties the heroine to the railroad tracks as a train approaches. The audience's attention is switched back and forth to show the oncoming train, the woman struggling to free herself, and the hero coming to her rescue.

Crosscutting cuts back and forth between different locations.

Film and Broadcast Design

Let's shift focus to the technical issues surrounding film and broadcast design as this is a popular destination for most motion design projects. Digital video components includes frame aspect ratios, formats, frame rates, Title Safe and Action Safe areas, and color space management. A good place to start is determining the proper frame size to use.

Aspect Ratios

Defining the space is crucial because it defines the area in which you compose your graphic elements. In video, the dimensions are referred to as the **frame aspect ratio**. It is the relationship between the width and height of an image. Standard computer monitors and television have a **4:3 frame aspect ratio**. Where did this ratio come from?

Motion pictures through the early 1950s had roughly the same aspect ratio. This became known as Academy Standard: an aspect ratio of 1.37:1. Television adopted the Academy Standard to a 1.33:1 aspect ratio. This is the recognized video standard commonly referred to as a 4:3 frame aspect ratio.

Standard 4:3 Aspect Ratio: For every four units of width, there are three units of height.

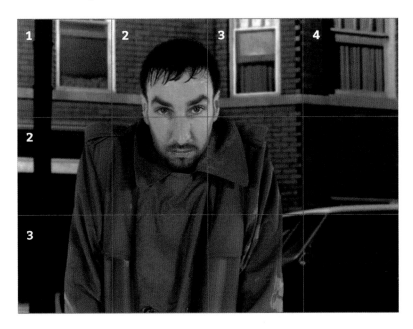

In 1953 Hollywood introduced the wide screen format for motion pictures. This was done in an effort to pry audiences away from their television sets. Today, wide screen film has three standardized ratios: Anamorphic Scope (2.39:1), Academy Flat (1.85:1), and European audiences watch films with a 1.66:1 aspect ratio.

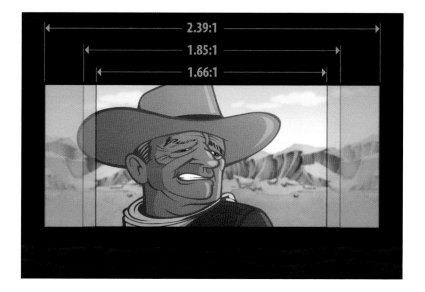

Three common wide screen aspect ratios used for theatrical films.

High-definition (**HD**) television adopted Academy Flat and has an aspect ratio of 1.78:1. This is referred to as a **16:9 aspect ratio**. This means that for every sixteen units of width there are nine units of height. This aspect ratio is an industry standard in motion design. The HD video format also provides higher resolution than standard analog video formats.

High-definition (HD) 16:9 Aspect Ratio: For every sixteen units of width, there are nine units of height.

Digital Video Display Formats

Digital video records information digitally, as bytes. This allows the video to be reproduced without losing any image or audio quality. Common high definition video display formats include **720p** (1,280 x 720 pixels) and **1080p** (1920 x 1080 pixels). The main difference between the two formats lies in the number of pixels that make up an image. **4K** is four times the pixel resolution of 1080p (4096 x 2160 pixels).

Analog video uses an electrical signal to capture video images onto magnetic tape, such as VHS tapes. There are analog format standards used throughout the world. **NTSC**, which stands for National Television Standards Committee, is the video format used in the United States, Canada, Japan, and the Philippines. Phase Alternating Line, or **PAL**, is the format of choice in most European countries. These standard video formats use a 4:3 frame aspect ratio.

Common video display formats.

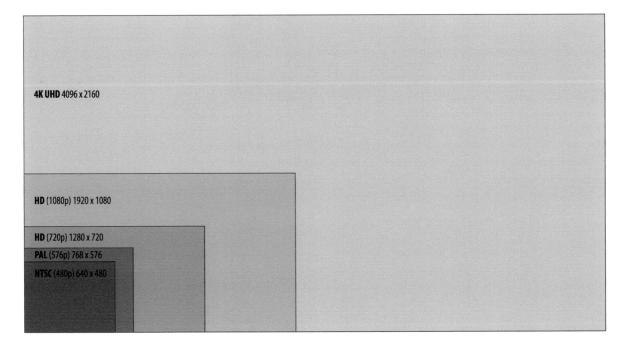

4K UHD 4096 x 2160

HD (1080p) 1920 x 1080

HD (720p) 1280 x 720

PAL (576p) 768 x 576

NTSC (480p) 640 x 480

Chapter 1 | Elements of Motion Design

Frame Rates

The timeline in After Effects consists of a sequence of frames. **Frame rate** is the speed at which the frames are played back to the viewer. The default frame rate for a theatrical film is 24 frames-per-second (fps). The smoothness of the movement is affected by its frame rate. If the frame rate is too slow, the motion will appear jagged. Some common frames-per-second settings used today include:

- **12 fps:** Minimum speed required for the illusion of movement
- **24 fps**: Standard frame rate for film and used for high definition video
- **25 fps**: Standard frame rate for PAL video
- **29.97 fps**: Standard frame rate for NTSC and high definition video
- **60 fps:** Threshold above which most people will not perceive smoother movement

Frame rate affects the motion's smoothness.

60 FPS

30 FPS

24 FPS

12 FPS

1 Second

Title Safe and Action Safe Areas

Television screens do not show the entire video picture. This problem is known as **overscan**. Think of it as cropping an image in Photoshop. Some broadcasters crop, magnify, or stretch the original video based on the picture's aspect ratios. To solve this problem, television producers defined the **Title Safe** and **Action Safe** areas.

The Title Safe area is a space, roughly 20% in from the edges of the screen, where text will not be cut off when broadcast. The Action Safe area is a larger area that represents where a typical TV set cuts the image off. After Effects provides Title Safe and Action Safe guides to use in your projects to guarantee any vital information is not lost.

Title Safe and Action Safe areas solve broadcast overscan.

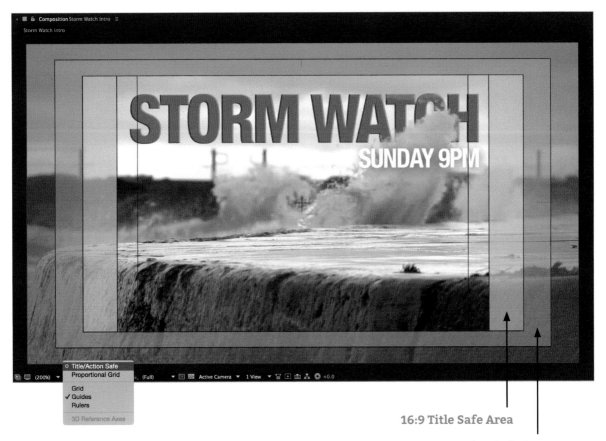

16:9 Title Safe Area

16:9 Action Safe Area

Color Spaces

Computer screens display an **RGB color space**. This is an additive color system defined by three primary colors: red, green, and blue. The most common color space used by computer monitors, consumer to mid level cameras, and home printers is called **sRGB**. For HDTV, **Rec. 709** is the international recognized video color space. It is almost identical to the sRGB color space, but with a larger gamut.

After Effects allows you to choose a color space for your motion design project. Just remember where the final deliverable will be output to. If your targeted format is HD video, choose **HDTV (Rec. 709)**. If your output will be delivered on the computer screen, select the **sRGB IEC61966-2.1** setting. This is the default for most Windows monitors, and a good choice if you're designing a movie for the Web.

Computer screens display RGB colors. The industry standard color space is sRGB. HDTV uses the Rec. 709 color space.

Rendering and Video Compression

When you are finished with a motion design project in After Effects, you need to render it to a file that can be viewed by others. **Rendering** creates each of the frames of a movie. After Effects renders projects for the web, television, film, and even playback on mobile devices. The trick is knowing how to optimize the video for the final destination and still achieve great-looking video.

Compression reduces the amount of transferable data, referred to as the **data rate**, needed to display an acceptable image. It analyzes a sequence of images and sounds. From that, it encodes a file that removes as much data as possible while still providing a reproduction that, to our senses (sight and sound), closely retains the quality of the original source.

There is a compressor and a decompressor, known as a **codec**, that performs the actual compression. A compressor reduces the amount of digital information required to store the video. A decompressor decodes the compressed data during playback. It's important to use the same codec for the compressor and decompressor. If the decoder can't understand the data, you will not be able to view the video.

Table 1.1: Common Codecs used in After Effects

Codec Name	Usage
Animation	Use this for files that will be reused or composited with other footage in After Effects or Adobe Premiere. It provides no loss in quality.
GoPro CineForm	This is commonly used for the Windows platform in film and television workflows that use HD or higher resolution media. It supports alpha channels.
Apple ProRes 422 HQ or 4444	This is commonly used for the Macintosh platform in film and television workflows that use HD or higher resolution media. It supports alpha channels.
MPEG-4	This codec is an efficient compression system used for DVDs, mobile devices, and web content. It delivers good video and audio results with a small file size.
H.264	This is a new standard designed to maximize quality with a low bitrate and small file size. It is a common encoding standard for Blu-ray, and is a good format for online video platforms such as YouTube and Vimeo. Unfortunately, it does not support alpha channels.

Digital Audio Basics

Let's not forget about audio. Computers record audio as a series of zeros and ones. Digital audio breaks the original waveform up into individual samples. This is referred to as digitizing or **audio sampling**. The sampling rate defines how often a sample is taken during the recording process.

When audio is recorded at a higher sampling rate, the digital waveform perfectly mimics the original analog waveform. Low sampling rates often distort the original sound because they do not capture enough of the sound frequency. The frequency of a sound is measured in Hertz (Hz), which means cycles per second. A kilohertz (kHz) is a thousand cycles per second. The table below lists some common sampling rates used in digital audio.

Table 1.2: Common Digital Audio Sampling Rates

Sampling Rate	Usage
8000 Hz	Low quality with low file size used for the web
11,025 Hz	Good for narration only – do not use for music
22,050 Hz	Adequate quality and file size used in older multimedia
44,100 Hz	Audio CD quality, used for video and music
48,000 Hz	DVD quality, used for video and music

Once the audio has been sampled, it can be saved out into a number of file formats. Here are some common audio file formats that can be imported into After Effects:

- **AIFF** (Audio Interchange File Format) is a standard audio format for the Mac.
- **WAV** (Waveform Audio Format) is a standard audio format on a Windows-based computer.
- **MP3** (Motion Picture Expert Group) uses a compression algorithm to remove certain parts of sound that are outside the hearing range of most people. As a result, the audio still sounds great, but with a small file size.

Summary

This completes the chapter. Motion design is a mixture of several key ingredients. Design and animation principles are crucial elements in communicating messages using both space and time. Cinematic storytelling analyzes camera shots in terms of distance, angle, and movement to effectively create an emotional response from an audience. While each of these elements were discussed separately in this chapter, keep in mind that they all come into play within a single shot.

The next chapter focuses on After Effects, its workspace and workflow. Before you start designing a motion project, you also need to be aware of the technical requirements for film and broadcast design. Some key concepts to remember include:

- Frame aspect ratio is the relationship between the width and height of an image. There are two common video aspect ratios: 4:3 and 16:9.

- Frame rate is the speed at which After Effects plays back its frames. Film uses a frame rate of 24 fps.

- Title Safe and Action Safe guides solve the problem of television overscan. After Effects provides these guides for all projects.

- Compression reduces the amount of transferable data needed to display an acceptable video image.

- A compressor and a decompressor, known as a codec, performs the actual compression.

2

Creating a Motion Design Project in After Effects

With Adobe After Effects, artists and designers can develop and implement time-based designs that go beyond print and static imagery. This chapter reviews the underlying framework in creating a motion design project and introduces After Effects, its interface, and methods of workflow.

At the completion of this chapter, you will be able to:

- Describe a basic project workflow, from production to final render
- Create and name project files and compositions
- Import and composite graphic media and type for motion
- Animate layers by setting keyframes
- Apply effects for stylizing and enhancing motion graphics
- Render for delivery to film, broadcast, the web, and mobile devices

Project Workflow

Before we jump into action, it is important to outline a typical road map in building a successful motion design project. You always start by defining what the end product will be. Write down key words that describe the project's content and desired emotional impact. Design mind maps to outline all of your ideas and possible solutions.

Once you have a clear goal in mind, pre-visualize your ideas using sketches, storyboards, style frames, and animatics. **Pre-visualization** helps communicate to the client a clear and unified visual direction before production begins. These solutions are presented to the client in the form of a **pitch** to sell the designer's ideas and get them hired.

A typical project pipeline consists of defining the end-product followed by pre-visualization to determine the look and narrative design. Production and publication complete the workflow.

Once you connect with the client, you create your assets, and import and arrange the media elements on layers within a timeline in After Effects. Once everything is in place, you add complexity to the project through compositing, animation, and visual effects. After previewing and refining the project to meet its output goals, you publish the project for its intended destination.

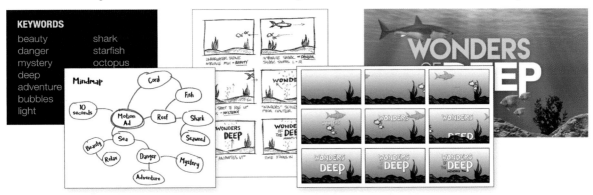

1. Define the Project

2. Sketch and Storyboard

3. Determine the Visual Style

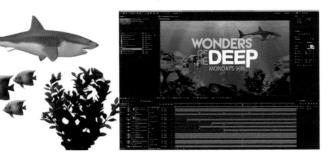

4. Build the Assets

5. Compose, Animate, Preview

6. Publish the Motion Project

Define the Project Scope

Designers first need to understand the intended scope of the project. From the initial client meetings, formulate how much work needs to be done, and confirm when the final deliverable is due. If possible, identify any possible constraints and compensate for any delays. A well-planned project should provide clarity and a unified perspective on who is providing what to complete the project.

Questions for the client:

- What type of motion design project is it?
- What is the overall goal in developing this project?
- What is the message that needs to be communicated?
- Who is the message intended for?
- Who is providing content?
- Any existing logos or branding style-guides to follow?
- What is the duration for the motion design?
- When is the project due?

Questions for the designer:

- Do I need to hire/collaborate with an expert?
 - Animator
 - Videographer
 - Actors
 - Voice talent
 - Technology developer
- What additional expenses exist?
- Hardware and software?
- Server space?

Ask the right questions to determine the project's scope.

What TYPE of motion design project?

Who is the AUDIENCE?

Project GOALS?

How LONG is the project?

When is the project DUE?

Do I need to HIRE TALENT?

Communicate Your Ideas

You start a motion design project with a **content brief**. This document could come from the client, or it is created by the designer. Its purpose is to communicate the client's needs and the project's goals and objectives. A timeline should be included that identifies milestone deliverables for the project over a period of time. Any additional client requests made outside of the approved plan is referred to as scope creep and can negatively impact the final design.

In this chapter, you will build a basic motion design project in Adobe After Effects. The project is an opening title sequence for a fictitious television program. Download the chapter files. To see what you will build, locate and play the **WondersDeep.mov** in the **Completed** folder inside **Chapter_02**. Let's deconstruct how this project was visualized.

Download the **Chapter_02.zip** file at *www.routledge.com/cw/jackson*. It contains all the files needed to complete the chapter exercise.

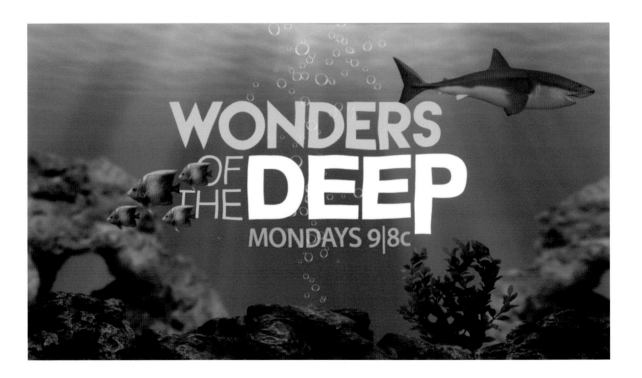

Thumbnail Sketches

Start with sketching. On a sheet of paper, sketch out compositions that you think would be effective in illustrating your project. You don't have to draw well to create a **thumbnail board**, so don't spend a lot of time fine-tuning your art. Its purpose is to quickly determine the layout of your shots, not highlight your illustration skills.

Even though the artwork is rough, the thumbnail sketches should still clearly define which graphic elements are in a shot, the camera's position, and the direction of motion, if any. List details underneath each sketch as notes to clarify what you envision. This can include anything from a shot description, animation direction, and transitions. Create a rough thumbnail board first to help you organize your layout and provide a visual format to build your storyboard.

A thumbnail board consists of rough drawings that illustrate the overall composition. This includes each shot's framing and staging of graphic elements, directions of movement, and transitions from one shot to the next.

Storyboards

A **storyboard** is a production tool that illustrates a motion design project shot-by-shot using a series of sequential images. In film, it allows the director to plan the camera shots, the camera angles, and the camera movement to produce a cohesive and entertaining story to the audience. When finished, your storyboard will become a blueprint for all the important shots that will be in the final deliverable. In visual form, it looks like a comic strip.

A storyboard should visually answer the following questions:

Storyboards are visually more refined than thumbnail sketches and illustrate the shot-by-shot flow of the project. Movement is highlighted using arrows, typically drawn in a different color.

- Which graphic elements are in the frame?
- How are the elements moving?
- Where is the camera positioned?
- Is the camera moving?

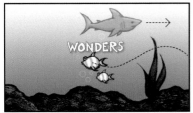 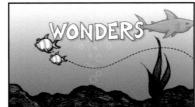

Style Frames

It is always better to show, rather than tell, a client what the project will look like. Whereas sketches and storyboards establish framing, staging, and movement of graphic elements from shot to shot, a **style frame** establishes the visual look for the graphic elements. It is a single image that represents how the finished project will look. Designing a series of style frames creates a **design board** that collectively evokes the intended feeling and tone of the narrative component in the project.

A style frame is a quicker and more cost effective alternative to jumping directly into the animation in After Effects. It is a communication tool used to ensure both the client and the designer are on the same page from the beginning. Any refinements can be made simply and quickly without having to render a new movie from After Effects.

Think of a style frame as a snapshot of one frame from the final motion design project. Style frames allow clients and designers to work together to refine the visual look and feel before production begins.

The goal of a style frame is to define the visual look including color, type, image style, and texture. Once approved, the style frames become an indispensable guide for the designer during production.

Animatics

When you add the element of time to a storyboard, you get an **animatic**. Basically, it is an animated storyboard. Each storyboard image is digitally imported into a time-based application, such as Adobe After Effects or Adobe Premiere. The images are stitched together sequentially to determine the correct timing and pace for the motion design. Additionally, animatics often include audio narration, sound effects, and a scratch soundtrack used as a placeholder for the final musical score.

Animatics are storyboards in motion. They are used to determine the proper timing and pace for the motion design project.

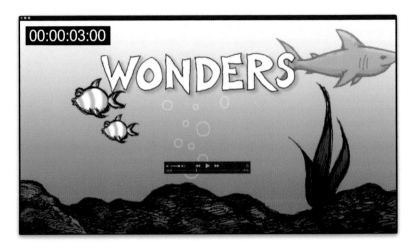

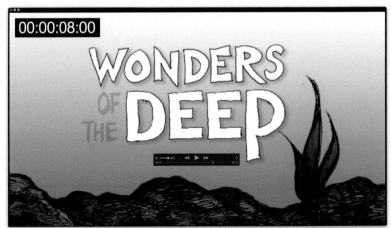

Chapter Exercise:
Getting Started in After Effects

Once the client has approved the preproduction, production begins. As previously mentioned, you are going to build a basic motion design project in this chapter. The following chapter exercise is broken into five main steps: creating a new project using imported media, setting keyframes, applying visual effects, nesting compositions, and rendering out the final composition as a QuickTime movie.

Download the **Chapter_02.zip** file to your hard drive, if you have not already done so. It contains all the files needed to complete the chapter exercise. The goal of this project is to provide an overview on how to assemble and animate a project in After Effects. It is a step-by-step tutorial that introduces you to After Effects, its workspace and workflow.

Download the **Chapter_02.zip** file at *www.routledge.com/cw/jackson*. It contains all the files needed to complete the chapter exercise.

Exercise 1: Creating a New Project

All your work in After Effects begins with a project file. This project file references the imported files and holds the compositions created using those files. When you finish this first exercise, you should know what the **Project**, **Composition**, and **Timeline** panels are and how they work together. In addition to that, you'll know how to import media elements and save your project.

The basic structure and workflow for an After Effects project.

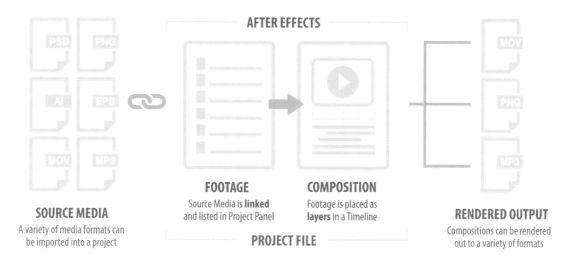

AFTER EFFECTS

FOOTAGE
Source Media is **linked** and listed in Project Panel

COMPOSITION
Footage is placed as **layers** in a Timeline

SOURCE MEDIA
A variety of media formats can be imported into a project

RENDERED OUTPUT
Compositions can be rendered out to a variety of formats

PROJECT FILE

Only one project in After Effects can be opened at a time. This is a key concept to understand. If you try to open another project or create a new project within After Effects, After Effects will close down the current project you are working on.

1. Launch **Adobe After Effects**. It opens an empty project by default. The graphical user interface, referred to as the "workspace," can be configured in many ways.

The Workspace

The workspace is divided into several regions called panels. The panels are docked to reduce screen clutter. Most of the work done in After Effects revolves around three panels: the Project, Composition, and Timeline panel.

- The **Project** panel displays imported linked footage and stores the self-contained movies, called compositions, created within a project.

- The **Composition** panel is used to compose, preview, and edit your footage layers.

- The **Timeline** shows how the structure of your composition is built. The panel is divided into two sections. The right section is the actual Timeline where each layer's starting and stopping points, duration, and keyframes are displayed. The left section of the Timeline panel is broken up into a series of columns and switches. These affect how the layers are composited together.

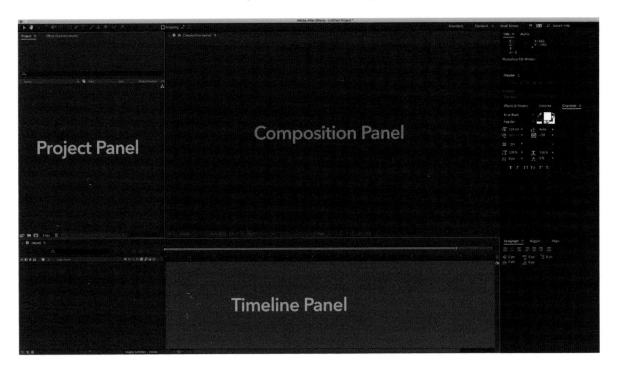

2. To make sure that you are using the same configuration as the book, locate the Workspace menu in the upper right corner. Select **Standard**.

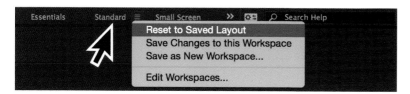

The project's workspace should be set to **Standard** to be consistent with exercises in this book.

Projects are made up of **compositions**. A composition in After Effects is a self-contained movie. Each composition contains its own timeline. Even though After Effects can only open one project file at a time, there can be multiple compositions within the project. Let's create one.

3. Select **Composition > New Composition**. Make the following settings in the dialog box that appears:

* Composition Name: **Comp_WondersDeep**

* Preset: **HDV/HDTV 720 29.97**

* Duration: **0:00:10:00** (10 seconds)

* Click **OK**.

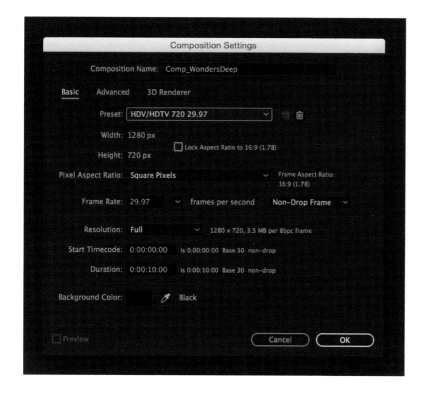

After Effects provides a number of presets for different types of motion projects. The presets automatically set the composition's frame size, pixel aspect ratio, and frame rate for the selected output format.

A new composition opens in the Composition and Timeline panel. The Project panel also lists the composition. You can also create compositions by importing layered Photoshop and Illustrator files which you will do in the next exercise.

Import Footage – Photoshop

You create compositions from various imported files referred to as **footage**. Footage can be bitmap images, vector art, layered Photoshop and Illustrator files, image sequences, 3D files created in Cinema 4D, digital video clips, and audio files.

1. Keep the current After Effects project file open.

2. Select **File > Import > File**. This opens the import dialog box.

3. From within the Import File dialog box, locate the **Footage** folder for this chapter. From within the **Footage** folder, select the **TheDeep_Scene.psd** file. It is a layered Photoshop file.

4. Choose **Import As > Composition Retain Layer Sizes**. Click **Open**.

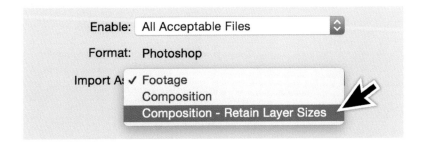

5. In the **TheDeep_Scene.psd** dialog box that appears, click **OK**. After Effects will import each layer and match its appearance in Photoshop, and preserve any blending modes and layer styles as editable.

Why was this layered Photoshop file imported this way? Selecting the **Footage** option flattens all the layers into a single layer. Choosing **Composition** maintains each layer set to the same dimension as the composition frame (1280 x 720 pixels). The final option, **Composition - Retain Layer Sizes**, maintains each layer and keeps its own dimensions.

For example, the width and height of layer that holds the fish illustration will only be as big as the graphic itself. This makes each layer easier to animate in After Effects. This also allows designers to build the static composition in Photoshop and then animate it directly in After Effects.

Imported footage is linked to, not embedded within, the project file. Always keep your source footage material organized in folders.

There are many ways to import footage into After Effects. The keyboard shortcut to import footage is **Command + i** (Mac) or **Control + i** (Windows). You can also drag files from the desktop into After Effects. Another import time saver is to double-click inside the Project panel.

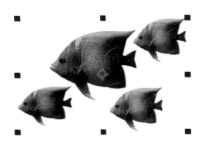

Organize the Project Panel

Let's organize the Project panel a little better by creating a new "Comps" folder that will only contain compositions. To do this:

1. Deselect any selected item in the Project panel by clicking on the gray area under the footage.

2. Click on the **Folder** icon ▢ at the bottom of the Project panel.

3. Rename the new folder to **Comps**.

4. Click and drag the two compositions (**Comp_WondersDeep** and **TheDeep_Scene**) into the new **Comps** folder.

You can rename any folder or layer at any time by selecting it and pressing the **Return/Enter** key on the keyboard. This highlights the name and allows you to rename the item.

Project panel: This displays the linked footage files. Folders can be created to organize the assets better.

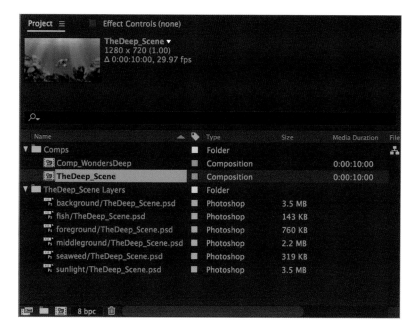

As projects become more complex, the Project panel can get quite cluttered. It is not uncommon to have hundreds of footage files. Get into the habit of organizing your footage into separate folders. Let's add some more footage to this project.

Import Footage – Illustrator

1. Go to the Project panel and double-click in the empty gray area. This is a shortcut that opens the import dialog box.

2. From within the Import File dialog box, locate the **Footage** folder. From within the **Footage** folder, select the **TheDeep_Title.ai** file.

3. Choose **Import As > Composition**. Click **Open**.

4. In the Project panel, delete the **TheDeep_Title** composition. You only need the imported layers folder from the Illustrator file.

Delete the composition. You only need the imported layers from the Illustrator file.

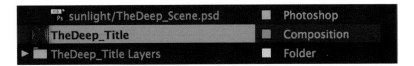

Import Footage – Image Sequence

In addition to layered Photoshop and Illustrator files, you can import a series of image files as one still-image sequence. The files must be in the same folder and use the same file naming pattern, for example image001, image002, image003.

1. Go to the Project panel and double-click in the empty gray area to open the Import File dialog box.

2. From within the **Footage** folder, open the **3D Shark Render** folder. This folder contains a PNG image sequence of a great white shark. The images were rendered using Cinema 4D.

3. Select the first PNG file labeled **shark0000.png**.

Only the first image in the sequence needs to be selected. After Effects will import the remaining images in the folder with the same file naming pattern.

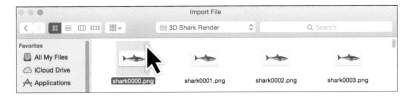

4. Make sure the check box for **PNG Sequence** is checked.

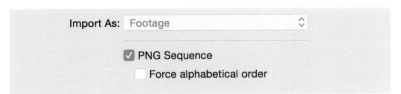

5. Click **Open**. After Effects recognizes the selected image as one file in the PNG image sequence. The remaining image files in the same folder are imported into a single footage file in the Project panel.

The image sequence appears as a single footage file in the Project panel.

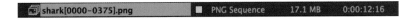

Add Footage to the Composition

A **composition** is a container that holds layers of footage. These layers are manipulated within the space and time defined by the composition. Compositions are independent timelines. Now that you have imported some footage, let's add them to a composition to animate later.

1. Go to the Project panel. Double-click on the **TheDeep_Scene** composition. The composition opens to display the imported Photoshop layers in the Composition panel. The Timeline also opens. These two panels work closely together.

The Composition Panel

The Composition panel (referred to as the Comp panel) acts like a theatrical stage. You use it to compose, preview, and edit your project. Buttons along the bottom of the Comp panel include controls for magnification, viewing color channels, displaying the current frame, and adjusting the resolution.

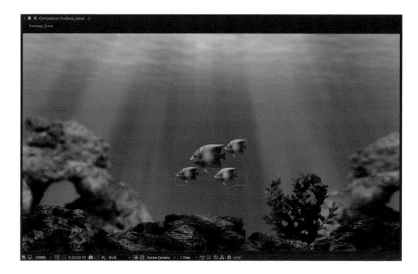

The Composition ("Comp") panel is used to arrange your footage and preview your motion design project.

The Timeline Panel

The Timeline shows how the structure of your composition is built. The panel is divided into two sections. The right section is the actual Timeline where each layer has a color-coded bar that represents its starting and stopping points and duration. The left section of the Timeline panel is broken up into a series of columns and switches. These affect how the layers are composited together.

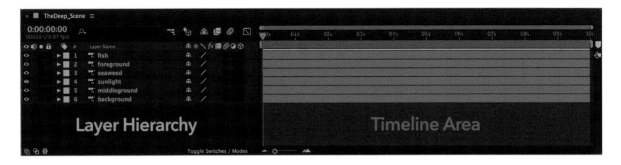

The Timeline panel is divided into two sections. Controls and switches for layer compositing are on the left. The actual Timeline is on the right.

As the Timeline becomes more populated and complex, you may want to zoom in or out. Use the Zoom slider at the bottom of the Timeline.

Zoom in to frame level, or out to entire comp (in time)

2. Go to the Project panel. Click and drag the **TheDeep_Title Layers** folder from the Project panel to the left side of the Timeline panel.

Select the imported Illustrator folder in the Project panel.

3. Position it above the **seaweed** layer. Release the mouse. Four Illustrator layers are added to the Timeline. The title appears in the center of the Composition panel.

Drag and drop the folder into the Timeline panel.

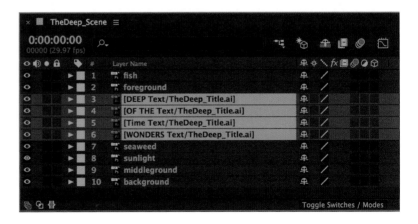

4. Click and drag the **shark[0000-0375].png** footage from the Project panel to the left side of the Timeline panel.

5. Position it above the **middleground** layer. Release the mouse. The great white shark appears in the Timeline and the Comp panel.

Drag and drop the PNG image sequence footage into the Timeline panel.

6. Your first motion design project is well on its way. Before you do anything else, save your project. Select **File > Save**. The keyboard shortcut is **Command + s** (Mac) or **Control + s** (Windows). This opens the Save As dialog box.

7. Name your file **01_WondersDeep** and save it in your **Chapter_02** folder on your hard drive. Click **Save**. The file has an **.aep** file extension. This stands for After Effects Project (AEP). The saved file is not meant to be a standalone file; it is only read by After Effects.

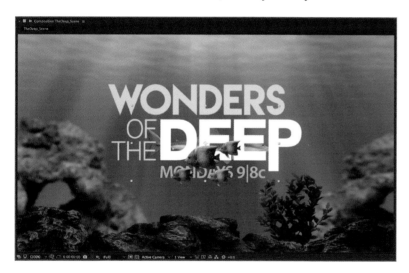

The Comp panel shows the layered footage for the chapter exercise.

Let's do a quick review. The three primary panels you used in this exercise include the Project, Composition, and Timeline panel. You created a new project, imported footage into the Project panel, and then added the footage to a composition.

The remaining amount of work takes place in both the Composition and the Timeline panels. The Comp panel works in conjunction with the Timeline panel. Any changes made to layers within the Timeline will be reflected visually within the Comp panel. Now it's time to learn how to bring this project to life.

Exercise 2: Setting Keyframes

The output delivered from After Effects is referred to as time-based media. This means that the media content changes with respect to time. Keyframes are used to record these changes. The word, **keyframe**, comes from traditional animation and designates the starting and ending points of any transformation in position, rotation, opacity, etc.

A keyframe is used to record the start and end points for any type of transformation.

Each layer in a composition has transform properties associated with it. These include Anchor Point, Position, Scale, Rotation, and Opacity. These transform properties can have keyframes assigned at different points in time to create an animation. All you need is a start keyframe, a change in time, and an end keyframe. Let's see how it works in After Effects.

Animate Position

After Effects stacks layers in the same order as Photoshop. Layers that are higher in the Timeline panel will appear in front of lower layers in the Comp panel. Just like Photoshop, you can place or move a layer anywhere in the stacking order.

1. Select the **fish** layer in the Timeline panel.

Select the **fish** layer in the Timeline.

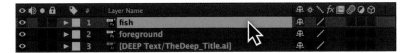

2. Click and drag the **fish** artwork off the right side of the Composition panel. This will be the starting position for the fish.

You can drag the footage to the Comp panel. This allows you to place it where you want. You can also drag the footage to the Timeline where it automatically centers in the Comp panel. After Effects will only display pixel information for footage contained within the Composition image area. Any item that falls outside the Comp panel is displayed as an outlined bounding box.

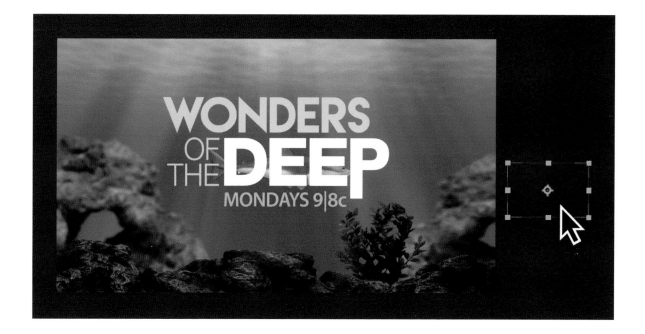

3. To create an animation, you keyframe transform properties inherent to a layer. In the Timeline, click the **twirler** ▶ to the left of the **fish** layer. This will reveal the word Transform. Each layer has its own transform properties.

4. Click the Transform twirler to reveal five properties, the values of which you can adjust over time. The transform properties are Anchor Point, Position, Scale, Rotation, and Opacity.

If you don't set a keyframe, the current position of the fish will remain constant for the duration of the composition. You would never see them because they are outside the Comp panel.

5. In the Timeline panel, make sure the **Current Time Indicator** (CTI) is on frame 0. The CTI is the blue vertical line on the right side of the Timeline panel, and it indicates what frame is currently being displayed in the Composition panel.

Position the fish artwork off the right side of the Comp panel.

The Current Time Indicator (CTI) shows where you are in time.

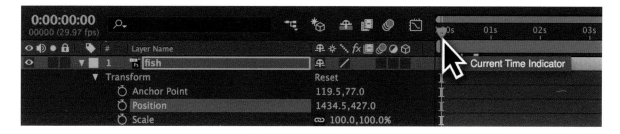

6. In the Timeline panel, click on the **stopwatch** icon 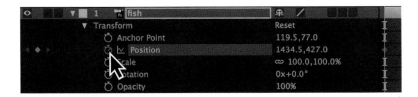 next to the Position property. This enables the Position property for keyframing. A keyframe in the form of a blue diamond ◆ appears in the Timeline at the current time.

The Stopwatch activates keyframes for animation. It records the fish's position on the first frame of the Timeline.

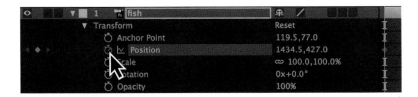

7. In order to create the animation, you need to move forward in time. Move the **Current Time Indicator** (CTI) to **eight seconds (08:00)** in the Timeline.

8. Click and drag the fish off the left edge of the Comp Window. After Effects interpolates the movement between the two keyframes. You do not need to click on the stopwatch icon again.

Position the fish artwork off the left side of the Comp panel. After Effects automatically generates a new keyframe at the 8-second frame in the Timeline panel.

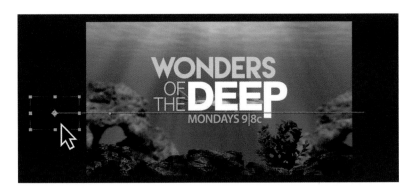

A **motion path** appears in the Comp panel. This dotted line traces the path of animation from start to finish. Each dot represents the position of the fish at each frame in the Timeline. Let's add more movement to the motion path.

9. Move the **Current Time Indicator** (CTI) to **two seconds (02:00)**.

10. In the Comp panel, click on the fish and move them up slightly. Since you are changing its position at a different point in time, a new keyframe is automatically generated.

11. Move the **Current Time Indicator** (CTI) to **four seconds (04:00)**.

12. In the Comp panel, click on the fish and move them down slightly.

13. Move the **Current Time Indicator** (CTI) to **six seconds (06:00)**.

14. In the Comp panel, click on the fish and move them up slightly.

The motion path contains Bezier handles next to each keyframe. These allow you to fine-tune the curve of the motion path.

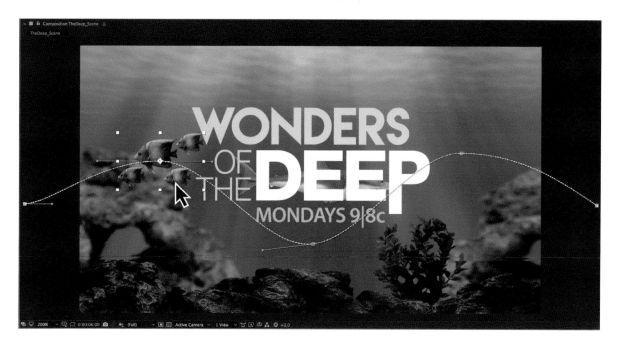

15. Let's preview the animation you just created. The Preview panel is a secondary panel located to the right of the Comp panel. It contains buttons similar to DVD controls. Click on the **Play/Stop** button.

Use the Preview panel to play back the animation. You can set a keyboard shortcut. The default key is the **Spacebar**.

There are two parts to the preview. First, the Current Time Indicator moves across the Timeline loading the content at each point in time. A green bar appears under the time ruler indicating what has been loaded into RAM. After the first pass is complete, After Effects does its best to play back the animation in real time.

Let's review. After Effects uses **interpolation** to fill in the transitional frames between two keyframes. Once keyframes have been activated by clicking on a property's stopwatch icon, interpolation occurs automatically as changes are made at different points in time.

16. Select the **shark[0000-0375].png** layer in the Timeline. The shark footage is layered underneath the title layers and it is difficult to move in the Comp panel without accidentally moving other layers.

17. Click on the **Solo** switch to the left of the layer's name. This switch reveals only the selected layer in the Comp panel and hides all the other layers. This is a toggle switch; it is either on or off.

 Video: turns on or off visibility

Audio: turns on or off audio layers

Solo: reveals only the selected layer

Lock: locks the layer

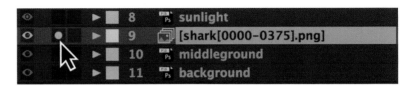

18. Move the **Current Time Indicator** (CTI) to the first frame (**00:00**).

19. Click and drag the shark artwork off the top-left side of the Comp panel. This will be its starting position.

Position the shark artwork off the top-left side of the Comp panel.

Transform Properties: Keyboard Shortcuts

A for Anchor Point

P for Position

S for Scale

R for Rotation

T for Opacity

U for all properties with keyframes

20. Type **P** on the keyboard to show only the Position property. Each transform property has a keyboard shortcut that will reveal only that property. This helps reduce clutter in the Timeline panel.

21. Click on the **stopwatch** icon next to the Position property. This enables the Position property for keyframing.

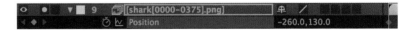

22. Move the **Current Time Indicator** (CTI) to **eight seconds (08:00)**.

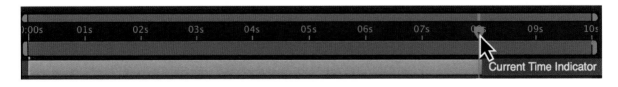

23. Click and drag the shark artwork off the top-right side of the Comp panel. Since you are changing its position at a different point in time, a new keyframe is automatically generated.

24. Click on the **Solo** switch again to turn it off and reveal all the layers in the Composition.

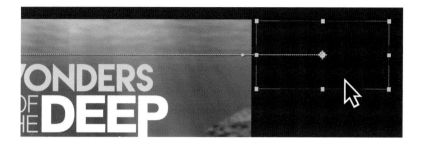

Position the shark artwork off the top-right side of the Comp panel.

25. Click on the **Play/Stop** button in the Preview panel. Both the fish and shark artwork animate across the underwater scene.

26. Save your project file. Select **File > Save**.

Spatial Interpolation

After Effects interpolates both space (spatial) and time (temporal). It bases its interpolation methods on the Bezier interpolation method. **Spatial interpolation** is viewed in the Comp panel as a motion path. Directional handles are provided for you to control the transition between keyframes. The default interpolation used is **Auto Bezier**. This creates a smooth rate of change from one keyframe to the next.

Spatial interpolation is displayed as a motion path in the Comp panel.

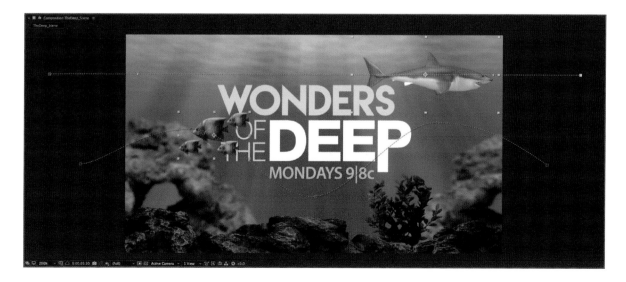

Trim and Animate Layers

The last set of keyframes you need to set are for the title. Typically in title sequences, the title doesn't appear on the first frame. After Effects allows you to change when a layer appears in the Comp panel.

1. Move the **Current Time Indicator** (CTI) to **one second (01:00)**.

2. Select the **WONDERS Text/TheDeep_Title.ai** layer in the Timeline.

3. Position your mouse cursor at the left edge of the **WONDERS Text** timeline bar. The cursor will change to a double arrow indicating that it can be dragged.

The keyboard shortcut for trimming the **Set In Point** is **Option/Alt + [**. To trim the **Set Out Point**, use **Option/Alt +]**.

4. Click and drag the **WONDERS Text** bar's **Set In Point** to align with the CTI at **one second (01:00)**. This is referred to as **trimming**. The word "WONDERS" will now appear at the one second mark.

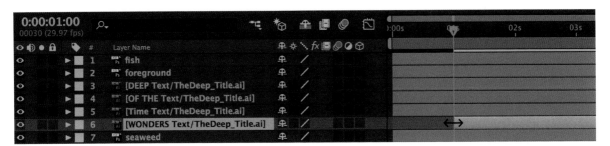

5. Make sure the **Current Time Indicator** (CTI) is at **one second (01:00)**. Type **S** on the keyboard to show only the **WONDERS Text** layer's Scale property.

6. Scrub through the numeric value and set it to **0%**.

7. Click on the **stopwatch** icon next to Scale to activate keyframes.

8. Move the **Current Time Indicator** (CTI) to **two seconds (02:00)**.

9. Scrub through the Scale numeric value and set it back to **100%**. A keyframe is automatically generated.

Set keyframes for the Scale property.

10. Click on the **Play/Stop** button in the Preview panel. The **WONDERS Text** layer scales up from 0 to 100%.

11. Move the **Current Time Indicator** (CTI) to **two seconds (02:00)**.

12. Select the **DEEP Text/TheDeep_Title.ai** layer in the Timeline.

13. Position your mouse cursor at the left edge of the **DEEP Text** timeline bar. The cursor will change to a double arrow indicating that it can be dragged.

14. Click and drag the **DEEP Text** bar's **Set In Point** to align with the CTI at **two seconds (02:00)**. The keyboard shortcut is **Option/Alt + [**.

15. Type **P** on the keyboard to show only the Position property.

16. Click on the **stopwatch** icon next to Position to activate keyframes.

17. Currently, the word "Deep" is in its final position. Let's record that as well. Move the **Current Time Indicator** (CTI) to **four seconds (04:00)**.

18. Click on the gray diamond to the left of the word Position to record a keyframe without having to change the layer's position manually.

19. Move the **Current Time Indicator** (CTI) back to **two seconds (02:00)**.

20. Click and drag the word "Deep" off the bottom of the Comp panel.

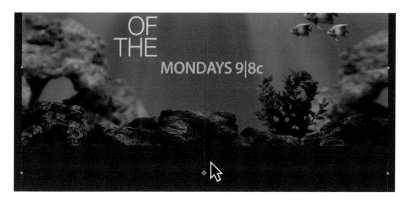

21. Click on the **Play/Stop** button. The **DEEP Text** layer animates up from the bottom of the underwater scene.

22. Save your project file. Select **File > Save**.

Keyframe Navigation Shortcuts

Hold the **Shift** key while you drag the CTI and it will snap to a set keyframe. Type **J** to go to the previous keyframe. Type **K** to go to the next keyframe.

Animate Opacity

The keyboard shortcut for Opacity is **T**. Think of transparency. Opacity can be set from **0%** (transparent) to **100%** (opaque). Let's finish the title animation by fading in the last two Illustrator layers.

1. Move the **Current Time Indicator** (CTI) to **three seconds (03:00)**.

2. Select the **OF THE Text/TheDeep_Title.ai** layer in the Timeline.

3. Trim the **OF THE Text** bar's **Set In Point** to align with the CTI at **three seconds (03:00)**.

4. Type **T** on the keyboard to show only the **OF THE Text** layer's Opacity property. Scrub through the numeric value and set it to **0%**.

5. Click on the **stopwatch** icon next to Opacity to activate keyframes.

6. Move the **Current Time Indicator** (CTI) to **four seconds (04:00)**.

Set keyframes for the Opacity property.

7. Scrub through the Opacity numeric value and set it back to **100%**.

8. Make sure the **Current Time Indicator** (CTI) is at **four seconds (04:00)**. Select the **TIME Text/TheDeep_Title.ai** layer in the Timeline.

9. Trim the **TIME Text** bar's **Set In Point** to align with the CTI at **four seconds (04:00)**.

10. Type **T** on the keyboard to show only the **TIME Text** layer's Opacity property. Scrub through the numeric value and set it to **0%**.

11. Click on the **stopwatch** icon next to Opacity to activate keyframes.

12. Move the **Current Time Indicator** (CTI) to **five seconds (05:00)**.

Set keyframes for the Opacity property.

13. Scrub through the Opacity numeric value and set it back to **100%**.

14. Click on the **Play/Stop** button. The title animation is now complete.

15. Save your project file. Select **File > Save**.

Temporal Interpolation

Temporal interpolation refers to the change in value between keyframes with regards to time. You can determine whether the value stays at a constant rate, accelerates, or decelerates. The default temporal interpolation used in the Timeline is **Linear**. That means the value changes at a constant rate.

Before you finish this exercise, there is one more topic to cover: keyframe assistants. **Keyframe assistants** automate the task of easing the speed into and out of keyframes. Easing provides more realistic movement to objects since nothing in real life moves at a constant speed.

After Effects provides three types of keyframe assistants: Easy Ease, Easy Ease In, and Easy Ease Out. Easy Ease smooths both the keyframe's incoming and outgoing interpolation. Let's apply a keyframe assistant.

1. Select the **Position** property in the **DEEP Text/TheDeep_Title.ai** layer. This selects all the keyframes.

2. Select **Animation > Keyframe Assistant > Easy Ease**. The keyframes change from diamonds to hourglass shapes ⚯ in the Timeline.

3. Repeat these two steps with the remaining title layers. First click on the layer's transform property name to select all its keyframes. Then, select **Animation > Keyframe Assistant > Easy Ease**.

Apply the keyframe assistant, **Easy Ease**, to the title keyframes.

Let's quickly review the basic process for setting keyframes. Each layer has transform properties inherent to it. These include Scale, Position, and Opacity. You set keyframes for each transform property by clicking on its stopwatch icon. This icon activates the keyframes. After Effects automatically records new keyframes for changes made at different points in time.

The next exercise focuses on applying visual effects to your project. This is what After Effects is known for. Effects allow you to enhance, transform, and distort both video and audio layers. The possibilities are endless.

Exercise 3: Applying Effects

This is where After Effects truly shines. Once you see how easy it is to apply effects, you'll never want to stop. There are hundreds of effects that ship with the program. You can add any combination of effects and modify properties contained within each effect. It's insane! The only limitation is your creativity.

Effects are used to enhance a project in After Effects. These effects range from very simple drop shadows to complex 3D particle systems. In this exercise you will apply three visual effects: a 3D particle generator, a tint effect for color correction, and a distortion effect. These effects will add the finishing touches to your motion design project.

Add a Particle Effect

1. Make sure the Timeline panel is highlighted. Select **Layer > New > Solid**. The keyboard shortcut is **Command/Control + Y.** The Solid Settings dialog box appears. A solid layer is just that, an area of color.

2. Enter **Bubbles** for the solid name.

3. Click on the **Make Comp Size** button.

4. Click **OK**. The color of the solid layer doesn't matter.

The keyboard shortcut to create a new solid layer is **Command + Y** (Mac) or **Control + Y** (Windows).

All solid layers are stored in a **Solids** folder in the Project panel. This folder is automatically generated when you create your first solid layer. Any new solid layers you create will also be stored in the the same folder.

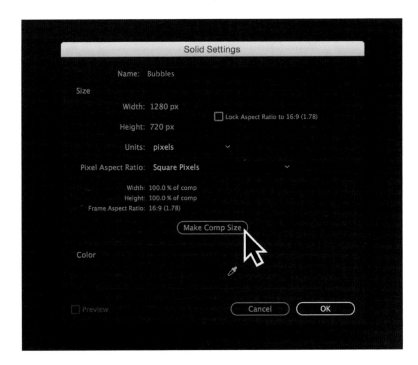

5. Reposition the **Bubbles** solid layer under the **foreground** layer.

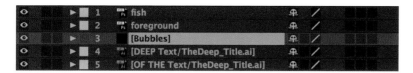

Position the solid layer under the
foreground layer in the Timeline.

The Effects & Presets panel is located to the right of the Comp panel. All effects are stored in a Plug-Ins folder inside the After Effects application folder. The Effects & Presets panel categorizes effects according to their function.

6. Go to the Effects & Presets panel. Enter **Foam** into the input text field. The item in the effects list that matches is displayed.

7. To apply the Foam effect to the solid layer, click and drag the effect to **Bubbles** layer name in the Timeline panel. Release the mouse.

8. The effect is applied automatically. Notice that the solid color disappears and is replaced with a red circle in the center of the Comp panel. Click on the **Play/Stop** button to see the Foam effect.

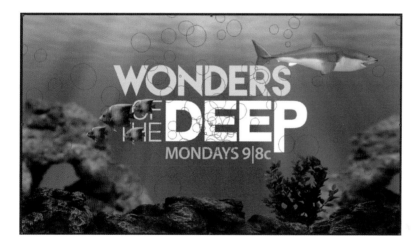

Foam is a 3D particle generator that creates bubbles.

Wireframe outlines of bubbles come out of the red circle in the center of the Comp panel. The Foam effect generates bubbles that flow, stick together, and pop. When you apply an effect, the Effect Controls panel opens as a new panel in front of the Project panel. It contains a list of properties associated with the effect. Let's experiment with the Foam properties to change the motion and visual style.

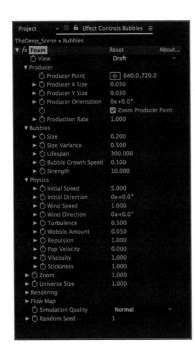

If the Effect Controls panel is not visible, select **Effect > Effect Controls**.

Change the view from **Draft** to **Rendered** to see a better representation of the bubbles in the Comp panel.

9. Click on the **twirler** to the left of **Producer**. This controls where the bubbles originate from. Change the Producer Point coordinates to **640, 720**. This lowers the vertical position of the producer point to the bottom of the Comp panel.

10. Click on the **twirler** to the left of **Bubbles**. This controls the size and lifespan of the bubbles. Change the Size parameter to **0.200**. This makes the bubbles smaller.

11. Click on the **twirler** to the left of **Physics**. This controls how fast the bubbles move and how close they stick together. Make the following changes:

- Initial Speed: **5.000**
- Wind Speed: **1.000**
- Wind Direction: **0 x 0.0**
- Viscosity: **1.000**
- Stickiness: **1.000**

12. Click on the **twirler** to the left of **Rendering**. This controls the visual look of the bubbles. Change the Bubble Texture from **Default Bubble** to **Spit**.

13. To see the finished results, select **Rendered** from the View pop-up menu at the top of the Effect Controls panel.

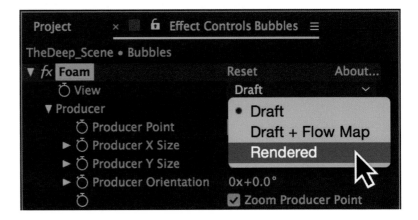

Apply a Tint Effect

You often will need to adjust the colors of one or more of the layers in a composition. For this project, the shark does not blend perfectly with the background. A simple color correction can help solve this. For this next part, you will use the Tint effect to alter the layer's RGB colors.

1. Select the **shark[0000-0375].png** layer in the Timeline.

2. Go to the Effects & Presets panel. Enter **Tint** into the input text field. The item in the effects list that matches is displayed.

3. To apply the Tint effect to the shark layer, drag and drop the effect onto the **shark[0000-0375].png** layer name in the Timeline panel.

4. Go to the Effect Controls panel, next to the Project panel. Click on the **Map White To** color swatch. This opens a dialog box.

5. Change the RGB settings to **R:30, G:135, B:185**. Click **OK**.

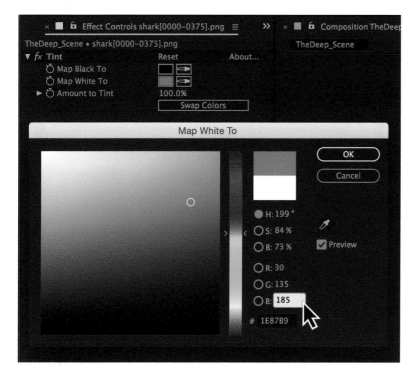

The Tint effect replaces the pixel color values with a value between the colors specified by Map Black To and Map White To parameters.

6. Change the Amount to Tint parameter to **75%**. The shark's colors now blend in better with the underwater scene.

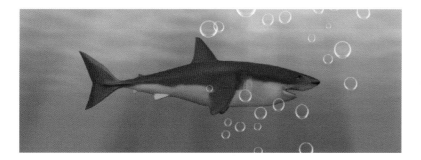

You often need to adjust or correct the colors of one or more of the layers in an After Effects project.

Create an Adjustment Layer

Adjustment layers in After Effects work just like they do in Photoshop. This type of layer holds effects, not footage. Any effect applied to an adjustment layer is also applied to all the layers below it.

1. Select the Timeline panel so that it is highlighted.

2. Select **Layer > New > Adjustment Layer**. Position the added adjustment layer at the top of the layers in the Timeline.

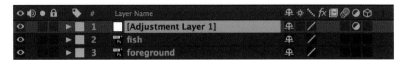

Create an adjustment layer and position it at the top of the layers in the Timeline.

Apply a Displacement Map Effect

You are going to use the **Noise.mov** footage to create the illusion of being underwater. This is done using a Displacement Map. The Displacement Map pushes and pulls pixels based on changes in luminosity (brightness and darkness) occurring in the Noise QuickTime movie.

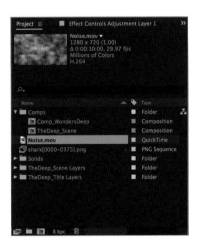

1. Import the **Noise.mov** file from the **Footage** folder into the Project panel.

2. Click and drag the **Noise.mov** file to the bottom of the layers in the Timeline. It will be hidden underneath the water layer. That is OK since the effect only needs to access the changing grayscale information.

Import the **Noise.mov** footage and position it at the bottom of the layers in the Timeline.

3. Go to the Effects & Presets panel. Enter **Displacement** into the input text field.

4. Click and drag the Displacement Map effect to **Adjustment Layer 1** in the Timeline panel. Release the mouse.

The Displacement Map needs to use the grayscale information from the **Noise.mov** layer to distort pixels within a layer. Areas of light grays will displace pixels up and to the right. Darker grays do just the opposite. Since this grayscale information is constantly changing in this movie, the displacement will also animate over time.

5. In the Effect Controls panel make the following changes:

- Change the Displacement Map Layer to the **Noise.mov** layer.
- Use for Horizontal Displacement: **Luminance**
- Max Horizontal Displacement: **7.0**
- Use for Vertical Displacement: **Luminance**
- Max Vertical Displacement: **7.0**

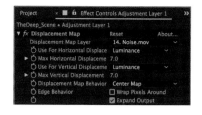

6. Click on the **Play/Stop** button to see the displacement effect.

Change the parameters in the Effect Controls panel. This effect distorts pixels horizontally and vertically based on the color values of pixels in another layer.

7. There is one small problem. The edges of the **background** layer are also distorting. As a result, the black color underneath is being revealed. To correct this, select the **background** layer.

8. Type **S** on the keyboard to show only the Scale property. Scrub through the numeric value and set it to **102%**. Now the edge distortion occurs outside the Comp Window.

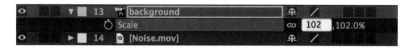

Scale the **background** layer up slightly to hide the edge distortion caused by the Displacement Map effect.

9. Increase the Scale property of the **middleground** and **foreground** layer to **102%** to hide their edge distortion.

10. Click on the **Play/Stop button** to see the final animation.

11. Save your project. Select **File > Save**.

The Displacement Map effect simulates the bending of light seen underwater.

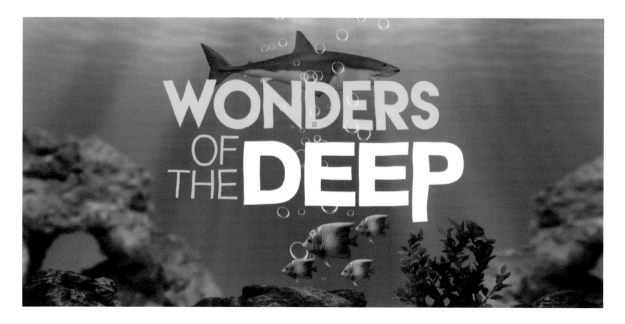

Exercise 4: Nesting Compositions

You are almost done with your first motion design project. The next step in the workflow is to build the final composition. You will use the first composition you built to do this. After Effects allows you to place one composition inside another as a single layer. This is referred to as **nesting compositions**. Think of it as grouping layers together.

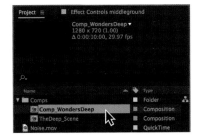

Open the first composition you created for this chapter exercise.

1. Open the **Comp_WondersDeep** composition you created at the beginning of this chapter exercise by double-clicking on it in the Project panel.

2. Click and drag the **TheDeep_Scene** comp from the Project panel to the Timeline. You have just nested a composition inside another.

3. Select **File > Import > File**. This opens the import dialog box.

4. From within the Import File dialog box, locate the **Footage** folder. Select the **GoExplore.mov** QuickTime file. Click **Open**.

5. Click and drag the imported QuickTime footage to the Timeline. Position it above the **TheDeep_Scene** layer.

6. Notice that the duration of the QuickTime movie is shorter than the composition's duration. Align the right end of the **GoExplore.mov** layer to the end of the composition.

Align the right edge of the QuickTime footage layer to the end of the composition in the Timeline panel.

7. Select **File > Import > File**. This opens the import dialog box.

8. From within the Import File dialog box, locate the **Footage** folder. Select the **InkBlot_Transition.mov** QuickTime file. Click **Open**.

9. Click and drag the imported QuickTime footage to the Timeline. Position it above the **GoExplore.mov** layer.

10. Align the imported layer's bar to the **GoExplore.mov** layer's bar. The ink blot animation will be used to mask and reveal the logo layer underneath it using a track matte.

Create a Track Matte

A **track matte** uses the transparency from one layer to reveal another layer that is directly under it. For this project, you will use the ink blot animation as a track matte to reveal the Go Explore logo layer. The underlying layer (the logo layer) will get its transparency from the values of certain channels in the track matte layer (ink blot animation) – either its alpha channel or the luminance (grayscale values) of its pixels.

1. Select the **GoExplore_Logo.mov** layer in the Timeline panel.

2. Click on the **Toggle Switches / Modes** button at the bottom of the Timeline panel.

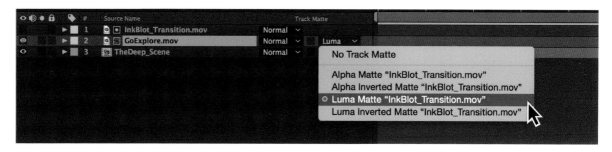

3. Define transparency for the track matte by choosing the **Luma Matte "InkBlot_Transition.mov"** option from the Track Matte menu for the **GoExplore.mov** layer.

4. Click on the **Play/Stop** button to see the track matte in action. The Luma Matte reveals the logo layer when the luminance value of a pixel is 100% (white) in the ink blot animation. Save your project.

Apply a track matte to the **GoExplore.mov** layer to reveal it in a unique way.

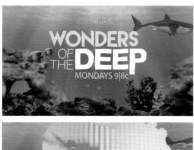

Exercise 5: Rendering a Composition

Your composition has been built and the layers are in place. Several of these layers animate in the Comp panel. Visual effects have been applied. Now it is time to see all of your hard work saved to a movie. This exercise focuses on rendering your composition to a movie file. After Effects renders compositions within a project. There are many file formats that the composition can be rendered out to.

1. Make sure the **Comp_WondersDeep** composition is still open in the Timeline panel.

2. Select **Composition > Add to Render Queue**. This opens the Render Queue. It replaces the Timeline panel in the After Effects workspace.

Compositions can be rendered directly from After Effects by adding them to the Render Queue. Adobe Media Encoder can also be used to render a composition.

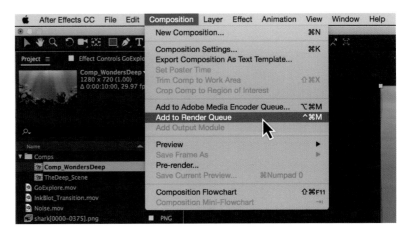

3. In the Output To dialog box select a destination on your hard drive as the final destination for the rendered movie. If this dialog box does not appear, click on **Comp_WondersDeep.mov** next to Output To.

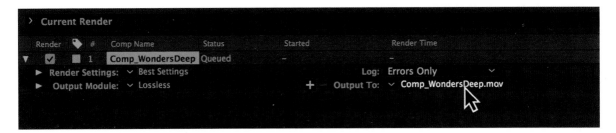

Select a destination for your rendered composition using the Output To link.

4. Click on the word **Lossless** next to Output Module.

5. Set the format to **QuickTime** movie.

6. Click on the **Format Options** button.

7. Under Format Options, set the video compression setting to **H.264**. Click **OK** to close the Format Options dialog box.

Set the compression setting to H.264 or MPEG-4 Video. H.264 is recommended for high-definition (HD) video. MPEG-4 offers a very good trade off on file size versus quality for digital television, animated graphics, and the web.

8. Click **OK** to close the Output Module Settings dialog box.

9. Click the **Render** button. Your composition will start to render.

The Render Queue provides feedback such as which frame is currently being rendered and approximately how much time is left. You have finished your first animated motion design project in After Effects.

10. Save your project. Select **File > Save**.

11. Locate and play the rendered QuickTime movie on your desktop.

The final rendered QuickTime movie.

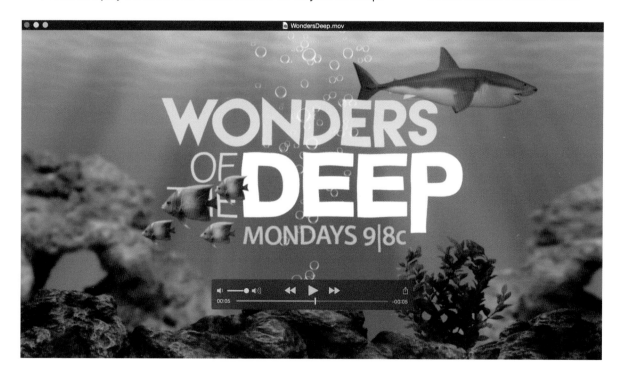

Summary

Your journey with After Effects has begun. This chapter introduced you to its workspace and workflow. The chapter exercises provided the steps it takes to create a typical motion design project. The remaining chapters will delve deeper into using After Effects for a variety of projects. The next chapter focuses on type in motion.

Table 2.1: After Effects Workspace Review

Workspace	Key Points to Remember
Project panel	Use it to organize imported files. A search feature allows you to quickly locate footage nested within folders.
Composition panel	Use it to compose and preview your project. The workspace outside the Comp panel's image area does not render pixels, only a bounding box.
Timeline panel	Use it to control the layer stacking order. Layers can be animated through individual transform properties.

Table 2.2: After Effects Workflow Review

Workflow	Key Points to Remember
Creating a project	Only one project file can be open at one time.
Importing footage	Files are not embedded in the project.
Setting keyframes	You activate keyframes by clicking on a layer's transform property stopwatch icon. After Effects interpolates both space and time.
Applying effects	After Effects provides hundreds of effects and an unlimited number of ways to combine them.
Rendering a project	You can render a composition out to a variety of output options.

3

Typography in Motion

Typography is a main staple in most design projects. With After Effects, static text comes alive and can move across the screen, or fade in and out. Applied motion and visual effects help reinforce the message behind the letters and words on screen. This chapter introduces the type engine in After Effects and shows how to apply basic movement to create a variety of kinetic typographic solutions.

At the completion of this chapter, you will be able to:

- Discuss terminology and limitations for on-screen type
- Create text layers in After Effects
- Animate a text layer along a path
- Apply text animators to a text layer
- Use text selectors to animate individual characters

Typographic Terminology

Typography is the art of arranging letters and characters to convey a message. It should never be overlooked when creating a motion design project. Designers need to carefully select typefaces, point sizes, appropriate line lengths and spacing for both a single line of text and multiline paragraphs. It might seem trivial, but even the smallest adjustment to a typeface, letter, or character arrangement can greatly impact how a message is communicated.

Anatomy of a Typeface

A **typeface** is a set of characters of the same design. These characters include letters, numbers, punctuation marks, and symbols. Just like the bones in our bodies, each part of a letter has its own special term. Here are some common typeface terms and their definitions:

- **Baseline:** The invisible line that a letter sits on
- **Cap height:** The distance from the baseline to the top of the capital letter
- **X-height:** The height of the body of the lowercase letter
- **Bar:** The horizontal strokes in letters
- **Stem:** The vertical strokes in a letter
- **Ascender:** A vertical stroke on a letter that extends above the x-height
- **Descender:** A vertical stroke on a letter that falls beyond the baseline
- **Bowl:** The curved part of the character that encloses the circular or curved parts of some letters
- **Counter:** The fully or partially enclosed space within a letter
- **Shoulder:** The curved stroke of the h, m, n
- **Loop:** The enclosed counter below the baseline of the g

Typeface terminology

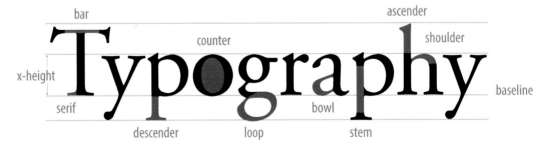

Type Classification

Type is classified based on its use of serifs. A **serif** is a small line, or foot, attached to the end of a stroke in a letter or symbol. The two main type classifications are called serif and sans serif. The term "sans serif" literally means "without serif." Other classifications include slab serif, blackletter, script, and decorative.

Type classifications

serif

Garamond Times

sans serif

Helvetica Futura

slab serif

Courier
Bitter

script

Brush Script
Snell Roundhand

decorative

ROSEWOOD
STENCIL

blackletter

Blackletter

Typeface versus Font

Often, the terms "typeface" and "font" are used interchangeably. There is a difference. A typeface is created by a type designer and describes the overall look, or aesthetics, of the characters. Each typeface is known by a name, such as Helvetica, Arial, Garamond, and Times New Roman. A **font** is the digital representation of a typeface. It is a file that generates a particular style of characters in a given typeface using computer code.

Some typefaces, like Helvetica, have a large number of variations in weight and widths. The **weight** refers to the thickness of the strokes of a letter or character. The **width** refers to how narrow or wide the whole letter or character is. You often see all of these referred to as a **font family** by type foundries. Fonts also come in different file formats.

design
design
design
design
design

The weight refers to the thickness of the strokes of a letter or character.

Font Formats

If you have ever downloaded fonts, you probably have encountered that there are several font formats to choose from. This can be very confusing. The three most common font formats are PostScript, TrueType, and OpenType. What is the difference between them?

- **PostScript:** This format was developed by Adobe for the Mac. Each font consists of two files: a screen font with bitmap information to display the typeface on computer monitors, and a file with outline information for printing the font.

- **TrueType:** This font file is the standard format for the Windows operating system. It was developed as a joint venture between Apple and Microsoft to create fonts that worked on both operating systems. A different file is needed for the normal, bold, italic, bold italic styles. TrueType typefaces are generally intended for business office use and will often display differently on different systems.

- **OpenType:** This is a newer format than TrueType, and it is supported across both Macintosh and Windows operating systems. An OpenType font file contains all the outline and bitmap data in one file. It renders the same on either a Mac or PC. OpenType also offers extended character sets including ligatures.

Designers also have **Web fonts** to choose from. These fonts have been created and optimized specifically for use on websites. Online resources like Google Fonts and Adobe Typekit offer a variety of typefaces to choose from. Aside from the actual resources, designers must approach typography differently from print design. Some common best practices for print do not translate well to screen design.

Common font formats include Postscript, TrueType, and OpenType.

Adobe Typekit offers a variety of typefaces that are optimized for the screen.

Type on Screen

Computer-screens are made up of **pixels**. These tiny units of color are grouped together to form an image. The resulting images tend to be photorealistic and larger in file size. A pixel-based image is resolution-dependent. If scaled too large, the pixel grid becomes noticeable.

Aliasing Issues

Aliasing plays a large part in enhancing both the legibility and aesthetics of type displayed on screen. **Aliasing** affects the diagonal and curved lines in type and displays them as a series of zigzag horizontal and vertical lines. **Anti-aliasing** adds shading to the pixels along the border of a letter or character to produce a smooth contour edge.

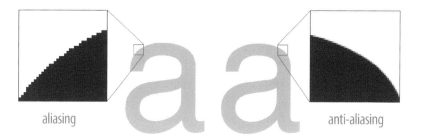

aliasing anti-aliasing

Aliasing affects how type is displayed.

The pixel shading produced by anti-aliasing works well on type sizes that are 12 points or higher. Type sizes below 12 points may appear soft or fuzzy which affects the legibility of the characters and, in turn, the readability of the word. Sans serif typefaces typically work better for smaller type on screen. Typefaces that contain serifs or thick and thin strokes will break apart the smaller the type size is on screen.

Use a sans serif typeface for smaller on-screen type (left image). The uniform stroke helps with legibility. Serifs (right image) tend to fall apart and create visual noise that impacts readability.

There are certain typefaces that work better on-screen. Arial, Verdana, Georgia, and Times New Roman were all designed with the screen's limitations in mind. When choosing a typeface, look for one with a larger x-height. This prevents lowercase letters such as "e" from breaking apart and becoming unreadable; it makes the letters actually look larger.

Kerning

A font's default spacing for certain letter combinations is often not ideal. **Kerning** focuses on the amount of space between two letters or other characters. Designers can adjust this space to avoid awkward-looking gaps that negatively impact legibility. Focus on the perceived amount of space between letters rather than the actual distance between them. The goal is for the typography to look right on the screen rather than achieving equal spacing between letters.

Kerning is the process of adjusting the space between letters to improve the overall readability of a word. Avoid using equal spacing between letters.

Type and Message

Think about the message you are communicating and match it with appropriate typography choices. Typefaces can set a mood to complement the overall visual theme. Serif typefaces evoke a feeling of classical, romantic, elegant, or formal. Sans serif typefaces signify something being modern, clean, minimal, or friendly.

Typographic hierarchy must also be considered. Size and weight are helpful in achieving this. Use only one or two typefaces within a motion design project. Color and style can create emphasis without adding more typefaces.

Typefaces can evoke a mood or feeling and compliment the overall visual theme.

classic (Garamond) modern (Helvetica)

romantic (Caslon) clean (Tahoma)

elegant (Baskerville) minimal (Avenir)

formal (Times) friendly (Gill Sans)

Motion Enhances the Meaning

Kinetic typography is type in motion. It employs animation principles and techniques to make letters streak across the screen, grow and shrink to add emphasis to the message being communicated. Motion can also reinforce the tone and emotion conveyed through a typeface. It is used for everything from film title design, advertising, to music videos.

Saul Bass is credited for the first use of kinetic typography in the 1959 Alfred Hitchcock's film *North by Northwest*. In the opening credits, the type moves up and across the screen in reference to the hero's journey in the movie. Saul Bass' title sequence for the film *Psycho* in 1960 slices the actors' names into several pieces. This motion is an abstract reference to the film's dramatic murder in the shower.

How do you make type move? After Effects allows you to create and animate text layers directly in a composition using transform properties and text animators. The following exercises use a variety of effects and motion techniques to create numerous text animation styles for motion design projects. Each exercise offers tips and tricks for animating text layers to best communicate your message.

Kinetic typography uses motion to reinforce the message, tone, and emotion conveyed through a typeface.

Creating Text Layers in After Effects

A text layer in After Effects provides an arsenal of text animators and properties to control and animate over time. Text is also vector-based in After Effects, so it can be scaled without losing quality. It may seem a little intimidating at first, based on all the text animator properties. By the time you complete the chapter exercises, you'll discover that animating text in After Effects is as easy as A-B-C.

Text layers include their own text animators that provide many properties to animate over time. In addition to these animators, After Effects also provides the same layer Transform properties: Anchor Point, Position, Scale, Rotation, and Opacity.

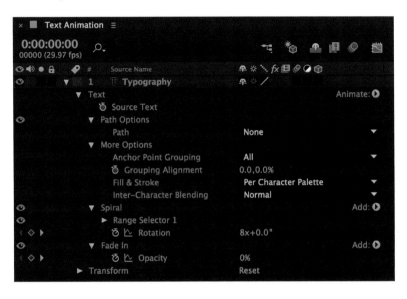

Adding text to a composition is a simple process. Select the **Type** Tool in the Tools panel, click anywhere in the Comp panel, and start typing. When you finish, press the **Enter** key on the numeric keypad to exit typing mode. If you press the **Return/Enter** key on the main keyboard, the type cursor drops down to the next line, just like in a word processor. You can also click anywhere outside the Comp panel or select another tool such as the **Selection** (arrow) Tool when you are done typing.

There are two Type Tools: the Horizontal and the Vertical Type Tool. Double-clicking on either tool will create a text layer in the center of the Comp panel.

When you click in the Comp panel an insertion point for the text appears at the cursor's location. If you want to center the text in the Comp Window select **Layer > New > Text**. After Effects places the insertion point in the center of the Comp panel. The text is set to center alignment as well. A text layer is automatically created in the composition and appears in the Timeline. It does not appear in the Project panel.

Text in After Effects falls into two categories, Point Text and Paragraph Text. When you click and start typing in the Comp panel you are creating Point Text. Each line of type is a continuous block of text. New lines will only be created when you press the **Return/Enter** key.

Click and drag the **Type** Tool in the Comp panel to create Paragraph Text. Paragraph Text automatically wraps text around to the next line to fit within the bounding box. The text's bounding box is defined by how far you dragged the cursor when you created the Paragraph Text layer.

Point Text is one block of text in After Effects. Paragraph Text automatically wraps the text to fit inside its bounding box.

If needed, you can resize the bounding box for Paragraph Text by first selecting the text using the **Type** Tool. Then click and drag on one of the handles around the perimeter of the bounding box. Hold down the **Shift** key to constrain the proportions of the bounding box.

Double-clicking a text layer in the Comp panel will highlight all of the text and switch you to the **Type** Tool. Once the text is selected, you can adjust Text properties such as font size and alignment using the Character and Paragraph panel. Both panels, by default, open when a text layer is created.

You can select all of the text or individual characters. Based on your selection, the adjustments you make only affect the highlighted characters. You can control the font, its size, leading (space between lines), kerning (space between individual characters), and tracking (space between all characters).

Chapter Exercise 1:
Animating a Text Layer

1. Launch **Adobe After Effects** and create a new project.

2. Select **Composition > New Composition**. Make the following settings in the dialog box that appears:

- Composition Name: **Supernova Text**
- Preset: **HDV/HDTV 720 29.97**
- Duration: **0:00:05:00** (5 seconds)
- Click **OK**.

3. The new composition opens with a black screen in the Comp panel. Select **Layer > New > Text**. After Effects places the insertion point in the center of the Comp panel. Type "SUPERNOVA." A text layer is created in the composition and appears in the Timeline.

4. Double-click on the text to select all. Change the font and font size to whatever you want using the Character panel. **Arial Black** was used for this exercise. The font size was set to **72** pixels and the color set to white. The alignment was set to centered in the Paragraph panel.

The type layer in the Timeline is named after the text you type. You can change its name the same way you'd change any layer name – select the layer name and press the **Return/Enter** key to rename the layer.

5. Notice that the spacing between the letters V and A is not ideal. Click in between the two letters with the **Type** Tool.

6. Hold down the **Option/Alt** key and press the **left arrow** key four times to tighten up the kerning between the two letters. This is a keyboard shortcut to adjust the kerning between letter combinations.

7. Click on the **Selection** Tool in the Tools panel.

8. In the Timeline twirl open the **SUPERNOVA** text layer to reveal its properties. There are two: Text and Transform. Twirl open the Transform properties: Anchor Point, Position, Scale, Rotation, and Opacity.

9. The layer's Anchor Point affects how it scales and rotates. It is the point at which all the transform properties are calculated from. Set the Anchor Point value to **0.0, -24.0**. This changes the vertical position of the layer's anchor point ◇ from the baseline of the text to the center of the text.

10. Move the **Current Time Indicator** (CTI) to **two seconds (02:00)**. Click on the **stopwatch** icons 🕐 for Position, Scale, and Rotation. This sets keyframes for each property at that time.

11. Press the **Home** key to move the **Current Time Indicator** (CTI) to the beginning of the composition (**00:00**). Make the following changes to the transform properties:

- Set the Scale value to **900%**. Text layers are vector-based.

- Set the Rotation value to **-30.0**.

12. Reposition the text in the Comp panel. Click and drag the text layer down, off the bottom right corner of the window.

Click and drag the text layer off the bottom right corner in the Comp panel. A dotted motion path displays the spatial animation.

13. Click on the **Play/Stop** button in the Preview panel. The text layer flies in from the right side to the center of the Comp panel. The transform properties affect the entire layer of text, similar to other footage layers in a composition.

14. Save your project file. Select **File > Save**.

15. Make sure the text layer is selected in the Timeline. Go to the Character panel and double-click on the color swatch. Change the RGB color to **R: 230**, **G: 110**, **B: 255**. Click **OK**.

Change the color of the text.

16. Let's apply a blur effect to add more dynamic movement to the composition. Move the **Current Time Indicator** (CTI) to **two seconds** (**02:00**) so that you can see the effect.

17. Select **Effect > Blur & Sharpen > CC Radial Fast Blur**.

18. Go to the Effect Controls panel and change the Amount value to **100.0**. This increases the amount of blur, producing what looks like rays of light coming from the text. Click on the **stopwatch** icon next to Amount to set a keyframe.

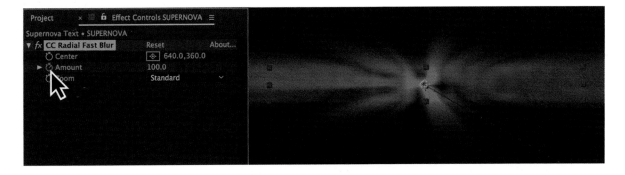

Apply the CC Radial Fast Blur to the text layer. Record a keyframe for the Amount property.

19. Move the **CTI** to **four seconds (04:00)**. Go to the Effect Controls panel and change the CC Radial Fast Blur Amount value to **5.0**.

20. Make sure the text layer is selected in the Timeline. Type **U** on the keyboard to show all properties with set keyframes. This keyboard shortcut helps reduce clutter in the Timeline panel.

21. Go to the Timeline section. Click and drag a marquee selection around all the keyframes to select them.

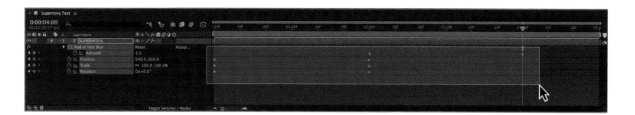

22. Select **Animation > Keyframe Assistant > Easy Ease**. The keyframes change from diamonds to hourglass shapes ⫯ in the Timeline. Easy Ease smooths both the keyframe's incoming and outgoing temporal (timing) interpolation.

Select all the keyframes in the Timeline and apply an Easy Ease to them to smooth out the animation.

23. Click on the **Play/Stop** button in the Preview panel. The animation resembles the opening credits to the *Superman* movie designed by Richard Greenberg. The only thing that is missing is a star field. Let's add that using a solid layer and an effect.

24. Make sure the Timeline panel is highlighted. Select **Layer > New > Solid.** The keyboard shortcut is **Command/Control + Y.** The Solid Settings dialog box appears. Make the following changes:

* Enter **Starfield** for the solid name.

* Click on the **Make Comp Size** button.

* Set the color of the solid layer to **white**.

* Click **OK**.

25. A solid layer of color appears in the Timeline and in the Comp panel. Reposition the **Starfield** solid layer underneath the **SUPERNOVA** text layer in the Timeline.

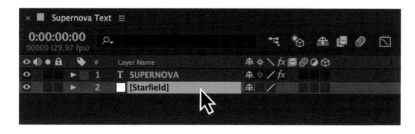

Rearrange the staking order so that the solid layer is underneath the text.

26. Make sure the **Starfield** solid layer is still highlighted in the Timeline. Select **Effect > Simulation > CC Star Burst**. This effect generates an animated star field. Go to the Effect Controls panel and make the following changes:

* Set the Speed to **.20**.

* Set the Size to **20**.

Apply the CC Star Burst effect to the white solid layer to create a star field.

The keyboard shortcut to create a new solid layer is **Command + y** (Mac) or **Control + y** (Windows).

Rearrange the staking order so that the black solid layer is on the bottom.

27. Let's add a lens flare to create a supernova in the background. Make sure the Timeline panel is highlighted. Select **Layer > New > Solid.** The Solid Settings dialog box appears. Make the following changes:

- Enter **Lensflare** for the solid name.
- Click on the **Make Comp Size** button.
- Set the color of the solid layer to **black**.
- Click **OK**.

28. Reposition the **Lensflare** solid layer underneath the **Starfield** text layer in the Timeline.

29. Move the **Current Time Indicator** (CTI) to **three seconds (03:00)**.

30. Select **Effect > Generate > Lens Flare**.

31. Go to the Effect Controls panel and make the following changes:

- Set the Flare Center to **640**, **360** (center of the Comp panel).
- Set the Flare Brightness value to **0%**.
- Click on the **stopwatch** icon next to Flare Brightness to record a keyframe.

32. Move the **Current Time Indicator** (CTI) to the end of the Timeline.

33. Go to the Effect Controls panel and change the Flare Brightness value to **300%**. The fills the screen with white.

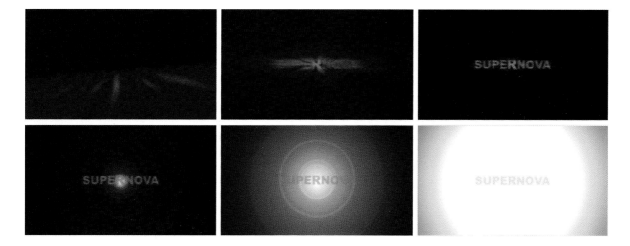

34. Click on the **Play/Stop** button. This completes this exercise on creating and animating a text layer. Experiment with the project. Fade out the text layer using the Opacity transform property. Add an Easy Ease to the new keyframes.

35. Save your project. Select **File > Save**.

As you can see, you can animate text layers as you would any other layer in a composition. But there is so much more you can do, such as animating the individual characters or words. You can also attach text to a curved path. In the next exercise, you will place your text on a mask path and animate it sliding along that path. Masks can also be animated by keyframing the Mask Shape property so your attached text can follow a morphing, undulating path.

Chapter Exercise 2: Animating Text Along a Path

In this exercise you will attach a text layer to a mask path to create a text animation. The path is created using the Pen tool in the Tools panel. Download the **Chapter_03.zip** file to your hard drive. It contains all the files needed to complete the exercises.

1. Open the **TextonPath.aep** inside the **02_TypePath** folder in **Chapter_03**. The Project panel contains the footage needed to complete this exercise.

2. If the **DUNE** composition is not open, double-click on it in the Project panel. It contains two layers of a desert scene at sunset.

Apply the Lens Flare effect to the black solid layer to create the supernova effect.

Download the **Chapter_03.zip** file at *www.routledge.com/cw/jackson*. It contains all the files needed to complete the chapter exercises.

3. Select **Layer > New > Text**. After Effects places the insertion point in the center of the Comp panel. Type "DUNE." A text layer is created in the composition and appears in the Timeline.

4. Double-click on the text to select all. Change the font and font size to whatever you want using the Character panel. **Arial Black** was used for this exercise. The font size was set to **200** pixels. The tracking was set to **-110** to tighten up the letterspacing.

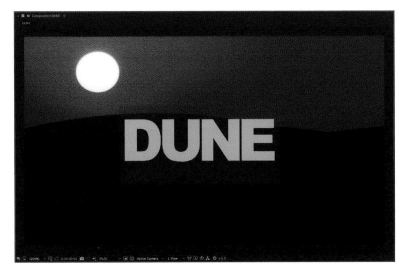

Insert a text layer and use the Character panel to set the typeface, size, and tracking.

5. Select the **DUNE** text layer in the Timeline. Select the **Pen** Tool from the Tools panel. This creates the path for the text. The path can be open or closed. If you close the mask path, set its mode to None and attach the text.

6. Go to the Comp panel and create a mask path that follows the contour of the hills using the Pen Tool. Start the path on the left side of the Comp panel. Click and drag a point to curve the shape of the mask. To adjust the mask path, click on the **Selection** (arrow) Tool.

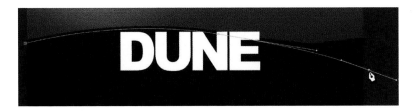

Create a mask path using the Pen Tool on the text layer.

7. In the Timeline, twirl open the **DUNE** layer to reveal its properties. Instead of using the layer's transform properties, twirl open the **Text** section properties. Twirl open the **Path Options** property group.

8. Select **Mask 1** from the Path property's pop-up menu. After Effects will instantly attach the text to the path in the Comp panel.

Attach the text layer to the mask path using the Path Option property.

9. Several new properties appear under the Path Options. Scrub through the **First Margin** value to move the text off the left side of the screen.

10. Press the **Home** key to move the **Current Time Indicator** (CTI) to the beginning of the Timeline (**00:00**). To animate the text moving along the path, click on the First Margin **stopwatch** icon 🖰.

11. Press the **End** key on the keyboard to move the **CTI** to the end of the composition. Go to the Timeline and scrub through the **First Margin** property to move the text off the right side of the Comp panel.

12. Click on the **Play/Stop** button in the Preview panel. The text animates in from the left side of the Comp panel and follows the hills across the screen. Save your project.

13. Experiment with the other Path Options. Turn the **Perpendicular to Path** option OFF and your text remains vertically aligned as it animates across the screen.

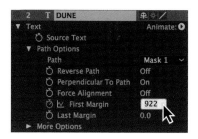

To animate the text moving along the path, set keyframes for either the First Margin or Last Margin properties.

Turn off the Perpendicular to Path option (right image).

14. Go to the Timeline. Reposition the DUNE layer to be in between the **Foreground/Sunset.psd** layer and the **Background/Sunset.psd** layer.

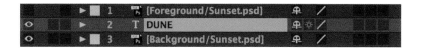

Move the text layer to be in between the Photoshop layers.

15. Make sure the text layer is selected in the Timeline. Go to the Character panel and double-click on the color swatch. Change the RGB color to **R: 20, G: 10, B: 5**. Click **OK**.

Change the color of the text to match the desert hills.

16. Select **Layer > Layer Styles > Bevel and Emboss**. Go to the Timeline and twirl open the **Layer Styles** properties. Twirl open the **Bevel and Emboss** properties.

17. Click on the **Highlight Color** color swatch. Change the RGB color to **R: 255, G: 115, B: 40**. Click **OK**. This creates an orange rim light effect on the type.

18. Click on the **Play/Stop** button. This completes this exercise on animating a text layer along a path. Experiment with the project. Render the composition as a QuickTime movie.

19. Save your project. Select **File > Save**.

Add a Bevel and Emboss layer style to the text layer.

Chapter Exercise 3:
Applying Text Animation Presets

The Character and Paragraph panels do not contain stopwatch icons to animate the font size, color, tracking, etc. Text animation is created using **text animators** which allow you to animate individual characters, words, or lines of text. After Effects ships with a ton of text animation presets. These are prebuilt animation effects sorted by category in the Effects & Presets panel. They can be easily applied to a text layer by a simple drag and drop interaction. Let's see how it works.

1. Launch **Adobe After Effects** and create a new project.

2. Select **Composition > New Composition**. Make the following settings in the dialog box that appears:

 - Composition Name: **Vertigo Text**
 - Preset: **HDV/HDTV 720 29.97**
 - Duration: **0:00:05:00** (5 seconds)
 - Click **OK**.

3. Click on the **Type** Tool at the top left of the screen. Go to the Comp panel and click inside to start typing. Type "VERTIGO." A text layer is automatically created in the composition and appears in the Timeline.

Use the **Type** tool to add a text layer.

4. For this exercise, you are going to install a font using Adobe Typekit. Select **File > Add Fonts From Typekit**. Your default browser opens to the Adobe Typekit page.

Adobe Typekit provides hundreds of typefaces that are easy to install and use in motion design projects.

5. There are several tools you can use to browse the typefaces in Adobe Typekit. Click on the **My Library** tab at the top of the web page to see all of the available typefaces.

• Type "VERTIGO" into the sample text field area. This helps you in selecting a typeface that matches your intended visual style.

• Select **Sort By Name** from the pop-up menu.

• In the Classification area, click on the **Sans Serif** button.

• In the Properties area, click on the buttons for **medium weight** and **medium contrast**. Click on the **large x-height** button.

Use the button filters to find a typeface.

6. The goal of this motion design project is to create a retro-style title from the 1950s. Click on the **Baileywick JG Gothic** button. Typekit loads another page that displays sample text.

7. Click on the **Sync** button next to the sample text. Feedback will display on screen once the font has been successfully synced.

8. Close the browser and go back to After Effects. Click on the **Selection** Tool in the Tools panel.

Realigned equestrian fez bewilders picky monarch

UNSYNC

Font is synced

9. Make sure the **VERTIGO** text layer is selected in the Timeline.

10. To apply the synced font, go to the Character panel. Select **Baileywick JG Gothic** for the font. Set the font size to **150** pixels and the color to white. The alignment needs to be set to centered in the Paragraph panel.

Use the Sync button in Adobe Typekit to add the font to your system. All synced fonts are available in any application, including After Effects.

Use the synced font from Adobe Typekit.

11. The Type tool allows you to place text anywhere in the Comp panel. If you want to center the placed text in the Composition panel, use the Align panel in After Effects. Select **Window > Align**.

12. Select **Composition** from the Align Layers to options.

13. Click on the horizontal and vertical center alignment buttons.

Use the Align panel to center the text layer in the Composition panel.

14. Let's animate the text layer. Click on the **Effects & Presets** tab.

15. Twirl open the **Animation Presets** folder. Twirl open the **Text** folder. This contains all the different preset folders of text animation.

16. Twirl open the **Animate In** folder and select **Center Spiral**. This effect rotates in each letter from the center of the text layer to form the word.

17. To apply the preset, click and drag the effect from the Effects & Presets panel to the text in the Comp panel. A red marquee box appears indicating the selected layer. Release the mouse and you will notice that the text disappears. This is because the text is at the beginning stage of the animation preset.

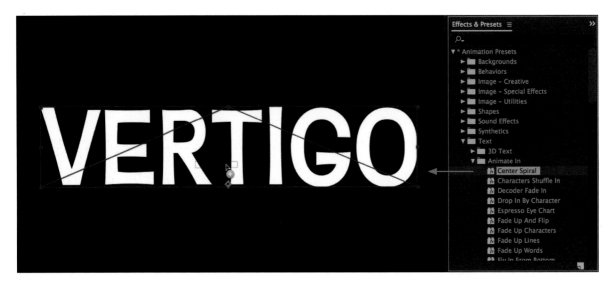

Drag and drop the text animation preset onto the text layer in the Comp panel.

18. Click on the **Play/Stop** button. The letters spiral in to form the word "Vertigo." That was easy. Save your project file. Select **File > Save**.

19. Wouldn't it be nice to see a preview of each text animation preset before you applied it? You can. Go to the Effects & Presets panel and click on the **menu icon** .

Adobe Bridge allows you to preview all the animation presets.

20. Select **Browse Presets** from the pop-up menu. This opens Adobe Bridge. Double-click on the **Text** folder. Open any Preset folder and single-click on the effect you want to see. A preview of how the effect works appears in the Preview panel on the right side.

21. Close Adobe Bridge and go back to After Effects. Select the Timeline panel and press the **Home** key on the keyboard. This moves the **Current Time Indicator** to the beginning of the composition (**00:00**).

22. Text animators are added to the text layer. Twirl open the **VERTIGO** text layer properties. Twirl open the **Text** section properties to see the Spiral and Fade In presets being used.

23. Twirl open the **Spiral** preset. It contains the Rotation property with two keyframes automatically applied. Click on the **Add arrow** to the right of the Spiral preset to open a pop-up menu.

• Select **Property** and then **Scale** from the pop-up menu.

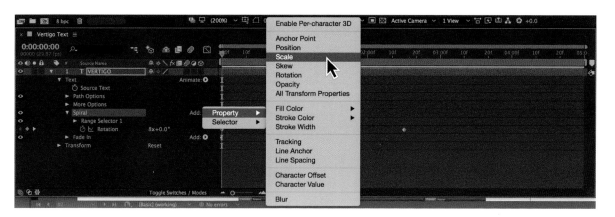

24. The Scale property is added to the Spiral animation preset. Click on its **stopwatch** icon ⏱ to start recording keyframes. Scrub through the numeric value and set it to **500%**.

25. Move the **Current Time Indicator** (CTI) to **four seconds** (**04:00**).

26. Scrub through the Scale numeric value and set the text layer back to **100%**. Now each letter will slowly scale down as it spirals in.

27. Select the **second Rotation keyframe** ◆ and move it to the **four seconds (04:00)** time mark to align with the Scale's keyframe.

28. Click and drag a marquee selection around all of the Scale and Rotation keyframes to select them. Select **Animation > Keyframe Assistant > Easy Ease**. The keyframes change from diamonds to hourglass shapes ⏳ in the Timeline.

29. Turn on the **Motion Blur** switch 🌀 for the "VERTIGO" text layer in the Timeline. This switch simulates the motion blur captured by a camera. In order to see the motion blur in the Comp panel, click on the master **Enable Motion Blur** button 🌀 at the top of the Timeline. Whenever this button is activated, any layer with the Motion Blur switch enabled will display the blur in the Comp panel.

30. Click on the **Play/Stop** button. The letters spiral in and scale down to form the word "Vertigo." Save your project file. Select **File > Save**.

Align the Scale and Rotation keyframes in the Timeline panel and apply an Easy Ease to smooth the animation.

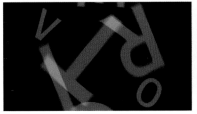

A motion blur affects moving objects. Motion blurs help make the movement look more dynamic and natural.

31. Let's import a background movie to complete the motion design project. Go to the Project panel and double-click in the empty gray area to open the Import File dialog box.

32. Locate the **Footage** folder inside the **03_TextAnimationPreset** folder. This folder contains a QuickTime movie named **Tunnel.mov**. Import the QuickTime movie as a footage file.

33. Click and drag the imported QuickTime footage to the Timeline. Position it under the **VERTIGO** text layer.

Import the background animation and add it as a layer in the Timeline panel.

34. Click on the **Play/Stop** button. This completes this exercise. Experiment with the project. Render the composition as a QuickTime movie. Save your project file. Select **File > Save**.

Think about what you just built. Twirl open the text layer and look at the properties used by the presets. A good way to start learning about text animation in After Effects is to dissect a text animation preset. In the next exercise you will use some of these properties and animator groups to create your own custom text animation.

The final rendered motion design project is a retro-style homage to Saul Bass and his title design for the movie *Vertigo*, 1958.

Chapter Exercise 4: Using Text Animators

Let's create a text animation from scratch. For this exercise you will not use any of the text animation presets. Text animators specify which text properties to animate, such as position and rotation. They use a range selector to specify how much each character is affected by the animator.

1. Create a project in After Effects. Select **File > New > New Project**.

2. Select **Composition > New Composition**. Make the following settings in the dialog box that appears:

- Composition Name: **Falling Text**
- Preset: **HDV/HDTV 720 29.97**
- Duration: **0:00:05:00** (5 seconds)
- Click **OK**.

3. Click on the **Type** Tool at the top left of the screen. Go to the Comp panel and click inside to start typing. Type "DESCENT." A text layer is automatically created in the composition and appears in the Timeline. Center the text in the Comp panel.

4. Double-click on the text to select all. Change the font and font size to whatever you want using the Character panel. **Avenir Light** was used for this exercise. The font size was set to **150** pixels and the color set to white. The alignment was set to centered in the Paragraph panel.

Double-click on the text to highlight all the characters. Change the Character properties to whatever you want.

5. Select the **DESCENT** layer in the Timeline and twirl open the text layer to display the Text and Transform sections. In the **Text** section, click on the **arrow** next to the word **Animate**. The pop-up menu contains all the Text properties you can animate on a per-character basis. Select **Position**.

The **DESCENT** layer instantly has more properties added that may be a little confusing at first. Let's deconstruct the properties you need to work with. **Animator 1** is an animator group that holds the property that you chose to animate and a **Range Selector**.

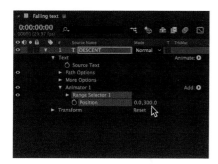

Add a text animator to the layer.

6. Let's focus on the Range Selector and the Position property. Scrub through the animator's Position value and set it to **0.0, 300.0**. All the letters move down at once.

The text animator's values are in relation to the layer's corresponding Transform properties values. So, when you change the animator's Position value, After Effects takes the current position of the text layer (Transform value) and adds 300 pixels to its vertical position. This causes the letter to move down in the Composition panel.

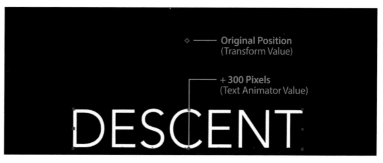

7. What happens if you want the letters to move separately? To do this, twirl open the **Range Selector**. Scrub through the **End** value to reposition each letter separately. The End value ranges from 0 to 100. Set the End value to **0** to move the letters to their original position. Click on its **stopwatch** icon 🖊 to set a keyframe at the current time.

Change the Animator's Position value to move the letters in relation to the layer's original Position transform property.

The Range Selector's Start and End values allow you to animate each letter either from the left (Start) or the right (End). Most often you only set keyframes for the selector and adjust the ending values for the animator properties.

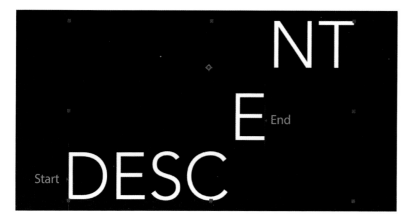

8. Move the **Current Time Indicator** (CTI) to **four seconds (04:00)**.

9. Go to the Timeline and set the text animator's **End** value to **100**.

10. Click on the **Play/Stop** button in the Preview panel to see the results. Each letter starts out at its original position and then animates down. It's a good start, but let's add more properties to create a more interesting animation. Save your project. Select **File > Save**.

11. Now that you have set up the keyframes for the Range Selector, this will be applied to any additional property added to the text layer. On the **Animator 1** layer, select the pop-up menu next to the word **Add**. Select **Property > Rotation**.

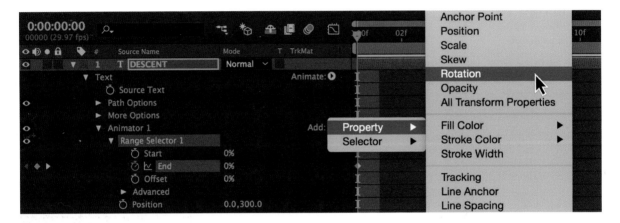

You can add additional text properties to an Animator group.

12. The Rotation property is added underneath Position. Just like with the Position property, the Rotation's value indicates the starting property for the text. Scrub through the value and set it to **90°**. Now each letter will rotate to 90° one-by-one as they move down.

13. Add another text animator. This time, select **Property > Opacity**.

14. The Opacity property is added underneath Rotation. Scrub through the value and set it to **0**. Now each letter will fade out one-by-one as they rotate 90° and move down.

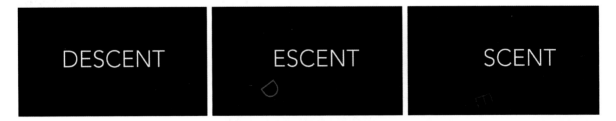

15. Save your project. Select **File > Save**.

16. Add another text animator. This time select **Property > Blur**.

17. The Blur property is added underneath Opacity. Scrub through the value and set it to **100**.

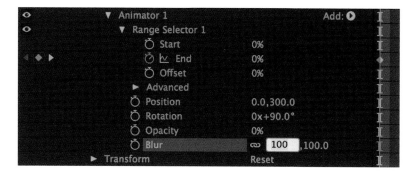

Add a Blur property to the Animator group.

18. The animation is getting better, but it needs a background to make it more dynamic. Deselect the text layer in the Timeline. Make sure nothing is highlighted. Go to the Effects & Presets panel. Twirl open the **Backgrounds** folder inside Animation Presets. Double-click on **Smoke Rising**. A new solid layer is added to the project.

19. When you apply an effect, the Effect Controls panel opens as a new panel in front of the Project panel. Go to the Effects Control panel and change the Fractal Type to **Threads**.

20. Twirl open the Transform properties. Increase the Scale Width to **300**.

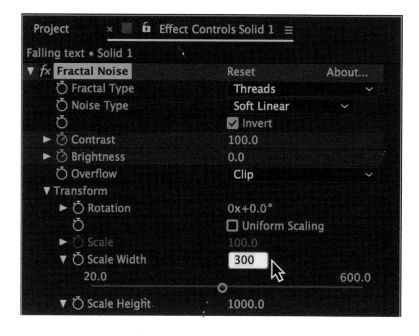

Double-click on the **Smoke Rising** preset to add the background effect. You can customize the animation preset using the Effect Controls panel.

21. In the Timeline, move the **Solid 1** layer to the bottom of the stack.

22. Select the **DESCENT** text layer. Type **U** on the keyboard to show only the keyframed properties – the Range Selector's End property.

23. Move the first keyframe to the **one-second (01:00)** time mark. This allows the viewer to read the word before it starts animating.

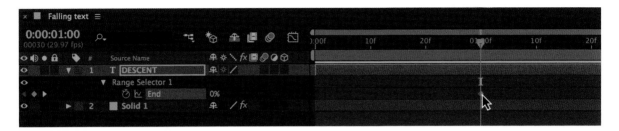

Reposition the first keyframe to start the animation later in the Timeline.

24. Click on the **Play/Stop** button in the Preview panel to see the results. This completes this exercise. This entire composition was created in After Effects without any imported footage. Only one text animator property has keyframes. Save your project. Select **File > Save**.

25. Experiment with the project. If you want to delete a text animator property, simply select it in the Timeline and press the **Delete/ Backspace** key on the keyboard.

26. When you are done, select **Composition > Add to Render Queue**.

• Click on **Lossless** next to Output Module. In the dialog box that opens, set the Format to **QuickTime**.

• Click on **Format Options** and set the video codec to **H.264**. Click **OK**.

• Click **OK** again. Click on **Output To** and select your hard drive.

• Click the **Render** button.

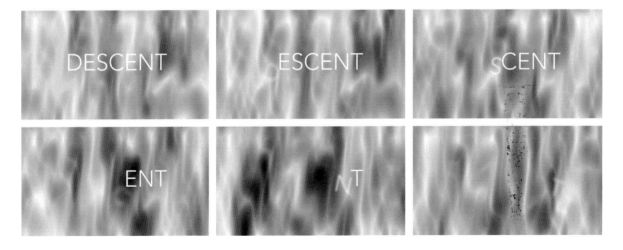

Chapter Exercise 5: Animating Tracking

Tracking and kerning are often used interchangeably, but there is a difference. As previously mentioned, kerning focuses on the amount of space between two letters or other characters. **Tracking** involves adjusting the spacing for the entire word. Text layers in After Effects can have their tracking animated over time. Be very careful when animating tracking, as it can quickly impact readability.

1. Create a project in After Effects. Select **File > New > New Project**.

2. Select **Composition > New Composition**. Make the following settings in the dialog box that appears:

- Composition Name: **Tracking Text**
- Preset: **HDV/HDTV 720 29.97**
- Duration: **0:00:05:00** (5 seconds)
- Click **OK**.

3. Select **Layer > New > Text**. After Effects places the insertion point in the center of the Comp panel. Type "RADAR." A text layer is created in the composition and appears in the Timeline.

Download the **Chapter_03.zip** file at *www.routledge.com/cw/jackson*. It contains all the files needed to complete the chapter exercises.

RADAR

Insert a text layer into the composition.

4. Select **File > Add Fonts From Typekit**. Your default browser opens to the Adobe Typekit page.

5. Search for the **Paralucent** typeface. Click on the **Sync** button next to the **ParalucentStencil Medium** sample text. Feedback will display on screen once the font has been successfully synced.

ParalucentStencil Medium

Realigned equestrian fez bewilders picky monarch

UNSYNC

Font is synced

6. Close the browser and go back to After Effects.

7. Double-click on the text to select all. Go to the Character panel. Change the font to **ParalucentStencil Medium**. Set the font size to **150** pixels and the color set to white. Set the alignment to centered using the Paragraph panel.

Use the synced font from Adobe Typekit.

8. Select the **RADAR** layer in the Timeline and twirl open the text layer to display the Text and Transform options. On the **Text** layer click on the **arrow** 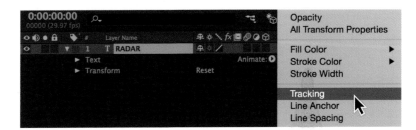 next to the word **Animate**. Select **Tracking**.

Add a Tracking text animator to the layer.

9. Make sure the **Current Time Indicator** (CTI) is at the beginning of the Timeline (**00:00**). To animate the tracking, click on the Tracking Amount **stopwatch** icon. Keep the numerical value at **0**.

10. Move the **Current Time Indicator** (CTI) to **two seconds (02:00)**.

11. Scrub through the animator's **Tracking Amount** value and set it to **-100**. The letters are stacked on top of one another.

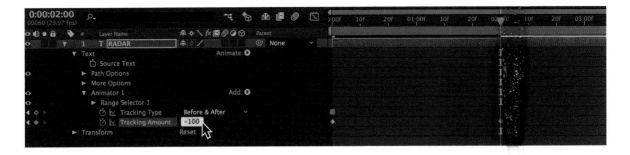

12. Press the **End** key on the keyboard to move the **CTI** to the end of the composition.

13. Scrub through the animator's **Tracking Amount** value and set it to **-260**. The letter spacing opens up.

14. Click on the **Play/Stop** button to see the text animation. The word "radar" is a palindrome. It can be read the same way, regardless of starting from left or right.

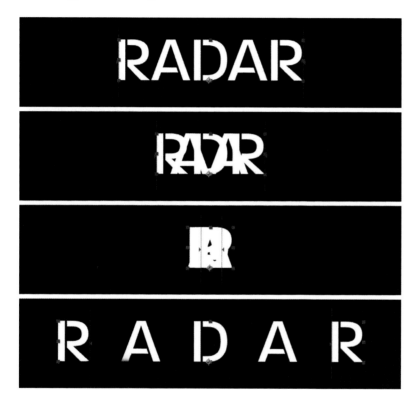

Tracking allows you to expand or collapse the spacing between all the letters in a word. Use the Tracking Amount property to achieve both goals.

15. Save your project file. Select **File > Save**.

16. Let's import a background image to complete the motion design project. Go to the Project panel and double-click in the empty gray area to open the Import File dialog box.

17. Locate the **Footage** folder inside the **05_Tracking_Text** folder. This folder contains an image file named **MapBackground.jpg**. Import the JPEG image as a footage file.

18. Click and drag the imported footage to the Timeline. Position it under the **RADAR** text layer. Let's enhance the overall cinematic effect by adding a subtle zoom using a scale transform property.

Add the background image layer.

19. Make sure the **Current Time Indicator** (CTI) is at the beginning of the Timeline (**00:00**).

20. Select the **MapBackground.jpg** layer in the Timeline. Type **S** on the keyboard to open only the layer's Scale property.

21. Hold down the **Shift** key and type **R** on the keyboard to open the Rotation property in addition to the Scale property.

22. Click on its **stopwatch** icons for both the Scale and Rotation transform properties to start recording keyframes.

23. Press the **End** key on the keyboard to move the **CTI** to the end of the composition.

24. Scrub through the **Scale** numeric value and set it to **110%**. Set the **Rotation** numerical value to **3**. The map will slowly scale and rotate.

Slowly scale and rotate the background image layer to create a zoom effect.

25. Go to the Comp panel and click on the text layer and drag it down slightly to center it better on the background image.

26. Click on the **Play/Stop** button to see the text animation. Save your project file. Select **File > Save**.

Click and drag the text layer to center it better over the background image.

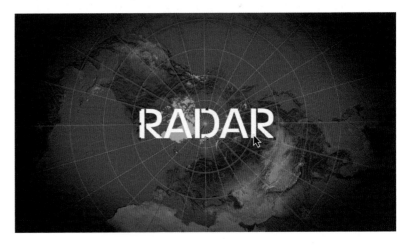

A

The keyboard shortcut to create a new solid layer is **Command + y** (Mac) or **Control + y** (Windows).

27. The motion design project is almost done, but it needs a visual effect of radio waves animating out from the center of the composition. Select **Layer > New > Solid.** The Solid Settings dialog box appears.

28. Make the following changes for the Solid layer:

- Enter **Radio Waves** for the solid name.

- Click on the **Make Comp Size** button.

- Set the color of the solid layer to **black**.

- Click **OK**.

29. Reposition the **Radio Waves** solid layer underneath the **RADAR** text layer in the Timeline.

30. Select **Effect > Generate > Radio Waves**. This effect creates animated circles that simulate sound waves.

31. Go to the Effect Controls panel and make the following changes:

- Set the Lifespan (sec) to **5.0** (match the duration of the composition).

- Set the Stroke's Fade-in Time value to **3.000**.

- Set the Stroke's Fade-out Time value to **3.000**.

- Set the Stroke's Start Width value to **1.00**.

- Set the Stroke's End Width value to **3.00**.

- Use the Color **eye dropper** to select a green color from the map.

32. Click on the **Play/Stop** button. The radio waves add interest to the motion project, but need to emphasize the word "radar" more.

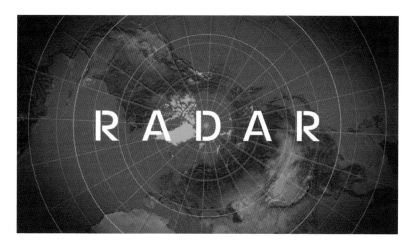

33. Go to the Effect Controls panel and change the stoke's profile from **Square** to **Sawtooth In.** The default value of Square produces a solid stroke. The Sawtooth In value creates a gradual fade in opacity.

34. To see the stroke's change in transparency, increase the Stroke's End Width value to **100.00**.

Create a new solid layer and position it under the text layer in the Timeline.

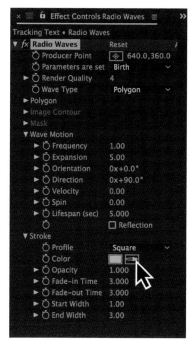

Use the Effect Controls panel to adjust the radio waves animation.

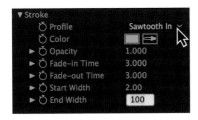

Change the Radio Waves Stroke Profile to **Sawtooth In** and increase the end width to create a visual effect similar to sonar waves.

35. Click on the **Play/Stop** button. This completes this exercise on animating tracking. Experiment with the project.

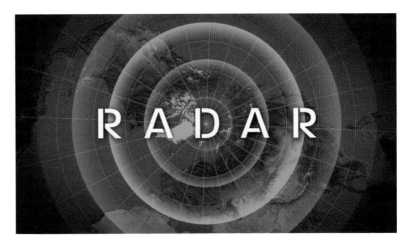

36. When you are done, select **Composition > Add to Render Queue**.

- Click on **Lossless** next to Output Module. In the dialog box that opens, set the Format to **QuickTime**.

- Click on **Format Options** and set the video codec to **H.264**. Click **OK**.

- Click **OK** again. Click on **Output To** and select your hard drive.

- Click the **Render** button.

37. Save your project file. Select **File > Save**. The last exercise will focus on the Wiggly text selector which creates random movement.

Chapter Exercise 6: Using the Wiggly Selector

The Wiggly selector adds a specified amount of randomness to text animators over time. It allows you to create complex animation fairly easily using several built-in properties.

1. Create a project in After Effects. Select **File > New > New Project**.

2. Select **Composition > New Composition**. Make the following settings in the dialog box that appears:

- Composition Name: **Wiggly Text**

- Preset: **HDV/HDTV 720 29.97**

- Duration: **0:00:05:00** (5 seconds)

- Click **OK**.

3. Select **Layer > New > Text**. After Effects places the insertion point in the center of the Comp panel. Type "SCARY." A text layer is created in the composition and appears in the Timeline.

Insert a text layer into the composition.

4. Select **File > Add Fonts From Typekit**. Your default browser opens to the Adobe Typekit page.

5. For this motion project, let's use a decorative font that resembles more of a hand-drawn look. Search for the **Sketchnote** typeface. Click on the **Sync** button next to the **Sketchnote Square Regular** sample text. Feedback will display on screen once the font has been successfully synced.

Sketchnote Square Regular ⚙ <> View details ›

Realigned equestrian fez bewilders picky monarch

6. Close the browser and go back to After Effects.

7. Double-click on the text to select all. Go to the Character panel. Change the font to **Sketchnote Square Regular**.

8. Set the font size to **150** pixels and the color set to white. Set the alignment to centered using the Paragraph panel.

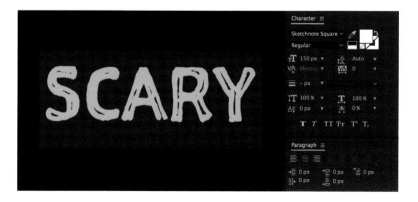

Use the synced font from Adobe Typekit.

9. Select the **SCARY** layer in the Timeline and twirl open the text layer to display the Text and Transform options. On the **Text** layer click on the **arrow** 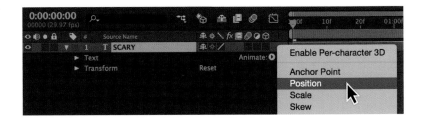 next to the word **Animate**. Select **Position**.

Add a Position text animator to the layer.

10. Scrub through the animator's Position value and set it to **0.0, 15.0**. All the letters move down at once.

11. On the **Animator 1** layer, select the pop-up menu next to the word **Add**. Select **Property > Rotation**.

12. The Rotation property is added underneath Position. Scrub through the value and set it to **15°**.

Add an additional Rotation text property to the **Animator 1** group.

13. Selectors allow you to specify a range to affect, and by how much. On the **Animator 1** layer, select the pop-up menu next to the word **Add**. Select **Selector > Wiggly**.

Add a Wiggly selector to **Animator 1**.

14. Twirl open the **Wiggly Selector 1**. Scrub through the **Wiggles/ Second** value to set it at **15**. This will increase the random variations that occur in the text's position and rotation per second.

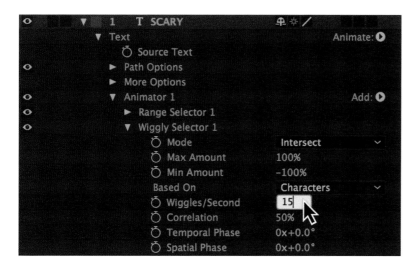

Increase the wiggles-per-second property to create a jittery text animation effect. This will reinforce the meaning of the word "scary."

15. Click on the **Play/Stop** button to see the text animation. The letters randomly animate to reinforce the meaning of the word.

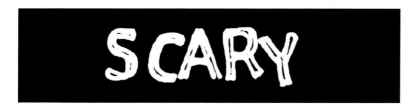

The Wiggly selector randomly picks a value set from the text animator properties (position and rotation) to create the jittery text animation effect.

16. Save your project file. Select **File > Save**.

17. The animation is getting better, but it needs a background to make it more dynamic. Deselect the text layer in the Timeline. Make sure nothing is highlighted.

18. Press the **Home** key to move the **Current Time Indicator** (CTI) to the beginning of the Timeline (**00:00**).

19. Go to the Effects & Presets panel. Twirl open the **Backgrounds** folder inside Animation Presets. Double-click on **Sweeping Curves**. A new solid layer is added to the project.

20. When you apply an effect, the Effect Controls panel opens as a new panel in front of the Project panel. Go to the Effects Control panel and twirl open the Fractal Noise's Transform properties.

Double-click on the **Sweeping Curves** preset to add the background effect.

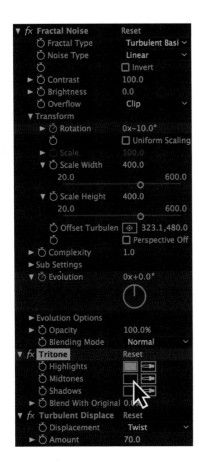

▼ *fx* **Fractal Noise** Reset
 Ö Fractal Type Turbulent Basi ✓
 Ö Noise Type Linear ✓
 Ö ☐ Invert
 ▶ Ö Contrast 100.0
 ▶ Ö Brightness 0.0
 Ö Overflow Clip ✓
 ▼ Transform
 ▶ Ö Rotation 0x-10.0°
 Ö ☐ Uniform Scaling
 ▶ Ö Scale 100.0
 ▼ Ö Scale Width 400.0
 20.0 600.0
 ▼ Ö Scale Height 400.0
 20.0 600.0
 Ö Offset Turbulen ⊕ 323.1,480.0
 Ö ☐ Perspective Off
 ▶ Ö Complexity 1.0
 ▶ Sub Settings
 ▼ Ö Evolution 0x+0.0°

 ▶ Evolution Options
 ▶ Ö Opacity 100.0%
 Ö Blending Mode Normal ✓
 ▼ *fx* **Tritone** Reset
 Ö Highlights
 Ö Midtones
 Ö Shadows
 ▶ Ö Blend With Original 0.(
 ▼ *fx* **Turbulent Displace** Reset
 Ö Displacement Twist ✓
 ▶ Ö Amount 70.0

You can customize the animation preset using the Effect Controls panel. If the Effect Controls panel is not visible, select **Effect > Effect Controls**.

21. Set the Scale Width and the Scale Height values to **400**.

22. Go to the Tritone effect listed in the Effect Controls panel. Set the **Highlights** color to a bright orange and the **Midtones** color to a deep purple.

23. Click and drag the background layer in the Timeline. Position it under the **SCARY** text layer.

24. Click on the **Play/Stop** button. This completes this exercise on using the Wiggly selector. Experiment with the project.

25. When you are done, select **Composition > Add to Render Queue**.

- Click on **Lossless** next to Output Module. In the dialog box that opens, set the Format to **QuickTime**.

- Click on **Format Options** and set the video codec to **H.264**. Click **OK**.

- Click **OK** again. Click on **Output To** and select your hard drive.

- Click the **Render** button.

26. Save your project file. Select **File > Save**.

Summary

This completes the chapter on typography in motion. You covered a lot of ground with text and all its properties. This chapter only scratches the surface of what you can do with the text engine in After Effects. The best way to keep learning is to apply the text animation presets and examine their structure. From there, you can start creating your own custom presets. In the next chapter you will animate logos.

Logos in Motion

Logos come in a variety of forms, but they all share the same purpose – to provide a visual identity to a company or brand. An effective logo is simple, scalable, recognizable, and distinct. This chapter explores how to energize logos with motion. The chapter exercises provide different methods in preparing and animating logos created in Photoshop and Illustrator.

At the completion of this chapter, you will be able to:

- Describe the different types of logos
- Determine the best types of file formats to acquire from clients
- Prepare raster-based and vector-based logos for animation
- Import and animate logos in After Effects
- Use masks, track mattes, and the Stroke effect to reveal a logo
- Add and animate Shape Layers
- Create a lower-thirds animation for broadcast

What Makes an Effective Logo?

A **logo** is a visual mark used for a business or a product. Its goal is not to sell a product or promote a business. A logo's purpose is as an identifier, and must reflect the company's brand. Think about the timeless logos you see everyday. What makes them effective? A well designed logo consists of several characteristics:

- **Simple:** It is easy to read.
- **Recognizable:** It creates a memorable impression and is unique enough to stand out among its competition.
- **Scalable:** It does not lose its functionality at different sizes.
- **Versatile:** It can interact with the entire brand experience, from packaging to online content and broadcast delivery. It can be used on dark or light backgrounds.
- **Communicative:** It sets the tone and clearly identifies the product or service being marketed.

Types of Logos

Logos come in all shapes, sizes, and forms. They can consist of a typographic solution, symbol or icon, or a combination of the two. There are a number of different types of logo "marks."

- **Monograms:** This consists of a company's initials used for brand identification purposes rather than its lengthy name. Examples of monogram company logos include IBM, CNN, HP, and HBO.
- **Logotypes:** This form of logo consists of typographic elements that identifies the business' name. Google and Coca-cola are examples of companies that have a well-designed logotype.
- **Pictorial Marks:** This type of logo consists of a symbol or icon. Think of the iconic Apple logo, the Twitter bird, or the Target bullseye. The symbol can also be abstract such as the Pepsi wave logo.
- **Combination:** This logo is comprised of an icon and typographic elements. The icon and text can be placed side-by-side, stacked on top of each other, or fused together to create the logo.
- **Emblem:** This logo encases the company name within the design. Examples include Starbucks and Harley-Davidson Motorcycles.

Types of logo "marks" include:

1. Logotypes
2. Pictorial or Abstract Marks
3. Combination of Symbol and Type
4. Emblem

Broadcast Terminology for Branding

A designer must understand what a client is asking for, especially when the end product is intended for broadcast. Television companies use specific terminology to describe when and where the logo or typography will be displayed on the screen. Here are some common broadcast terms used for on-air graphics:

- **Ident (Station ID):** This is a short animation used to brand a channel. It typically displays the channel's name and logo.

- **Opening (Leader):** This is a motion graphics sequence that plays at the beginning of a TV show.

- **Promo:** This is a short motion graphics sequence (5-10 seconds) that advertises an upcoming show.

- **Lineup:** This is a variation of a promo that plays in-between shows, and advertises the channel's upcoming schedule.

- **Lower Third:** A graphic that sits at the bottom third of the screen. It typically includes information about the content being displayed on screen, most commonly a news reporter's name or location.

- **Snipe:** This is a 5-10 second lower third animation that plays during a TV show promoting another show or what's coming up next on the channel's schedule.

- **Stinger:** This is a full screen animated graphic transition with a sound effect used to announce "breaking news" or "continuing coverage."

- **Bug:** This is a small graphic that appears in the corner of the screen, used to identify the TV show, channel, or broadcast company.

The call letters for this station ID are "WJMJ" located in upstate New York. The channel "33" identifies the dial position.

A Lineup promotes a TV channel's upcoming schedule of shows.

Working with Client Logos

Animating a client's logo is a common starting point for many motion designers. These short animations allow for plenty of creative possibilities to work with. One of the hardest tasks a designer often faces is obtaining the client's logo in a high-resolution file format.

When it comes to animating a logo, some file formats are preferable over others. Avoid using logos screen captured from a presentation or downloaded from a website. Often these logos will not have enough image resolution to work with in After Effects. The best logo file format to acquire from a client is either an Adobe Illustrator (AI) file or an Encapsulated Postscript (EPS) file.

Understanding Vector and Raster Art

Adobe Illustrator and EPS files are vector-based. **Vector art** uses math to store and create an image. This makes the artwork resolution-independent. It can be scaled without losing any detail. As a result, vector-based artwork produces rather small file sizes that are ideal for web delivery. After Effects does support vector-based art.

Adobe Photoshop focuses primarily on raster-based art, not vectors. **Raster images** are made up of pixels and are resolution-dependent. If scaled too large, the pixel grid becomes noticeable. Raster images tend to be photorealistic and larger in file size. Compression can be applied to reduce the overall file size, but can have a negative impact on the image quality.

Vector art uses math to create the lines and curves in a graphic.

Scaled vector art versus scaled raster art.

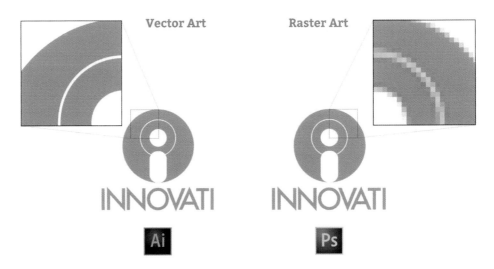

Vector Art Raster Art

A **Joint Photographic Experts Group (JPEG)** file is an example of a compressed raster-based image. This is a lossy compression type which means it alters the pixel structure and creates digital artifacts. Exporting a JPEG file results in a loss of quality making it less useful for future image editing, similar to a photocopy of a photocopy. This is why designers typically avoid using JPEG files in motion projects.

An alternative is a **Portable Network Graphics (PNG)** file. It is a lossless format, meaning that the compression doesn't affect the quality of the image. **PNG-24** allows you to render images with millions of colors, just like a JPEG, but also preserves any transparency. If you cannot acquire the native Photoshop file, then a PNG-24 file is a good option.

Another acceptable raster-based file format is the **Tag Image File Format (TIFF)**. It is a standard graphics format and widely used in programs like Adobe Photoshop and InDesign. If you can only get a PNG or TIFF version of the logo, then make sure the image is at least twice the resolution of your final video format. Doubling the size of the image often produces acceptable results and more opportunities for animation.

Preparing Images for After Effects

After Effects is a great tool for adding the element of time to still images. However, it is not the best program to create the still images in. Many designers prefer to start their projects in either Photoshop or Illustrator, then bring the files to life in After Effects. Before importing an image into After Effects, consider the following:

- **RGB Color:** All images need to be saved in RGB format, not CMYK. After Effects works in an RGB color space.

- **Image Size and Resolution:** For HD video, use 1920 x 1080 pixels at 72 DPI or 1280 x 720 pixels at 72 DPI. Higher resolution files can be used if the images will be scaled over 100% in After Effects.

- **Content:** Crop any parts of the image that you do not want to be visible in After Effects.

- **Composition:** Make sure that all the important content falls within the Title Safe and Action Safe areas. Adobe Photoshop and Illustrator provide built-in presets for film and video with the safe zones set up with guide lines.

- **Fine details:** Avoid using thin 1-pixel lines in images or thick and thin typefaces because they may flicker during broadcast.

Preferable still image file formats:

Preparing a Photoshop File for After Effects

After Effects works closely with both Photoshop and Illustrator. Logos created in Photoshop can be easily translated over to After Effects with proper planning. Let's take a quick look at how to prepare a Photoshop layered file into After Effects:

Adobe Photoshop provides video presets for motion design projects. Guide lines are automatically generated for the Title Safe and Action Safe areas.

- **Film & Video Preset:** Create a new Photoshop document using the Film & Video presets. There are several video presets to choose from that include both standard 4:3 and HD 16:9 aspect ratios.

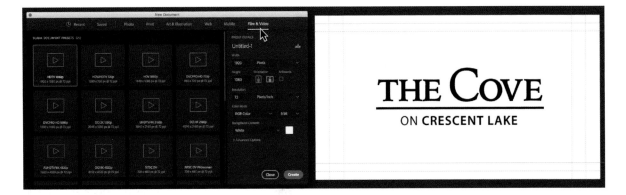

- **Scale:** Design your images at 100% scale within Photoshop. If you plan on scaling the images up in After Effects, design them a little larger. It is always better to scale an image down rather than enlarge it.

- **Layers:** Use layers to separate the individual components of the logo that you wish to animate. Make sure that your Photoshop layers are organized, properly named, and unlocked, as After Effects will import each layer preserving its name, order, transparency, and layer styles.

Use layers and an appropriate naming conventions for the raster graphics.

- **Text:** Any editable text in Photoshop can be converted into editable text in After Effects after the file has been imported. In After Effects, go to the Timeline and select any layers that were text in Photoshop and choose **Layer > Convert To Editable Text**.

Preparing an Illustrator File for After Effects

Logos are typically designed in Adobe Illustrator to take advantage of the vector art. Preparing Illustrator files for After Effects follows a similar process as Photoshop. Here's what you need to do.

- **Film & Video Preset:** Create a new Illustrator document using the Film & Video presets. Match the document size to the dimensions of the composition in After Effects. Click on the **More Settings** button to turn off the transparency grid. This allows you to view your vector art better.

Adobe Illustrator provides video presets for motion design projects.

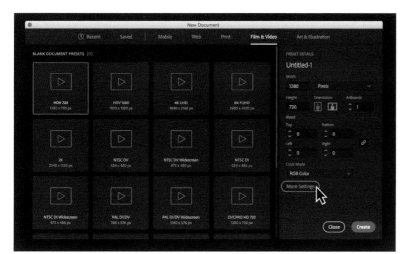

- **Scale:** Use the provided guide lines for the Title Safe and Action Safe areas to create, position, and scale the logo to the desired size.

- **Layers:** If you receive an Illustrator file from a client, or create a logo, that contains only one layer, you can easily separate each shape into its own layer. Open up the Layers panel in Illustrator. Select the logo layer. Click the menu icon ▤ at the top-right of the panel and select the **Release to Layers (Sequence)** option.

Adobe Illustrator can separate each shape into its own layer. This can be extremely helpful when it comes time to animate the logo in After Effects.

- **Top-level Layers:** Each individual shape is separated into its own layer. However, they're not top-level layers. Even though Illustrator can have sub-layers, After Effects will only separate the top-level layers. To fix this, select all the sub-layers and drag them outside of the top-layer they are all in. That empty layer can then be deleted.

Click and drag the separated sub-layers out to make all of them top-layers. Delete the empty layer when you are done.

- **Naming Convention:** Go through all the layers and rename them so you know which shape the layer contains. It may take a while, but it will save you time once you get into After Effects.

Use layers and an appropriate naming conventions for the vector graphics.

- **Text:** Unlike Photoshop, any editable text in Illustrator cannot be converted into editable text in After Effects.
- **Artboards:** If you use the Print presets, you can create multiple Artboards in one file. While this is great for storyboarding a motion design project, it can be a real problem when importing the file into After Effects. The best solution is to create separate files for each artboard using the Save options in Adobe Illustrator.

Save artboards into separate files using the Adobe Illustrator save options.

Chapter Exercise 1:
Revealing a Logo with Masks and Mattes

As you learned in Chapter 2, layered Photoshop and Illustrators can be imported into After Effects three ways. Selecting the **Footage** option flattens all the layers into a single layer. Choosing **Composition** maintains each layer set to the same dimension as the composition frame. The final option, **Composition - Retain Layer Sizes**, maintains each layer and keeps its own dimensions.

The following chapter exercise provides a step-by-step tutorial on how to animate a logotype created in Adobe Photoshop. Before you begin, download the **Chapter_04.zip** file to your hard drive. It contains all the files needed to complete the chapter exercises. To see what you will build, locate and play the **TheCove_Logotype.mov** in the **Completed** folder inside **Chapter_04**.

Download the **Chapter_04.zip** file at *www.routledge.com/cw/jackson*. It contains all the files needed to complete the chapter exercises.

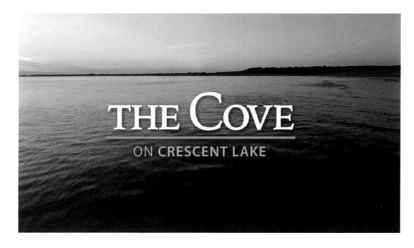

The animated logotype identifies a fictitious beach resort called "The Cove." When working with a client, always request the company's style guide. A **style guide** is a reference tool that defines how their logo is to be used. It not only describes the company's mission and vision, but it also shows visual examples of the logo in relation to its:

- **Size:** The minimum scaled size and proper proportions are provided.
- **Space:** The amount of white space that should surround it is provided.
- **Colors:** All variations (reversed, in color, black and white) are shown.
- **Don'ts:** The style guide should show examples of how the logo is not to be used.

Use the client's style guide as a reference tool for how the logo is to be used.

1. Open the **01_TheCove_Start.aep** file inside the **01_Photoshop_Logo** folder in **Chapter_04**. The Project panel contains the footage needed to complete this exercise. The Photoshop file was imported with the Composition – Retain Layer Sizes option selected.

2. If the **Cove_Logotype** composition is not open, double-click on it in the Project panel. It contains the four layers from the Photoshop file.

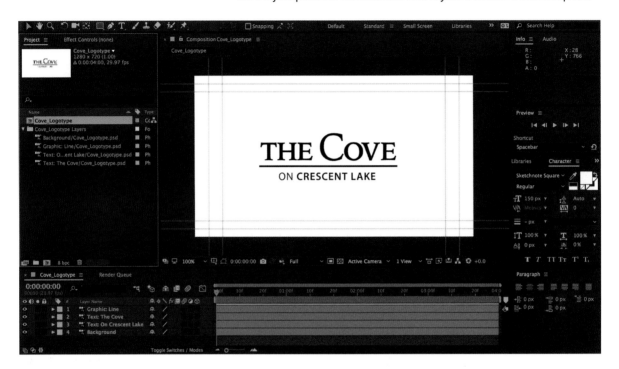

The composition matches the layer structure in the Photoshop file. The Title Safe and Action Safe guides are also imported into After Effects.

3. Go to the Timeline and turn off the visibility for the **Text: On Crescent Lake** layer. Click on the **Video** switch (**eyeball icon**) to hide the layer.

Use a Mask to Reveal a Layer

A **mask** in After Effects is an open path or closed shape used to define the alpha channel of a layer. The shape of the mask determines which part of a layer is shown and which part is hidden. These shapes can also be animated to reveal the content of a layer. The Rectangle and Pen Tool can create masks directly on a selected layer. Let's see how it works.

1. Go to the Timeline and select the **Graphic: Line** layer.

2. Select the **Rectangle** Tool in the Tools panel.

3. Make sure the **Graphic: Line** layer is still selected in the Timeline. Go to the Comp panel and draw a small rectangular shape to the left of the horizontal line. As you draw the mask shape, the line disappears because it is not contained inside the mask's shape.

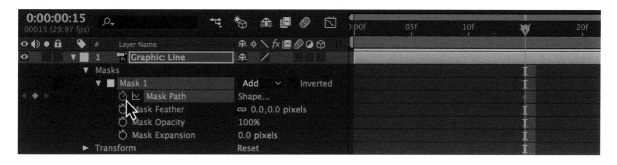

Use the Rectangle Tool to draw a mask shape to the left of the horizontal line. Only the content contained inside the mask shape will be visible.

4. Click on the **Selection** (Arrow) Tool in the Tools panel.

5. Move the **Current Time Indicator** (CTI) to **frame 15 (0:00:00:15)**.

6. Go to the **Graphic: Line** layer in the Timeline. Twirl open its **Mask 1** properties. Click on the **stopwatch** icon next to Mask Path.

7. Move the **Current Time Indicator** (CTI) to **one second (01:00)**.

Set a keyframe for the Mask Path.

8. Go to the Comp panel and double-click on the mask outline to reveal its Free Transform Points. The keyboard shortcut for this is **Command/Control + T**.

9. Click and drag the center-right point all the way to the right until the entire horizontal line is revealed.

Use the transform points to stretch the mask path and reveal the horizontal line.

10. Click and drag a marquee selection around both of the Mask Path keyframes to select them. Select **Animation > Keyframe Assistant > Easy Ease**. The keyframes change from diamonds to hourglass shapes ⊥ in the Timeline.

Apply an Easy Ease to the smooth the mask path's animation.

11. Click on the **Play/Stop** button. The line is revealed using the mask animation. Save your project file. Select **File > Save**.

Use a Track Matte to Create Transparency

The concept of a track matte was introduced in Chapter 2. To review, a **track matte** uses the transparency from one layer to reveal another layer that is directly under it. For this project, you will create a rectangular shape to reveal the words "The Cove." First, let's animate the layer.

1. Move the **Current Time Indicator** (CTI) to **two seconds (02:00)**.

2. Go to the Timeline and select the **Text: The Cove** layer. Type **P** on the keyboard to show only the Position property.

Set a keyframe for the Position property at the two-second mark.

3. Currently, the words "The Cove" are in their final position. Let's record that by clicking on the **stopwatch** icon ⬤ next to Position.

4. Move the **Current Time Indicator** (CTI) back to **one second (01:00)**.

Move the CTI to the one-second mark.

5. Go to the Comp panel. Click and drag the words "The Cove" down below the horizontal line.

Click and drag the logotype below the horizontal line in the Comp panel.

6. Click and drag a marquee selection around both of the Position keyframes to select them. Select **Animation > Keyframe Assistant > Easy Ease** to smooth the animation.

7. Deselect all the layers in the Timeline. Click in the gray area below the bottom layer, or use the keyboard shortcut of **Command/Control + Shift + A**.

You cannot use a mask to reveal "The Cove" rising up from underneath the horizontal line as masks are part of the layer and move with it. This is where a track matte comes to the rescue. It requires two layers.

8. Select the **Rectangle** Tool in the Tools panel to create the second layer. Make sure no layers are selected in the Timeline.

9. Go to the Comp panel and draw a rectangular shape above the horizontal line. The color of the shape is not important. Make sure it is large enough to cover the logotype. As you draw the rectangle, a Shape Layer is generated in the Timeline.

The Rectangle Tool create both masks and shape layers. When a layer is selected, the tools create masks. With no layers selected, the tools draw a Shape Layer.

10. Click on the **Selection** (Arrow) Tool in the Tools panel.

11. Rename **Shape Layer 1** by selecting it and pressing the **Return/Enter** key on the keyboard. Rename the layer **Track Matte**.

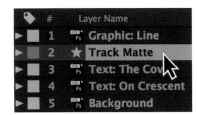

Toggle Switches / Modes

12. Click and drag the **Track Matte** layer. Reposition it between the **Graphic: Line** layer and the **Text: The Cove** layer.

13. Select the **Text: The Cove** layer in the Timeline panel.

14. Click on the **Toggle Switches / Modes** button at the bottom of the Timeline panel.

15. Define the transparency for the track matte by choosing the **Alpha Matte "Track Matte"** option from the Track Matte menu for the **Text: The Cove** layer.

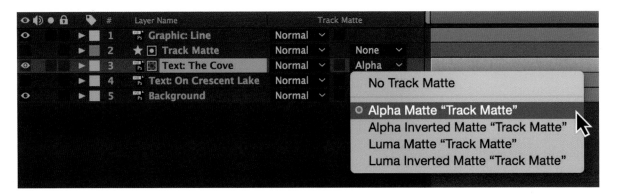

The stacking order for track mattes is important as the matte layer must be above the layer it is revealing. The end result shows the logotype rising up from beneath the horizontal line.

16. Click on the **Play/Stop** button to see the track matte in action. The Alpha Matte reveals the logo layer as it animates up into position. Save your project. Select **File > Save**.

Let's review. You create a track matte by placing the layer that contains the transparency content directly above, or on top of, its target layer in the Timeline. Then you choose one of the four options from the Track Matte pull-down menu: Alpha Matte, Alpha Inverted Matte, Luma Matte, and Luma Inverted Matte.

For this exercise, the Alpha Matte uses the alpha channel of the shape layer as if it were the alpha of the underlying logotype layer. Notice that the **Track Matte** layer's Video switch (eyeball icon) is turned off. Two, new additional icons appear next to the layers' names indicating which layer represents the matte and which layer represents the fill.

Animate the Tag Line

1. Go to the Timeline and turn on the visibility for the **Text: On Crescent Lake** layer. Click on the **Video** switch (**eyeball icon**) to reveal the layer again.

2. Move the **Current Time Indicator** (CTI) to **three seconds (03:00)**.

3. Go to the Timeline and select the **Text: On Crescent Lake** layer.

 - Type **P** on the keyboard to open the Position property.

 - Type **Shift + T** on the keyboard to open the Opacity property.

4. Currently, the tag line "On Crescent Lake" is in its final position. Click on the **stopwatch** icons next to Position and Opacity.

5. Move the **Current Time Indicator** (CTI) back to **two seconds (02:00)**.

6. Go to the Comp panel. Click and drag the words "On Crescent Lake" up slightly. Scrub through the Opacity numeric value and set it to **0%**.

7. Click and drag a marquee selection around both of the Position and Opacity keyframes to select them. Select **Animation > Keyframe Assistant > Easy Ease** to smooth the animation.

Transform Properties: Keyboard Shortcuts

A for Anchor Point

P for Position

S for Scale

R for Rotation

T for Opacity

U for all properties with keyframes

Create a keyframe animation for the tag line using the Position and Opacity transform properties.

8. Click on the **Play/Stop** button. The logo animation is almost done. Save your project. Select **File > Save**.

Apply the Style Guide Colors

1. Let's import a background movie to enhance the motion design project. Go to the Project panel and double-click in the empty gray area to open the Import File dialog box.

2. Locate the **Footage** folder inside the **01_Photoshop_Logo** folder. This folder contains a QuickTime movie named **BeachScene.mov**. Import the QuickTime movie as a footage file.

3. Click and drag the imported QuickTime footage to the Timeline. Position it above the **Background** layer.

Import the QuickTime video footage and add it as a layer in the Timeline.

4. Delete the **Background** layer.

5. Let's match the style guide colors for the animated logo to improve the contrast on the video background. Click on the **Text: The Cove** layer in the Timeline.

6. Select **Effect > Channel > Invert.** The logotype is now white.

Invert the logotype layer to make it white.

7. Click on the **Graphic: Line** layer in the Timeline.

8. Select **Effect > Color Correction > Tint.**

9. Go to the Effect Controls panel and click on the **Map Black To** color swatch. Change the RGB color to **R: 245, G: 140, B: 65.** Click **OK.**

The Tint effect replaces the pixel color values with a value you specify. If the Effect Controls panel is not visible, select **Effect > Effect Controls.**

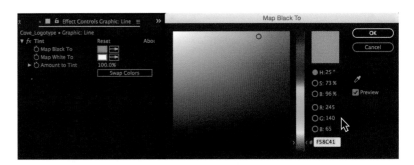

10. Click on the **Text: On Crescent Lake** layer. Select **Effect > Color Correction > Tint.**

11. Go to the Effect Controls panel and click on the **Map Black To** color swatch. Change the RGB color to **R: 155, G: 190, B: 240.** Click **OK.**

Use the Tint effect to change the color of the tag line to match the style guide.

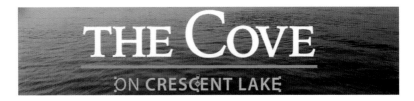

Precompose a Group of Layers and Add a Layer Style

Similar to Adobe Photoshop, After Effects provides layer styles. **Layer styles** offer additional effects such as drop shadows, glows, bevels, gradients, and strokes. For the last part of this exercise you will add a drop shadow to the entire logotype. To do this, the logo layers must first be grouped, or pre-composed, together in their own composition.

1. Click on the **Graphic: Line** layer in the Timeline.

2. Shift-click on layer 4 (**Text: On Crescent Lake** layer). This will select the first four layers.

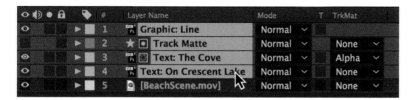

Use the **Shift** key to select the first four layers in the Timeline.

3. Select **Layer > Precompose**. The Precompose dialog box appears.

• Name the new composition **Pre-comp: Logotype**.

• Make sure the option, **Move all attributes into the new composition**, is selected.

• Click **OK**.

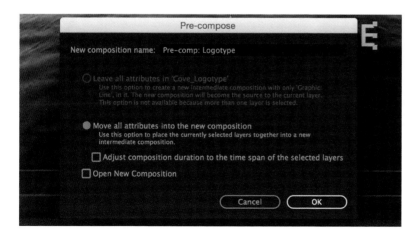

Pre-composing allows you to group select layers in the Timeline into a separate composition. This is similar to nesting comps that you learned in Chapter 2. Pre-composing is a useful technique that allows you to organize compositions into smaller, more manageable items.

4. The four layers are grouped into one layer in the Timeline. Select **Layer > Layer Styles > Drop Shadow**.

5. Go to the Timeline and Twirl open the **Drop Shadow** properties. Change the Size to **15.0**.

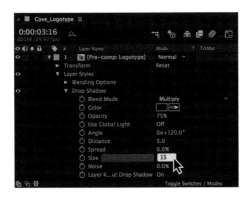

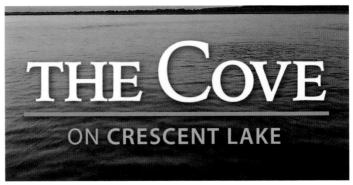

Increase the size of the drop shadow.

6. Click on the **Play/Stop** button. This completes this exercise. Experiment with the project.

7. When you are done, select **Composition > Add to Render Queue**.

- Click on **Lossless** next to Output Module.

- Set the Format to **QuickTime**.

- Click on **Format Options** and set the video codec to **H.264**. Click **OK**.

- Click **OK** again. Click on **Output To** and select your hard drive.

- Click the **Render** button.

8. Save your project file. Select **File > Save**.

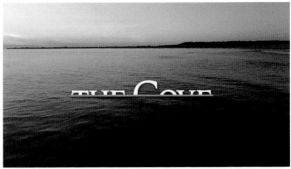

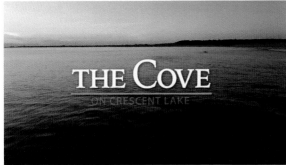

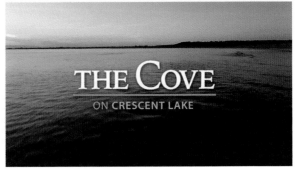

Chapter Exercise 2:
Animating Vector and Shape Layers

In the previous exercise, you created a Shape Layer to act as a track matte. The **Shape Layers** in Adobe After Effects are a wonder to behold. They contain vector graphic objects called, what else, shapes. The beauty of a Shape Layer lies in how it defines its vectors. You can create a shape with a stroke and a fill and scale it to any size without losing any detail or quality. After Effects takes shapes to the next level by allowing you to apply path operations that can animate the shape's outlines, creating some rather interesting motion graphics.

Path operations can manipulate the outline of Shape Layers over time.

This exercise begins with an introduction to Shape Layers. You will start with the basics and learn how to create and modify these vector objects in the Comp panel. From there, you will apply path operations to enhance a logo designed in Adobe Illustrator. Let's get started.

Making and Modifying Shapes

If you are familiar with drawing shapes in Adobe Illustrator, you should feel right at home in After Effects. Many of the Shape Tools are based on Illustrator's toolset. The Shape Tools are located in the Tools panel and consist of a Rectangle, Rounded Rectangle, Ellipse, Polygon, and a Star Tool. The Pen Tool also allows you to create bezier shapes.

The **Shape** Tools are located in the Tools panel. Click and hold to open the pop-up menu.

1. Launch **Adobe After Effects** and create a new project.

2. Select **Composition > New Composition**. Make the following settings in the dialog box that appears:

- Composition Name: **Shapes**
- Preset: **HDV/HDTV 720 29.97**
- Duration: **0:00:05:00** (5 seconds)
- Click **OK**.

3. Click and hold on the **Rectangle** Tool in the Tools panel. Select the **Star** Tool from the Shape Tool pop-up menu.

Click and drag in the Comp panel to create a shape. Use the **Up** arrow to add more points as you drag the mouse. A Shape Layer is automatically added to the Timeline.

4. Go to the Comp panel. Click and drag to scale and rotate the star as you draw it. As you drag and before you release the mouse, you can:

• Hold down the **Shift** key to only scale the star as you draw it.

• Hold down the **Space** bar to move its position in the Comp panel.

• Press the **Up** arrow key to add more points.

• Press the **Down** arrow key to remove points.

5. When you are finished drawing, release the mouse. A Shape Layer is added to the Timeline panel. Shapes in After Effects consist of a path, a stroke, and a fill. Fill and Stroke options are available for selected shapes to the right of the Toolbar.

6. With the shape still selected, click on the word **Fill** to open the Fill Options dialog box. Click on the **Radial Gradient** button. Click **OK**.

Fills and strokes can be set to one of four modes. None performs no paint operation. Solid color paints the entire fill or stroke with one color. Linear and Radial Gradient mixes two or more colors together based on a Start and End Points. For this example, the stroke mode is set to None.

7. Click on the Fill's **color swatch** to open the Gradient Editor dialog box. This allows you to choose a gradient color combination.

8. Click on the **Color Stop** icons ⬛ to change the color using the color picker at the bottom of the dialog box. Choose any colors you wish for your radial fill. When you are done, click **OK**.

Adjust the colors for the gradient fill. You can add additional Color Stops by clicking on the gradient bar. To delete a Color Stop, select it and click on the **Delete** button.

9. Click on the **Selection** (Arrow) Tool in the Tools panel.

10. To adjust the position of the radial gradient fill inside the shape's outline, select the **Shape Layer 1** layer in the Timeline. Go to the Comp panel. Using the Selection (arrow) Tool, click and drag the Start and End Points to modify the gradient's position.

11. In the Timeline, twirl open **Shape Layer 1** layer to display the shape's attributes. These attributes are contained within a shape group. Each group has its own attributes and transform properties.

12. Twirl open **Polystar Path 1** to reveal its attributes. Experiment with each of the values to modify the shape in the Comp panel. Notice that all of these attributes have a stop watch next to their name. This means that they can be animated over time. For this example the following changes were made:

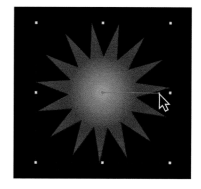

Adjust the Start and End Point to reposition the gradient fill.

- Increase the Points value to **24**.

- Increase the Inner Radius to **130**.

- Decrease the Outer Roundness to **-275**.

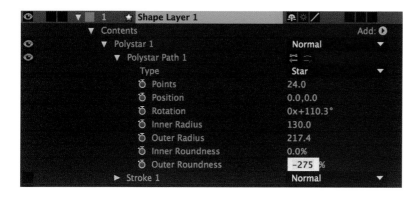

13. Path operations offer distortion effects such as Pucker & Bloat, Twist, Zig Zag, and an auto-animating Wiggle Paths. Click on the **Add arrow** to the right of Contents to open a pop-up menu. Choose **Pucker & Bloat** from the pop-up menu.

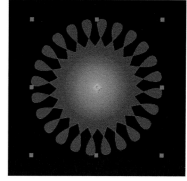

Open the Shape Group to reveal its attributes and transform properties.

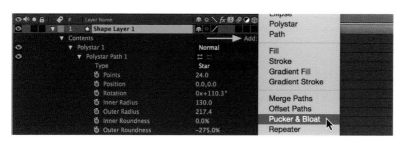

Add a path operation to the shape.

Pucker & Bloat bends the path segments between the path vertices to create some amazing and unique shapes and patterns.

The logo animation combines Shape Layers with Illustrator vector art.

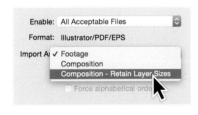

Import the layered Illustrator file as a composition and retain each layer size.

14. Twirl open **Pucker & Bloat 1**. Experiment with its attributes to modify the shape's path. For this example, the Amount value was set to **-50**.

15. Save your project and keep experimenting with the Shape Layer. When you create a shape by dragging with a Shape tool in the Comp panel, you create a **parametric** shape path. These paths are defined numerically and are the basic geometric shapes you can select from the Shape Tools pop-up menu.

Importing and Animating an Illustrator Layered File

Now that you have experimented with the Shape Layers and have a basic understanding of their attributes, let's create an animation using them. In this exercise, you will combine a shape layer animation with a logo designed in Adobe Illustrator. To see what you will build, locate and play the **Innovati_Logo.mov** in the **Completed** folder inside **Chapter_04**. The animated logo identifies a fictitious product and service design company called "Innovati." Let's animate the Illustrator artwork first.

1. Keep the current After Effects project file open.

2. Select **File > Import > File**. This opens the import dialog box.

3. From within the Import File dialog box, locate the **Footage** folder inside the **02_Illustrator_Logo** folder in **Chapter_04**. From within the **Footage** folder, select the **Innovati_Logo.ai** file.

4. Choose **Import As > Composition Retain Layer Sizes**. Click **Open**.

5. Double-click on the **Innovati_Logo** composition in the Project panel to open its Timeline and Comp panel. The hierarchal layer structure is retained from the Adobe Illustrator file.

6. Move the **Current Time Indicator** (CTI) to **frame 15 (0:00:00:15)**.

7. Go to the Timeline and select the **Logo Person** layer.

- Type **S** on the keyboard to open the Scale property.

- Type **Shift + R** on the keyboard to open the Rotation property.

8. Scrub through the Scale numeric value and set it to **0%**.

9. Click on the **stopwatch** icons next to Scale and Rotation.

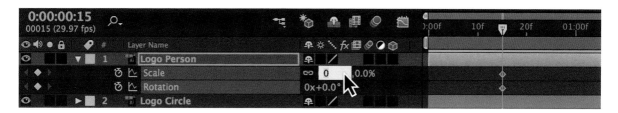

10. Move the **Current Time Indicator** (CTI) to the **one-second** and **15-frame** mark (**0:00:01:15**).

- Scrub through the Scale numeric value and set it back to **100%**.

- Set the Rotation property to **1x+0.0°**. This will create one complete 360° revolution.

11. Click and drag a marquee selection around both of the Scale and Rotation keyframes to select them. Select **Animation > Keyframe Assistant > Easy Ease** to smooth the animation.

Set keyframes for the Scale and Rotation properties in the Timeline.

12. Move the **Current Time Indicator** (CTI) to **frame 15 (0:00:00:15)**.

13. Go to the Timeline and select the **Logo Circle** layer. Type **S** on the keyboard to open the Scale property.

- Scrub through the Scale numeric value and set it to **0%**.

- Click on the **stopwatch** icon next to Scale.

Apply an Easy Ease to the keyframes.

14. Move the **Current Time Indicator** (CTI) to **frame 25 (0:00:00:25)**.

15. Scrub through the Scale numeric value and set it to **140%**. This will create an **overshoot** in the animation. This basic principle applies to any animated object that is coming to a stop. Instead of an abrupt end, the object will miss the stop point slightly before stopping eventually, creating a pendulum-like movement.

16. Move the **Current Time Indicator** (CTI) to **one second (01:00)**.

17. Scrub through the Scale numeric value and set it to **100%**.

18. Click and drag a marquee selection around all three Scale keyframes to select them. Select **Animation > Keyframe Assistant > Easy Ease** to smooth the animation.

Create an overshoot in the animation by scaling the layer slightly larger than 100% a few frames before the last keyframe.

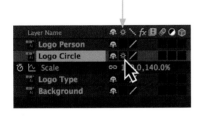

Turn on the Continuously Rasterize switch for the vector layer.

Continuously Rasterize Vector Layers

Despite the compatibility between the two programs, Illustrator art is rasterized by default in After Effects causing the vector art to blur if scaled over 100%. For vector layers, there is a **Continuously Rasterize** switch that can be enabled in the Timeline. Once activated, vector files scale as they would in Illustrator, within After Effects.

19. Turn on the **Continuously Rasterize** switch (sunburst icon) for the **Logo Circle** layer in the Timeline. This will maintain the crisp, vector path of the circle as it scales up to 140%.

20. Move the **Current Time Indicator** (CTI) to **two seconds (02:00)**.

21. Go to the Timeline and select the **Logo Type** layer.

• Type **P** on the keyboard to open the Position property.

• Type **Shift + T** on the keyboard to open the Opacity property.

22. Currently, the name "INNOVATI" is in its final position. Click on the **stopwatch** icons next to Position and Opacity.

23. Move the **Current Time Indicator** (CTI) back to **one second (01:00)**.

24. Go to the Comp panel. Click and drag the name "INNOVATI" down slightly. Scrub through the Opacity numeric value and set it to **0%**.

25. Click and drag a marquee selection around both of the Position and Opacity keyframes to select them. Select **Animation > Keyframe Assistant > Easy Ease** to smooth the animation.

Import the background animation and add it as a layer in the Timeline panel.

Create a keyframe animation for the company name using the Position and Opacity transform properties.

Repeating and Animating Shape Layers

You can draw a shape directly in the Comp panel and After Effects adds a new Shape Layer to the composition. You can also add a Shape Layer through the Layer menu. This technique will automatically center the shape in the Comp panel.

1. Press the **Home** key to move the **Current Time Indicator** (CTI) to the beginning of the composition (**00:00**).

2. Select **Layer > New > Shape Layer**. A Shape Layer is added to the Timeline and Composition panel. The default contents are empty. The next step will add the type of shape needed.

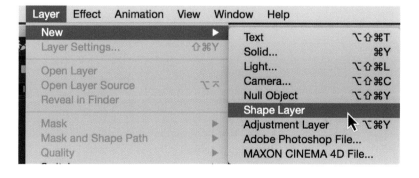

Add a Shape Layer using the Layer menu. This will automatically center the shape in the Comp panel.

3. In the Timeline, twirl open **Shape Layer 1** layer to display the shape's attributes. Notice that its Contents property is empty.

4. Click on the **Add arrow** to the right of Contents to open a pop-up menu. Choose **Ellipse** from the pop-up menu. A circular path is added to the Shape Layer's contents.

Add an Ellipse (circle) shape to the Contents property.

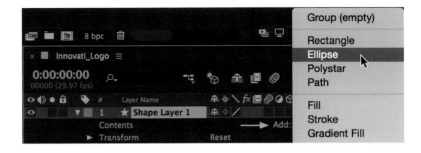

5. Twirl open the **Ellipse Path 1** property. Increase the Size to **200**. This will match the size of the Illustrator circle in the logo.

Increase the size of the ellipse's path to match the Illustrator artwork.

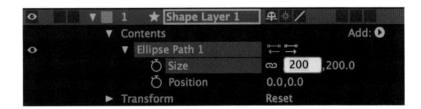

6. The ellipse path needs a stroke to be visible in the Comp panel. Click on the **Add arrow** to the right of Contents. Choose **Stroke** from the pop-up menu.

7. Twirl open the **Stroke 1** property. Click on the **color swatch** to open the Color dialog box. Change the RGB color to **R: 140**, **G: 140**, **B: 140**. This sets the stroke's color to a neutral gray. Click **OK**.

8. Increase the Stroke Width to **4.0**.

Add a Stroke property to the ellipse and set its color to gray and increase the width to 4 pixels.

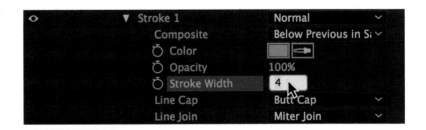

9. Click on the **Add arrow** to the right of Contents. Choose **Repeater** from the pop-up menu. Three new circles appear to the right of the original shape. The repeater is a path operation that creates virtual copies of all paths, strokes, and fills within a group.

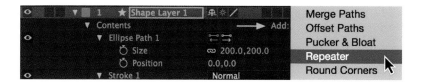

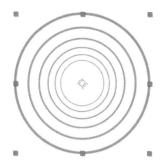

Add a Repeater path operation. The virtual copies of the original shape are only present in the Comp panel and do not appear as new layers in the Timeline.

10. Twirl open the **Repeater 1**. Increase the Copies value to **6**.

11. Twirl open the **Transform: Repeater 1**. You can define how each copy is transformed by modifying its position, scale, and rotation values, which accumulate for each copy. Make the following changes:

- Set the Position values to **0.0, 0.0**. This aligns all copies underneath the original shape.

- Change the Scale value to **80%**. Now you can see how the transform properties accumulate for each copy.

- Change the Rotation value to **0x+90.0°**. This change will not be noticeable yet, since all the copies are circular shapes. It will be visible later in the exercise.

12. Move the **Current Time Indicator** (CTI) to **frame 15 (0:00:00:15)**. Click on the **stopwatch** icon 🕐 for the Scale value in the Transform: Repeater 1 path operation.

13. Move the **Current Time Indicator** (CTI) to **frame 25 (0:00:00:25)**. Increase the Scale value to **100%**. All the virtual copies will scale up to match the size of the original shape.

Set keyframes to animate the Scale value for each virtual copy.

14. Click and drag a marquee selection around both of the Scale keyframes to select them. Select **Animation > Keyframe Assistant > Easy Ease** to smooth the animation.

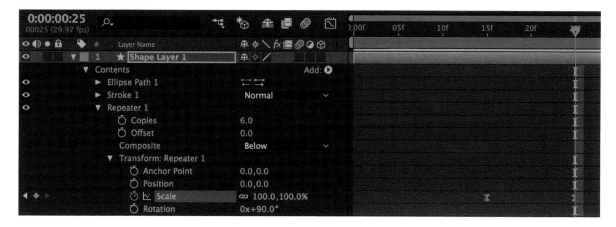

15. Save your project. Select **File > Save**.

16. Let's add another path operation to the Shape Layer. Click on the **Add arrow** to the right of Contents. Choose **Trim Paths** from the pop-up menu. This operation contains a Start and End property which will draw each virtual copy of the original shape.

Add a Trim Paths operation to the Shape Layer to create a "write-on" effect.

17. Twirl open the **Trim Paths 1**. Set the End value to **0.0**.

18. Move the **Current Time Indicator** (CTI) to **frame 5 (0:00:00:05)**. Click on the **stopwatch** icon 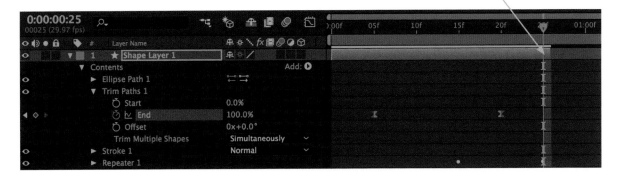 for the End value.

19. Move the **Current Time Indicator** (CTI) to **frame 20 (0:00:00:20)**. Increase the End value to **100%**.

20. Click and drag a marquee selection around both of the End keyframes to select them. Select **Animation > Keyframe Assistant > Easy Ease** to smooth the animation.

21. Move the **Current Time Indicator** (CTI) to **frame 25 (0:00:00:25)**.

22. Make sure the **Shape 1** layer is selected in the Timeline. Press **Option/Alt +]** to trim the layer's Set Out Point.

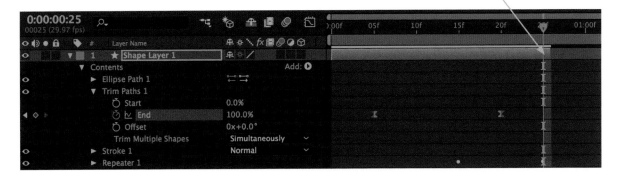

Trim the Shape Layer's Set Out Point.

23. Click and drag **Shape Layer 1**. Position it underneath the **Logo Type** layer in the Timeline. Rename the layer to **Concentric Circles**. To do this, select the layer's name and press the **Return/Enter** key.

Rename and reposition the Shape Layer.

24. Click on the **Play/Stop** button. Notice that each copy starts drawing on the screen at a different location. This is a result of changing the Rotation value in step 11. Save your project. Select **File > Save**.

The offset animation is based on the Repeater's Transform Rotation value.

Add Another Shape Layer

Let's add and animate another Shape Layer to create a visual accent.

1. Press the **Home** key to move the **Current Time Indicator** (CTI) to the beginning of the composition (**00:00**).

2. Select **Layer > New > Shape Layer**. A Shape Layer is added to the Timeline and to the center of the Composition panel.

3. In the Timeline, twirl open **Shape Layer 1** layer. Click on the **Add arrow** to the right of Contents to open a pop-up menu. Choose **Ellipse** from the pop-up menu.

4. The path needs a stroke to be visible in the Comp panel. Click on the **Add arrow** to the right of Contents. Choose **Stroke** from the pop-up menu.

5. Twirl open the **Stroke 1** property. Click on the **color swatch** to open the Color dialog box. Change the RGB color to **R: 255**, **G: 145**, **B: 0**. This sets the stroke's color to orange. Click **OK**.

6. Increase the Stroke Width to **8.0**.

7. Move the **Current Time Indicator** (CTI) to **frame 15 (0:00:00:15)**.

8. Twirl open the **Ellipse Path 1** property. Set the Size to **0**. Click on the **stopwatch** icon 🕐 for the Size value.

9. Move the **Current Time Indicator** (CTI) to **one second (01:00)**.

10. Increase the Size of the **Ellipse Path 1** to **1500**. This will scale the circle beyond the edges of the Comp panel.

11. Click and drag a marquee selection around both of the Size keyframes to select them. Select **Animation > Keyframe Assistant > Easy Ease** to smooth the animation.

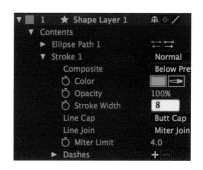

Create another Shape Layer and add an ellipse path and stroke to its contents. Set the color of the stroke to orange to match the logo and increase the stroke width.

12. Click and drag **Shape Layer 1**. Position it underneath the **Logo Type** layer in the Timeline. Rename the layer to **Orange Accent Circle**.

13. Click on the **Play/Stop** button. The logo animation is almost done. Save your project. Select **File > Save**.

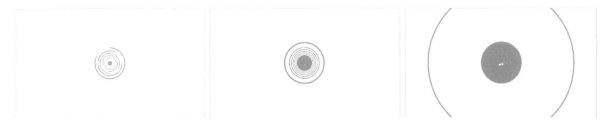

The second Shape Layer animation is used as a visual accent for the logo.

Precompose the Logo Animation

The logo is not centered in the Comp panel. For the last part of this exercise you will group, or pre-compose, the logo layers together in their own composition. Then, you will animate the new composition.

1. Click on the **Logo Person** layer in the Timeline.

2. Shift-click on layer 3 (**Logo Type** layer). This will select the first three layers.

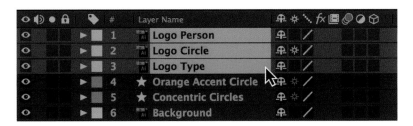

3. Select **Layer > Precompose**. The Precompose dialog box appears.

• Name the new composition **Pre-comp: Logo Animation**.

• Make sure the option, **Move all attributes into the new composition**, is selected.

• Click **OK**.

4. The three layers are grouped into one layer in the Timeline. Move the **Current Time Indicator** (CTI) to **one second** (**01:00**).

5. Select the **Pre-comp: Logo Animation** layer. Type **P** on the keyboard to open the Position property.

6. Click on the **stopwatch** icon next to Position.

Pre-compose the logo animation into a new composition.

7. Move the **Current Time Indicator** (CTI) to **four seconds (04:00)**.

8. Change the logo's Position to **640.0, 325.0**. This will move the new composition up slightly in the Comp panel.

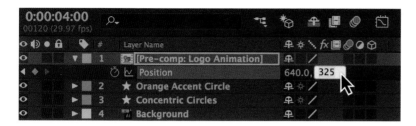

Animate the logo's position to center it better in the Comp panel.

9. Click on the **Play/Stop** button. Save your project. Select **File > Save**. This completes this exercise. Experiment with the project.

10. When you are done, select **Composition > Add to Render Queue**.

- Click on **Lossless** next to Output Module.

- Set the Format to **QuickTime**.

- Click on **Format Options** and set the video codec to **H.264**. Click **OK**.

- Click **OK** again. Click on **Output To** and select your hard drive.

- Click the **Render** button.

Chapter Exercise 3: Animating a Lower Third Overlay

In this exercise, you will animate a graphic overlay that sits at the bottom third of the screen within the Title Safe and Action Safe areas. This is commonly referred to as a lower third in the broadcast industry. It is used to display logos and text that describe who or what is on screen. To see what you will build, locate and play the **FloralFinders_Thirds.mov** in the **Completed** folder inside **Chapter_04**.

A lower third graphic is used to identify who, what, or location that is on screen. For this exercise, "Floral Finders" is a fictitious online service that locates and compares floral arrangement prices.

1. Open the **03_FloralFinders_Start.aep** file inside the **03_LowerThirds** folder in **Chapter_04**. The Project panel contains the footage needed to complete this exercise.

2. If the **Lower Thirds** composition is not open, double-click on it in the Project panel. It contains five layers.

When designing lower third graphics, it is important to use the Title Safe and Action Safe guides. As discussed in Chapter 1, older television sets overscan, or crop, a video image. The amount of overscan is not consistent between television sets, so you should design within the safe areas. Where are the guides for these safe areas in After Effects?

3. Go to the Composition panel. Click on the **Grid and Guide** button along the bottom of the panel. Select **Title/Action Safe** from the pop-up menu. This acts as a toggle to either show or hide the guides.

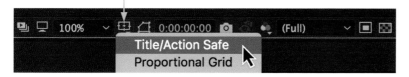

The graphic overlay is positioned within the Action Safe area, and the logo's name is placed within the Title Safe area. Notice that the bar starts at the left edge of the screen. Always design from one edge of the frame to the other, because computer monitors and newer HD television sets may show the entire frame.

4:3 Title Safe Area

16:9 Title Safe Area

16:9 Action Safe Area

4. Go to the Timeline and turn off the visibility for the **Logo/Floral_Finders_Logo.ai** and the **Logotype/Floral_Finders_Logo.ai** layers. Click on the **Video** switch (**eyeball icon**) to hide both layers.

Hide the logo layers using the **Video** (eyeball icon) toggle switch.

5. Select the **Pink Bar** layer in the Timeline. This is a Shape Layer. The layer's Anchor Point needs to be adjusted so that it can scale correctly. To move the layer's anchor point without moving the layer, select the **Pan Behind** (Anchor Point) Tool in the Tools panel.

6. Go to the Comp panel. Click and drag the layer's anchor point ⬦ to the left center. Hold down the **Command** key while you are dragging the anchor point to have it snap to the left center.

Click and drag the layer's anchor point to the left center using the Pan Behind (Anchor Point) Tool.

7. Click on the **Selection** (Arrow) Tool in the Tools panel.

8. Move the **Current Time Indicator** (CTI) to **frame 10 (0:00:00:10)**.

9. Make sure the **Pink Bar** layer is still selected in the Timeline. Type **S** on the keyboard to open the Scale property.

- Click on the **Constrain Proportions** icon 🔗 to the left of the Scale numeric values to turn off proportional scaling.

- Scrub through the first Scale numeric value and set it to **0%**.

- Click on the **stopwatch** icon next to Scale.

Scale only the pink bar's width.

10. Move the **Current Time Indicator** (CTI) to **one second (01:00)**.

11. Scrub through the first Scale numeric value and set it back to **100%**.

12. Click and drag a marquee selection around both of the Scale keyframes to select them. Select **Animation > Keyframe Assistant > Easy Ease** to smooth the animation.

13. Click on the **Play/Stop** button. The pink bar scales in from the left.

14. Make sure the **Pink Bar** layer is still selected. Duplicate the layer by selecting **Edit > Duplicate**. The keyboard shortcut is **Command/Control + D**. This will also duplicate the keyframes.

15. Rename the duplicated layer by selecting it and pressing the **Return/Enter** key on the keyboard. Rename the layer **White Bar**.

16. Click on the **Fill color swatch** in the top Tools panel. Change the color to white and click **OK**.

Duplicate the solid layer and change the duplicate's fill color to white.

17. Click and drag the **White Bar** layer. Reposition it under the **Pink Bar** layer.

18. Move the **Current Time Indicator** (CTI) to **frame 10 (0:00:00:10)**.

19. Click anywhere inside the colored bar for the **White Bar** layer and drag to the right. Align the left edge of the bar with the CTI.

20. Type **P** on the keyboard to open the Position property. Increase the vertical position (second numerical value) to **610**. This will lower the white bar in the Comp panel and create an underline effect.

Drag the duplicated layer's bar in the Timeline to offset the animation.

21. Click on the **Play/Stop** button. The pink bar animates first followed by the white bar as a visual accent. Save your project. Select **File > Save**.

Offsetting the duplicated layer's animation creates a visual accent that underlines the pink bar in the Comp panel.

Animate the Illustrator Layers

1. Move the **Current Time Indicator** (CTI) to **one second (01:00)**.

2. Select the **Logo/Floral_Finders_Logo.ai** layer (layer 2) in the Timeline.

 * Type **S** on the keyboard to open the Scale property.

 * Type **Shift + R** on the keyboard to open the Rotation property.

 * Click on the **stopwatch** icons next to Scale and Rotation.

3. Move the **Current Time Indicator** (CTI) back to **frame 10 (0:00:00:10)**. Make the following changes:

 * Scrub through the Scale numeric value and set it to **0%**.

 * Set the Rotation property to **0x-90.0°**.

4. Click and drag a marquee selection around both of the Scale and Rotation keyframes to select them. Select **Animation > Keyframe Assistant > Easy Ease** to smooth the animation.

Animate the logo's scale and rotation.

5. Turn on the visibility for the **Logo/Floral_Finders_Logo.ai** layer. Click on the **eye** toggle switch to reveal the layer again.

6. Click on the **Play/Stop** button. The flower icon scales and rotates in clockwise. Save your project. Select **File > Save**.

7. Turn on the visibility for the **Logotype/Floral_Finders_Logo.ai** layer (layer 3). Click on the **eye** toggle switch to reveal the layer again.

8. Move the **Current Time Indicator** (CTI) to **one second (01:00)**.

9. Select the **Logo/Floral_Finders_Logo.ai** layer (layer 3) in the Timeline. Type **P** on the keyboard to open the Position property.

10. Currently, the logotype is in its final position. Click on the **stopwatch** icon 🕐 next to Position.

11. Move the **Current Time Indicator** (CTI) back to **frame 10 (0:00:00:10)**.

12. Change the Position values to **295.0, 603.0**. This will create an animation where the logotype slides slightly to the right.

13. Click and drag a marquee selection around both of the Position keyframes to select them. Select **Animation > Keyframe Assistant > Easy Ease** to smooth the animation.

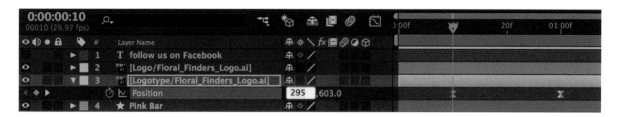

14. Click on the **Play/Stop** button. The logotype is visible on the first frame and needs to be revealed as the pink bar scales horizontally. As previously discussed, you need to create a track matte.

Animate the logotype's position.

Create a Track Matte to Reveal the Logotype

1. Select the **Pink Bar** layer in the Timeline. Duplicate the layer by selecting **Edit > Duplicate**. The keyboard shortcut is **Command** (Mac)/**Control** (Windows) **+ D**.

2. Rename the duplicated layer by selecting it and pressing the **Return/Enter** key on the keyboard. Rename the layer **Track Matte**.

3. Click and drag the **Track Matte** layer. Reposition it above the **Logotype/Floral_Finders_Logo.ai** layer.

Duplicate and rename the Shape Layer. Position it above the logotype layer. The duplicated layer will be used as a track matte to reveal the logotype.

4. Select the **Logotype/Floral_Finders_Logo.ai** layer.

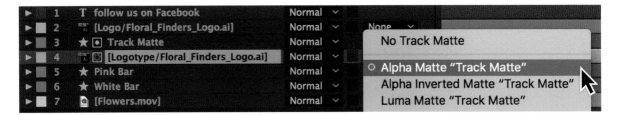

Toggle Switches / Modes

5. Click on the **Toggle Switches / Modes** button at the bottom of the Timeline panel.

6. Define the transparency for the track matte by choosing the **Alpha Matte "Track Matte"** option from the Track Matte menu for the **Logotype/Floral_Finders_Logo.ai** layer.

	1	T follow us on Facebook	Normal ∨	
	2	[Logo/Floral_Finders_Logo.ai]	Normal ∨	None ∨
	3	★ ⦿ Track Matte	Normal ∨	No Track Matte
	4	[Logotype/Floral_Finders_Logo.ai]	Normal ∨	
	5	★ Pink Bar	Normal ∨	○ Alpha Matte "Track Matte"
	6	★ White Bar	Normal ∨	Alpha Inverted Matte "Track Matte"
	7	[Flowers.mov]	Normal ∨	Luma Matte "Track Matte"

The track matte layer must be above the layer it is revealing. The end result reveals the logotype as the bar scales horizontally.

7. Go to the Composition panel. Click on the **Grid and Guide** 🔲 button along the bottom of the panel. Select **Title/Action Safe** from the pop-up menu. This will hide the guides.

8. Click on the **Play/Stop** button to see the track matte in action. The Alpha Matte reveals the logotype layer as the bar scales horizontally. Save your project. Select **File > Save**.

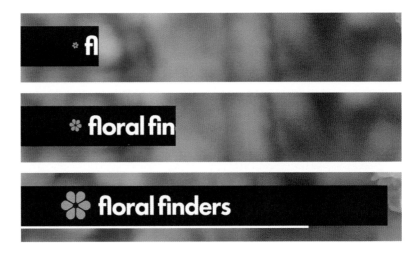

Animate the Social Network Tag Line

The project is almost done. The last part of this exercise is to animate the tag line, "Follow us on Facebook." To do this, we must first give the viewer enough time to see and read the logo. Let's finish the project.

1. Move the **Current Time Indicator** (CTI) to **three seconds (03:00)**.

2. Select the **Logo/Floral_Finders_Logo.ai** layer. If the Position property is not open, type **P** on the keyboard to open it.

3. Click on the **gray diamond** to the left of the word Position. This adds a keyframe at the current time (3 seconds). The two arrows allow you to jump to either the previous or next keyframe in the Timeline.

Add a keyframe at the current time.

4. Move the **Current Time Indicator** (CTI) to **four seconds (04:00)**.

5. Change the Position values to **1285.0, 603.0**. This animates the logotype off the right edge of the composition.

Change the position for the logotype.

6. Move the **Current Time Indicator** (CTI) to **three seconds (03:00)**.

7. Select the **Logo/Floral_Finders_Logo.ai** layer in the Timeline. If the Rotation property is not open, type **R** on the keyboard to open it.

8. Click on the **gray diamond** to the left of the word Rotation. This adds a keyframe at the current time (3 seconds).

Add a keyframe at the current time.

9. Move the **Current Time Indicator** (CTI) to **four seconds (04:00)**.

10. Set the Rotation property to **1x+0.0°** to create one 360° revolution.

11. Click on the **Play/Stop** button. Notice that the logotype layer disappears as it animates outside the pink bar. This is a result of the track matte. Save your project. Select **File > Save**.

Turn on the Text Layer's visibility.

Set keyframes for the Text Layer's opacity.

12. Move the **Current Time Indicator** (CTI) to **three seconds (03:00)**.

13. Turn on the visibility for the **follow us on Facebook** Text Layer. Click on the **eye** toggle switch to reveal the layer.

14. Select the Text Layer and type **T** on the keyboard to open the Opacity property. Scrub through the Opacity numeric value and set it to **0%**.

15. Click on the **stopwatch** icon 🕐 next to Opacity.

16. Move the **Current Time Indicator** (CTI) to **four seconds (04:00)**.

17. Scrub through the Opacity numeric value and set it to back to **100%**.

18. Click and drag a marquee selection around both of the Opacity keyframes to select them. Select **Animation > Keyframe Assistant > Easy Ease** to smooth the animation.

19. Click on the **Play/Stop** button. Save your project. Select **File > Save**. This completes this exercise. Experiment with the project.

20. When you are done, select **Composition > Add to Render Queue**.

- Click on **Lossless** next to Output Module.
- Set the Format to **QuickTime**.
- Click on **Format Options** and set the video codec to **H.264**. Click **OK**.
- Click **OK** again. Click on **Output To** and select your hard drive.
- Click the **Render** button.

Chapter Exercise 4:
Simulating Handwriting with a Stroke

The Pen Tool in After Effects serves a variety of purposes. It is similar in operation to the Pen Tools in Photoshop and Illustrator. You can create a Bezier mask using the Pen Tool on a selected layer in the Composition or Timeline panel. If you draw with the Pen Tool in the Comp panel with no layer selected, you create a vector shape on a new shape layer.

The Stroke effect creates a stroke along a Bezier path created with the Pen Tool. You can specify the stroke's color, opacity, and spacing. In addition, you can also set the stroke to appear on top of the image or use it to reveal the original alpha channel. Add a couple of keyframes and you can simulate a text layer being "written" on the screen. To see an example of this effect, locate and play the **Slash_Designs.mov** in the **Completed** folder inside **Chapter_04**.

The project simulates handwriting using the Stroke effect. The typeface chosen for "Slash Designs" lends itself well for this type of visual effect.

1. Open the **04_StrokeEffect_Start.aep** inside the **04_Handwriting** folder in **Chapter_04**. The Project panel contains the footage needed to complete this exercise.

2. If the **StrokeEffect** composition is not open, double-click on it in the Project panel. It contains three layers.

3. Select the **Slash** layer in the Timeline.

Select the **Slash** layer in the Timeline.

Trace the letter form using the Pen Tool.

4. Select the **Pen** Tool from the Tools panel. Go to the Comp panel and trace the letter "S" starting at the top of the letter. Click and drag to create a curved path. When you are done, hold down the **Command** (Mac)/**Control** (Windows) key and mouse click to stop drawing.

5. With the **Slash** layer still highlighted in the Timeline, trace over the remaining letters. Remember to hold down the **Command** (Mac)/**Control** (Windows) key and mouse click to stop drawing once you have completed each tracing.

6. Each Bezier path created with the Pen Tool appears as a property layer in the Timeline. To reveal all of the masks for a layer, select the layer and type **M** on the keyboard.

Trace the remaining letters forms using the Pen Tool. Each Bezier path is added as a property layer in the Timeline.

7. Click on the **Selection** (Arrow) Tool in the Tools panel.

8. Select **Effect > Generate > Stroke** to apply the effect to the layer.

9. Go to the Effect Controls panel. You can have the stroke follow one or more paths created using the Pen Tool. Since you have multiple paths, click on the **checkbox** for All Masks.

10. The color of the stroke doesn't matter since it will be used to reveal the letters in the **Slash** layer. Increase the Brush Size to **37.5**.

11. Move the **Current Time Indicator** (CTI) to **frame 10 (0:00:00:10)**.

12. In the Effect Controls panel, change the End value to **0**. Click on its **stopwatch** icon 🔘 to add a keyframe.

13. Move the **Current Time Indicator** (CTI) to **two seconds (02:00)**.

14. In the Effect Controls panel, change the End value back to **100**. This will create the animation of the strokes drawing sequentially in the Comp panel.

15. To create the final effect of handwriting, select **Reveal Original Image** from the Paint Style drop-down menu.

Apply the Stroke effect to all of the paths created with the Pen Tool.

Ö Color	
▶ Ö Brush Size	37.5
▶ Ö Brush Hardness	100%
▶ Ö Opacity	100.0%
▶ Ö Start	0.0%
▶ Ö End	100.0%
▶ Ö Spacing	15.00%
Ö Paint Style	Reveal Original Image
	On Original Image
	On Transparent
	○ Reveal Original Image

Change the Paint Style to reveal the letters in the original image.

16. Move the **Current Time Indicator** (CTI) to **two seconds (02:00)**.

17. Select the **Designs** layer and type **T** on the keyboard to open the Opacity property. Scrub through the Opacity numeric value and set it to **0%**. Click on the **stopwatch** icon 🔘 next to Opacity.

18. Move the **Current Time Indicator** (CTI) to the **two-seconds** and **frame 20** mark **(0:00:02:20)**. Scrub through the Opacity numeric value and set it to back to **100%**.

19. Click and drag a marquee selection around all the keyframes to select them. Select **Animation > Keyframe Assistant > Easy Ease** to smooth the animation.

20. Click on the **Play/Stop** button. Save your project. Select **File > Save**. This completes this exercise. Experiment with the project.

21. When you are done, select **Composition > Add to Render Queue**.

- Click on **Lossless** next to Output Module.
- Set the Format to **QuickTime**.
- Click on **Format Options** and set the video codec to **H.264**. Click **OK**.
- Click **OK** again. Click on **Output To** and select your hard drive.
- Click the **Render** button.

Summary

This completes the chapter on logos in motion. The best logo file format to acquire from a client is either an Adobe Illustrator (AI) file or an Encapsulated Postscript (EPS) file. The exercises provided different methods in preparing and animating logos created in Photoshop and Illustrator.

This chapter also introduced you to Masks and Shape Layers. Some key technical points to remember include:

- The Rectangle and Pen Tool create both masks and shape layers.
- When a layer is selected, the tools create masks.
- With no layers selected, the tools draw a Shape Layer.
- Shape Layers contain vector graphic objects that can be scaled to any size without losing any detail or quality.
- Shape Layers render as rasterized objects.

The next chapter focuses on user interface (UI) design in motion.

5

User Interface (UI) Design in Motion

UI design is a form of communication that bridges the user with a digital product. The movement of images and text can be used to communicate complex ideas and concepts. Movement can also guide the user's eye and influence their on-screen interactions. This chapter explores how to apply motion principles in user interfaces to provide feedback and show transition from one screen to the next.

At the completion of this chapter, you will be able to:

- Discuss the components of user experience (UX) design
- Discuss the benefits of incorporating motion into UI design
- Use the Graph Editor to fine-tune temporal interpolation
- Apply animation principles to UI graphic elements
- Build a basic motion UI prototype for mobile devices

Thinking About User-centered Design

Designers must take a holistic approach to understanding the users, their tasks, and their environments. The users must be involved throughout the design and development process. A user-centered design process is iterative and incorporates the following:

- **Affordances:** These are visual clues that help users understand how to use an object. If it looks like a button, it probably is a button.
- **Mental and conceptual models:** Users predict how an object will behave based on previous experiences. A shopping cart is a common model used for online purchases.
- **UI design patterns:** Use and repeat established design standards for the placement of graphical user interface assets, user interactions and feedback.

User-centered design is a process that assists designers in creating interactive content and user interfaces that are learnable, usable, and fun.

AFFORDANCES MENTAL MODELS UI PATTERNS

Finally, any digital design needs to empathize with the user. Users are emotional. They have needs, hopes, and fears. Designers affect users through visual communication. Users often make assumptions that will cause errors and disrupt the flow of the communication. Observation leads to a genuine understanding of how to solve a design problem and ultimately build a better project.

Empathy for the user includes discovering:

- What makes the users tick?
- What confuses them?
- What do they like and hate?
- Are there latent needs not yet addressed?

What is User Experience Design?

User experience design (UX) focuses on how useful and/or enjoyable the overall final interaction was to the user. It is all about how the user feels when interacting with a system, no matter what device is used. User experience design includes several design processes to determine how efficient and pleasant the experience was for the users.

For digital design, these processes include the following:

- **Information Architecture** determines the content, its priority, and where and when it will appear in the final project.
- **User Interface Design** facilitates the communication of content and how the user processes it on any given screen.
- **Interaction Design** establishes the methods for how the user controls the content.
- **Usability Testing** determines how the performance of the interactions met the user's needs and goals.

Designing User Interfaces

As a component of user experience design, UI design defines the visual clues that help the user understand what to interact with. Color, shape, and size help the user distinguish what is clickable and what isn't. If a button does not look like a button, the user may not see it.

User experience (UX) design includes several design processes to determine how efficient and pleasant the experience was for the users.

Designing for Mobile Devices

A user physically interacts with a smartphone or tablet device by tapping on it. This is a form of **direct manipulation**. A key factor to remember is that a touch gesture does not have the same accuracy as a mouse click. You must increase the touch target sizes and spaces for images, links, and buttons to reduce user errors.

So, how big should you create your buttons and links?

- Apple recommends a touch target size of at least 44 x 44 pixels.
- Google recommends a touch target size of 48 pixels.
- Microsoft suggests 34 pixels with a minimum touch target size of 26 pixels for the UI controls.

A mouse cursor can easily point and click on smaller buttons and links. Fingers are not as accurate. Target sizes must be big enough to record the touch action.

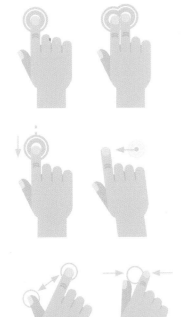

Mobile users interact with the content through some common gestures that include:

- **Tap:** The pressure of the user's finger activates a button or link.
- **Tap and Drag:** This gesture is used to push elements around on the screen. An example is to drag and move an app icon.
- **Swipe:** This gesture adds a directional movement to the tap. A swipe is typically used to access on-screen menus or move through content presented in a slideshow format.
- **Pinch:** This gesture uses two fingers to control zooming in and out of a screen.

Applying Motion to UI Design

Translating the animation principles into a static, two-dimensional digital document can help users understand what they're looking at. It can keep the user aware of their tasks at hand and where they are. Applying motion principles to your project provides many benefits, such as:

- **Guidance:** Motion provides a natural flow at a distinct pace for the user to follow
- **Focus:** Motion draws attention to objects and actions
- **Orientation:** Motion provides a sense of bearing for the user
- **Engagement:** Motion can add additional appeal and sense of delight to the content

Motion adds another dimension of realism to the elements on the screen. This provides users with the feeling of connectivity and control as they see how their actions physically change the UI and its content. By proper application, motion can indicate user control through:

- **Cause and effect:** When two events occur one right after the other, our brains interpret that the two events are related and that the first caused the second. When users click on a submit button and an online form disappears, they determine that they caused the action.
- **Feedback:** This indicates to a user that their actions triggered a response. UI elements should grow, shrink, expand, rotate, or collapse to communicate change.
- **Relationships:** Motion can depict where things are hierarchically and spatially in relation to one another. Movement can enhance the user's perception of depth.

Motion makes buttons a feel responsive and alive to the user. Keep the animation subtle. It is easy to overwhelm the user with complex animation moving all over the screen. The goal is to focus the user's attention on the screen.

CAUSE
Add Button Clicked

EFFECT
Animated Feedback

RELATIONSHIP
Added Option Clicked

- **Progression:** Motion can show the user's journey through a linear sequence. It can also depict what the system is currently doing such as with an animated loading bar, or spinning hourglass.

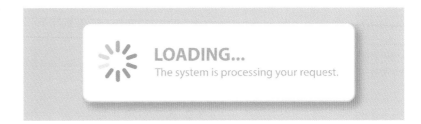

- **Transition:** This motion indicates changes in the content, location, or time. This helps orient the user to where they are and how they are moving through the content.

Just as motion can focus the user's attention, it can be disruptive to the overall user experience if misused. When adding motion to your projects, follow these best practices:

- **Less is more:** Too much animation creates visual noise and the user will lose focus on the content. Only use it to draw attention.
- **Be complimentary:** Make sure the motion serves a purpose to highlight the content, show progression, or provide feedback.
- **Don't take forever:** The user should not have to sit through a long animation. The timing required needs to effectively show a change without interfering with the system's perceived responsiveness.

Movement and Meaning

Creating transitions for interface elements is part of designing websites and mobile apps today. Applying the smallest movement can have a deep impact on the user's experience. In film, the goal in editing a scene is that you want the audience to presume that time and space has been uninterrupted. So how do you transition from one scene to the next and still preserve continuity?

- **Fade:** This is a common transition used in early filmmaking at the start and end of every sequence. A fade increases or decreases the overall value of the scene into one color. Fades indicate the passage of time or inactivity.

- **Wipe:** This transition clearly marks the change. One scene wipes across the frame and replaces the previous scene. Wipes can move in any direction and open from one side to the other.

- **Zoom:** This is an optical effect that magnifies the image. Scaling objects communicates hierarchy and provides focus for the user.

- **Clean Entrances and Exits:** If an object exits the frame, hold the empty frame for a second or two. Then show the second screen empty before the object enters the frame. By not seeing the object on screen for a second or two, the user will accept that it had time to travel to the different location in the following screen.

Transitions help preserve continuity in the content.

Chapter Exercise 1: Simulating a Swipe Gesture

So how does tapping or swiping affect the flow of content? Equally important to mobile interactivity is understanding how your reader can actually choose to read the content on a device. There are various models for delivering and navigating through digital content. The **slideshow** is a common linear navigation model that is similar to pages in a printed book. Let's start by animating a simple mock-up.

Think about how the user will navigate through the content.

SLIDESHOW

1 2 3 4

The following chapter exercise provides a step-by-step tutorial on how to animate a simple swipe gesture to move from one UI screen to the next. It also explores using the Graph Editor in After Effects to fine tune the keyframed animation. Before you begin, download the **Chapter_05. zip** file to your hard drive. It contains all the files needed for the exercise.

1. Open the **01_Slideshow_Start.aep** file inside the **01_Graph_Editor** folder in **Chapter_05**. The Project panel contains the footage needed to complete this exercise. The Illustrator file was imported with the Composition – Retain Layer Sizes option selected.

2. If the **Swipe** composition is not open, double-click on it in the Project panel. It contains the four layers from the Illustrator file.

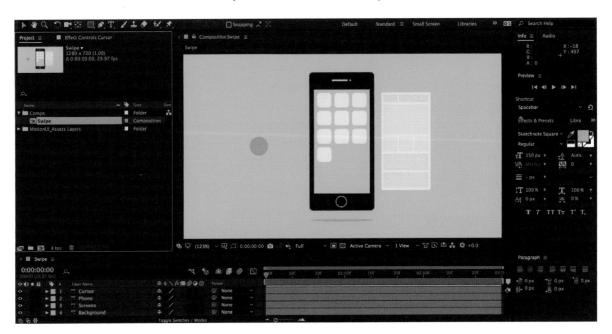

The composition matches the layer structure in the Illustrator file.

3. Move the **Current Time Indicator** (CTI) to **one second (01:00)**.

4. Go to the Timeline and select the **Screens** layer. Type **P** on the keyboard to show only the Position property.

5. Click on the **stopwatch** icon next to Position.

6. Move the **Current Time Indicator** (CTI) to the **one-second** and **frame 10** mark **(0:00:01:10)**.

7. Set the Position numeric values to **511.0, 341.5**. This will move the layer horizontally to the left to align the second screen with the phone graphic in the Comp panel.

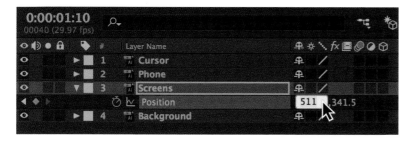

Animate the screens to show the content being swiped to the left.

8. Click on the **Play/Stop** button to see the screen animation. Save your project. Select **File > Save**.

9. Click and drag a marquee selection around both of the Position keyframes to select them. Copy them by selecting **Edit > Copy** or use the keyboard shortcut of **Command/Control + C**.

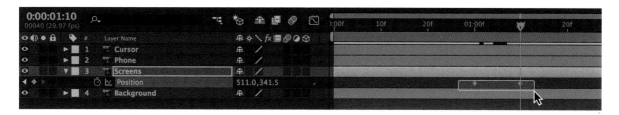

10. Let's animate the screens sliding back to their original positions. Move the **Current Time Indicator** (CTI) to **two seconds (02:00)**. This will create enough of a pause in the animation to allow the user to see and understand what is happening on screen.

Select and copy both Position keyframes.

11. Make sure the **Screens** layer is still selected. Select **Edit > Paste** or use the keyboard shortcut of **Command/Control + V**. The two copied keyframes appear starting at the two-second mark.

Paste both keyframes. To reverse the animation select **Animation > Keyframe Assistant > Time-Reverse Keyframes**.

12. Make sure both pasted keyframes are still selected. Select **Animation > Keyframe Assistant > Time-Reverse Keyframes** to reverse the animation.

13. Click on the **Play/Stop** button to see the layer move to the left, pause, and then animate back to its original position. Save your project. Select **File > Save**.

Use the Graph Editor to Control Acceleration

As discussed in Chapter 2, After Effects interpolates both space (spatial) and time (temporal) using keyframes. Spatial interpolation is viewed in the Comp panel as a motion path for a layer's position. There is also interpolation happening between the keyframes in the Timeline.

Spatial interpolation is visually represented by a motion path. The path shows where the layer is positioned in composition's space during an animation.

Motion Path

Temporal interpolation refers to the change in value between keyframes with regards to time. The default temporal interpolation is Linear where the value changes at a constant rate. The Keyframe Assistants apply easing to the interpolation to create smooth, realistic motion.

You can view and edit the temporal interpolation through the **Graph Editor** in After Effects. This visually displays the change in value between keyframes in the form of a graph. You can select keyframes and adjust their Bezier handles to affect the rate of change or speed.

1. Select the **Position** property for the **Screens** layer. This highlights all of its keyframes in the Timeline.

Turn on the Graph Editor. It shows the current Linear interpolation as a series of straight lines indicating motion set to a constant rate of change.

2. With the layer selected, click on the **Graph Editor** icon along the top of the Timeline. The colored bars are replaced with a graph showing the change in position over time as a linear interpolation.

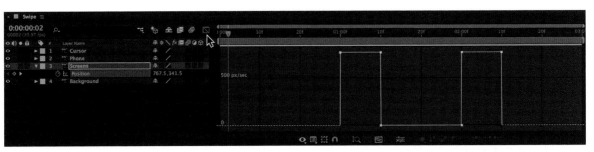

3. You can view the graph in a couple of modes. Click on the **Graph Type and Options** button ▣ at the bottom of the Graph Editor and select **Edit Speed Graph** from the pop-up menu.

The Speed Graph displays the animation as a series of flat lines. This indicates that the motion is maintaining a constant speed between keyframes.

4. Select the **Position** property again for the **Screens** layer. This highlights all of its keyframes in the Graph Editor. They are the yellow squares.

5. Click on the **Easy Ease** button 🔣 at the bottom of the Graph Editor. The flat lines change to form two sine waves that bend upward from the first keyframe and then bend back down to the second keyframe.

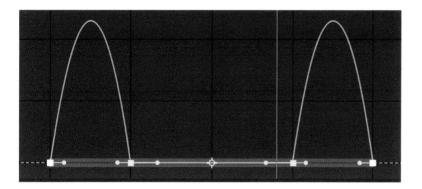

Easy Ease gradually changes the motion and is reflected by the changing slope of the line's path in the Graph Editor. Using data from the graph, you can calculate and control any **acceleration**, the change in speed and the change in time.

6. Click anywhere in the empty graph area to deselect all the keyframes.

7. Click on the first keyframe to display the Bezier handles. Drag the first handle to the right. As you drag a pop-up panel appears indicating the amount of influence being applied. Drag the handle to the right until the Influence value is at **100%**. Release the mouse.

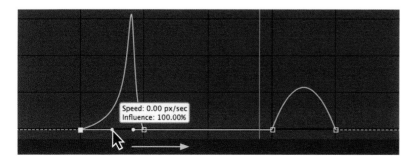

Change the line's slope by clicking and dragging the Bezier handles. The influence value defines how abrupt the speed changes – the steeper the slope, the faster the motion.

8. Click on the last keyframe. Drag its handle to the left until the Influence value is at **100%**. Release the mouse.

Adjust the Bezier curve to control the speed of the animation. This adjustment creates a faster start to the movement and then gradually slows it down as the CTI approaches the second keyframe. This motion is referred to as **deceleration**. It is a form of acceleration where the speed of the object is decreasing with time.

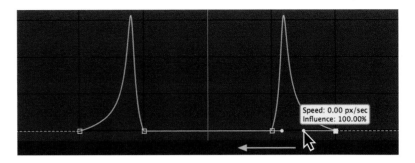

9. Click on the **Graph Editor** icon to hide the graph and bring back the colored bars in the Timeline.

10. Click on the **Play/Stop** button to see changes to the temporal (time) interpolation. The movement has a quicker, snappier feel to it. This type of motion works well in communicating the responsiveness of the interface to the user. Save your project. Select **File > Save**.

Animation helps users recognize when something changes in the mobile app, for example they swipe a screen and new information appears. The Graph Editor allows you to apply the animation principles of slow-in and slow-out to gradually change the speed of an object over time.

Animate the Cursor

Motion UI provides a better understanding of how the user interface design will work. This is referred to as a **prototype**. It represents what the final product will look like and simulates human interaction. Often a circular shape is used as a virtual "cursor" that represents a user's finger tapping on or swiping the mobile screen. A cursor graphic has been provided in this exercise. Let's animate it.

1. Move the **Current Time Indicator** (CTI) to **frame 15 (0:00:00:15)**.

2. Select the **Cursor** layer in the Timeline.

- Type **S** on the keyboard to open the Scale property.

- Type **Shift + T** on the keyboard to open the Opacity property.

- Scrub through the Scale and Opacity values and set them to **0%**.

- Click on the **stopwatch** icons next to Scale and Opacity.

3. Move the **Current Time Indicator** (CTI) to **frame 20 (0:00:00:20)**.

4. Scrub through the Scale numeric value and set it to **120%**. This will create an overshoot in the animation to create a dramatic entrance for the cursor.

5. Scrub through the Opacity numeric value and set it back to **100%**.

6. Move the **Current Time Indicator** (CTI) to **frame 25 (0:00:00:25)**.

7. Scrub through the Scale numeric value and set it to **100%**.

8. Click and drag a marquee selection around all Scale and Opacity keyframes to select them. Select **Animation > Keyframe Assistant > Easy Ease** to smooth the animation.

Transform Properties: Keyboard Shortcuts

A for Anchor Point

P for Position

S for Scale

R for Rotation

T for Opacity

U for all properties with keyframes

9. Move the **Current Time Indicator** (CTI) to **one second (01:00)**.

10. Type **Shift + P** on the keyboard to open the Position property.

- Set the Position numeric values to **640.0, 320.0**.

- Click on the **stopwatch** icon next to Position.

Change the cursor's scale and opacity to introduce it to the user.

11. Click and drag a marquee selection around both of the Opacity keyframes to select them. Copy them by selecting **Edit > Copy** or use the keyboard shortcut of **Command/Control + C**.

12. Move the **Current Time Indicator** (CTI) to the **one-second** and **frame 5** mark **(0:00:01:05)**.

13. Make sure the **Cursor** layer is still selected. Select **Edit > Paste** or use the keyboard shortcut of **Command/Control + V**.

14. Make sure both pasted keyframes are still selected. Select **Animation > Keyframe Assistant > Time-Reverse Keyframes** to reverse the animation. This will fade out the layer.

15. Move the **Current Time Indicator** (CTI) to the **one-second** and **frame 10** mark (**0:00:01:10**).

16. Set the Position numeric values to **450.0, 320.0**. This will move the layer horizontally to the left to simulate a swipe gesture.

17. Click and drag a marquee selection around the two Position keyframes to select them. Select **Animation > Keyframe Assistant > Easy Ease** to smooth the animation.

18. With the layer selected, click on the **Graph Editor** icon [icon] along the top of the Timeline.

19. Click on the first Position keyframe. Drag its Bezier handle to the right until the Influence value is at **100%**. Release the mouse.

20. Click on the **Play/Stop** button to see changes to the temporal (time) interpolation. Finish up the project by animating the cursor swiping to the right for the second screen movement. To see a completed version, open the **01_Slideshow_Done.aep** file inside the **01_Graph_Editor** folder in **Chapter_05**. Save your project. Select **File > Save**.

The completed project demonstrates a simple motion UI prototype for swiping a linear navigational slideshow.

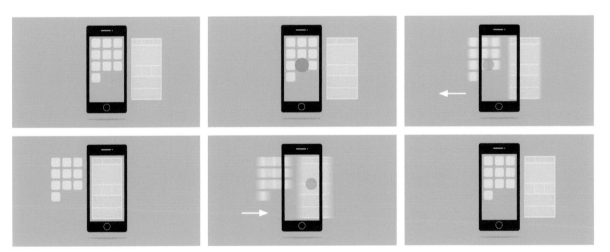

This completes the exercise. Let's review. A considerable amount of information about the motion can be obtained by examining the slope in the Graph Editor. You can view and control any acceleration. The height of the position curve increases to illustrate the acceleration in movement. As the layer's speed decelerates, the position curve drops. A flat line indicates no movement or change in position.

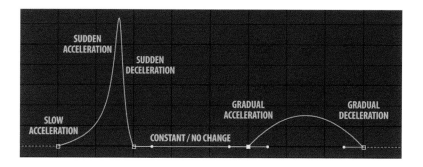

A horizontal line on a speed graph represents a constant speed. A sloping line represents an acceleration. The steeper the slope of the line the greater the acceleration. If the line slopes downwards from left to right, this means that the object is slowing down.

Chapter Exercise 2: Animating a Button

Motion performs various functions in an interface: it can guide the user through a process, improve orientation and provide feedback on interactions. That is the focus of this next exercise. It provides a step-by-step tutorial on how to animate a button to reinforce an interaction. When adding motion to UI elements, make sure that the movement supplements the interaction with small details to improve its usability, as well as being fun and offering emotional appeal.

All animations used in any interface design must be based on the animation principles discussed in Chapter 1. The previous exercise focused on the principles of slow-in and slow-out. This next exercise applies follow-through and overlapping animation to the button movement. Let's get started.

Overlapping action observes that parts of an object do not move at the same time. Follow-through shows parts of an object bounce or wiggle at the end of its motion, as if attached to a spring.

1. Open the **02_Button_Start.aep** file inside the **02_Button_Animation** folder in **Chapter_05**. The Project panel contains the footage needed to complete this exercise. The Illustrator file was imported with the Composition – Retain Layer Sizes option selected.

2. If the **Button** composition is not open, double-click on it in the Project panel. It contains the five layers from the Illustrator file.

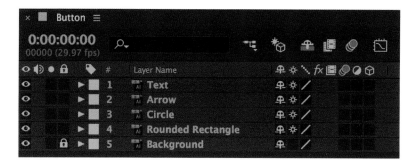

The composition matches the layer structure in the Illustrator file.

Notice that the size of the composition is not formatted in a typical 4:3 or 16:9 aspect ratio. Its dimensions are set to that of a mobile phone. In addition to film and video presets, both Adobe Illustrator and Photoshop provide presets for mobile devices. The Illustrator file used for this exercise is set for an iPhone 6 (750 x 1334 px).

Adobe Illustrator and Photoshop provide mobile presets for UI design projects. Examples of common screen sizes include:

320 x 480 = iPhone 3G
480 x 800 = Android (Medium)
560 x 960 = Android (Large)
640 x 960 = iPhone 4
640 x 1136 = iPhone 5
750 × 1334 = iPhone 6
1242 × 2208 = iPhone 6 Plus

3. Go to the Timeline and turn off the visibility for the **Text** and the **Rounded Rectangle** layers. Click on the **Video** switch (**eyeball icon**) to hide the layers.

Turn off the visibility of the layers.

4. Go to the Timeline and select the **Circle** layer. Type **S** on the keyboard to open the Scale property.

• Scrub through the Scale numeric value and set it to **0%**.

• Click on the **stopwatch** icon next to Scale.

5. Move the **Current Time Indicator** (CTI) to **frame 10 (0:00:00:10)**.

6. Scrub through the Scale numeric value and set it to **120%**.

7. Move the **Current Time Indicator** (CTI) to **frame 20 (0:00:00:20)**.

8. Scrub through the Scale numeric value and set it to **100%**.

9. Apply an Easy Ease to all the Scale keyframes to smooth the animation.

10. Press the **Home** key on the keyboard. This moves the **Current Time Indicator** (CTI) to the beginning of the composition (**00:00**).

11. Click and drag a marquee selection around the three Scale keyframes to select them. Copy them by selecting **Edit > Copy** or use the keyboard shortcut of **Command/Control + C**.

12. Select the **Arrow** layer. Type **S** on the keyboard to open the Scale property. Click on the **stopwatch** icon ⏱ next to Scale.

13. Make sure the **Arrow** layer is still selected. Select **Edit > Paste** or use the keyboard shortcut of **Command/Control + V**. The copied keyframes appear starting at the beginning of the composition.

Copy and paste the Scale keyframes so that both layers scale the same way.

14. Make sure the **Arrow** layer is still selected. Type **Shift + R** on the keyboard to open the Rotation property.

- Set the Rotation property to **0x-180.0°**.
- Click on the **stopwatch** icon ⏱ next to Rotation.

15. You are going to create the follow-through action where the arrow wiggles at the end of its main movement. This involves setting several keyframes over a short span of time.

- Move the **Current Time Indicator** (CTI) to **frame 15 (0:00:00:15)**.
- Set the Rotation property to **0x+10.0°**.
- Move the **Current Time Indicator** (CTI) to **frame 20 (0:00:00:20)**.
- Set the Rotation property to **0x-10.0°**.
- Move the **Current Time Indicator** (CTI) to **frame 25 (0:00:00:25)**.
- Set the Rotation property to **0x+5.0°**.
- Move the **Current Time Indicator** (CTI) to **one second (0:00:01:00)**.
- Set the Rotation property to **0x-5.0°**.
- Move the **Current Time Indicator** (CTI) to the **one-second** and **frame 5** mark (**0:00:01:05**).
- Set the Rotation property to **0x+0.0°**.

As you learned, follow-through and overlapping action is the offset in time until all parts of an object come to a standstill.

16. Apply an Easy Ease to all the Rotation keyframes to smooth the animation.

17. Click on the **Play/Stop** button to see button animation and follow-through action. Save your project. Select **File > Save**.

Create a Shape Layer from a Vector Layer

1. The next part of this exercise will focus on the remaining parts of the button. Turn on the visibility for the **Text** and the **Rounded Rectangle** layers. Click on the **Video** switch (**eyeball icon**) to show the layers.

2. Press the **Home** key on the keyboard. This moves the **Current Time Indicator** (CTI) to the beginning of the composition (**00:00**).

3. Select the **Rounded Rectangle** layer. Rather than scaling the layer, let's alter the points that define the vector shape. Unfortunately, you cannot get to the individual points directly using the imported Illustrator art. You need to create a Shape Layer out of it.

4. Select **Layer > Create Shapes from Vector Layer**. A new Shape Layer appears above the **Rounded Rectangle** layer.

<div style="float:left; width:30%;">
Create a Shape Layer from the imported vector art. The new layer will match the size, shape, and color of the imported vector art.
</div>

⦿		▶ ■	1	Text	♙ ✳ ╱
⦿		▶ ■	2	Arrow	♙ ✳ ╱
⦿		▶ ■	3	Circle	♙ ✳ ╱
⦿		▶ ■	4	★ **Rounded Rectangle Outlines**	♙ ✳ ╱
		▶ ■	5	Rounded Rectangle	♙ ✳ ╱
⦿	🔒	▶ ■	6	Background	♙ ╱

5. Move the **Current Time Indicator** (CTI) to **one second (01:00)**.

6. Select the **Rounded Rectangle Outlines** Shape Layer. Twirl open its **Contents** to reveal the **Path 1** property located in **Group 1**. Click on the **stopwatch** icon 🕐 next to Path.

<div style="float:left; width:30%;">
Set a keyframe for the Shape Layer's path. The Path property will allow you to select the individual points that define the shape.
</div>

7. Move the **Current Time Indicator** (CTI) back to **frame 10 (0:00:00:10)**.

8. Go to the Comp panel. Click and drag a marquee around the three points on the right end of the button to select them.

Select the points in the Comp panel.

9. With the points selected, click and drag them to the left. Hold down the **Shift** key while dragging to constrain the movement horizontally. Align the selected points to the right side of the circle.

Drag the selected points to the left to align with the circle graphic.

10. Apply and Easy Ease to all the Path keyframes to smooth the animation. As you can see, Shape Layers offer a great alternative to manipulating vector art in After Effects.

Animate the Button Name

1. Move the **Current Time Indicator** (CTI) to **frame 20 (0:00:00:20)**.

2. Go to the Timeline and select the **Text** layer. Type **P** on the keyboard to open the Position property.

3. Currently, the word "DOWNLOAD" is in its final position. Click on the **stopwatch** icon 🕰 next to Position.

4. Move the **Current Time Indicator** (CTI) back to **frame 10 (0:00:00:10)**.

5. Set the Position numeric values to **356.0, 1210.0**. This will move the word down and outside of the button shape.

6. Click and drag a marquee selection around both of the Position keyframes to select them. Select **Animation > Keyframe Assistant > Easy Ease** to smooth the animation.

7. Let's use a track matte to reveal the word. Click and drag the **Rounded Rectangle** layer. Reposition it above the **Text** layer.

8. Select the **Text** layer.

Animate the **Text** layer.

9. Click on the **Toggle Switches / Modes** button at the bottom of the Timeline panel.

10. Define the transparency for the track matte by choosing the **Alpha Matte "Rounded Rectangle"** option from the Track Matte menu for the **Text** layer.

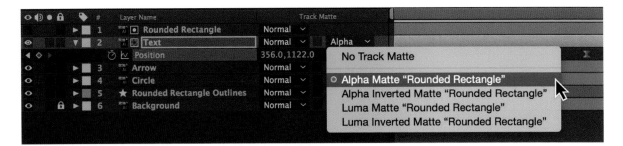

The track matte layer must be above the layer it is revealing. The end result reveals the button name as the button shape scales horizontally.

11. Click on the **Play/Stop** button to see the track matte in action. The Alpha Matte reveals the text as the button's shape scales horizontally. Save your project. Select **File > Save**.

Use the Graph Editor to Refine the Animation

1. The project is almost done, but it still needs some refinement with each layer's timing. Make sure the **Text** layer is still selected in the Timeline. You will use the Graph Editor to alter its speed.

2. With the layer selected, click on the **Graph Editor** icon along the top of the Timeline.

3. Click on the **Position** property name to display its speed graph.

4. Click on the first Position keyframe. Drag its Bezier handle to the right until the Influence value is at **100%**. Release the mouse.

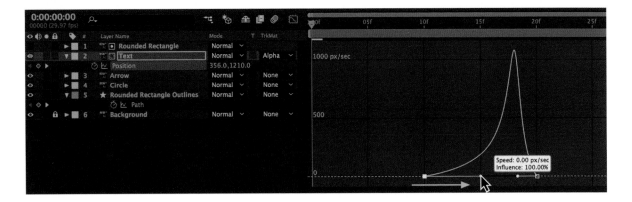

5. Select the **Rounded Rectangle Outlines** Shape Layer. Type **U** on the keyboard to reveal its keyframed properties.

6. Click on the **Path** property name to display its speed graph.

7. Click on the second Path keyframe. Drag its Bezier handle to the left until the Influence value is at **100%**. Release the mouse.

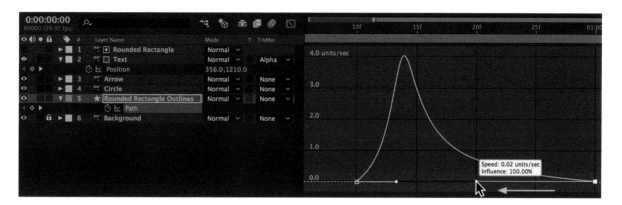

8. Select the **Circle** layer. Type **U** on the keyboard to reveal its keyframed properties.

Adjust the timing of the Shape Layer's path animation.

9. Click on the **Scale** property name to display its speed graph.

10. Click on the first Scale keyframe. Drag its Bezier handle to the right until the Influence value is at **100%**. Release the mouse.

11. Click on the **Graph Editor** icon to hide the graph and bring back the colored bars in the Timeline.

Adjust the timing of the scale animation.

12. Move the **Current Time Indicator** (CTI) to **frame 10 (0:00:00:10)**.

13. Select the **Rounded Rectangle Outlines** Shape Layer. Press **Option/ Alt + [** on the keyboard to trim the layer's Set in Point.

Trim the Shape Layer's Set Out Point.

The final button animation combines Shape Layers with Illustrator vector art. It also uses follow-through and overlapping actions to reinforce the functionality of the button and add some fun and appeal. This button type is referred to as a **call-to-action** as it solicits an action from the user.

14. Finish up the project by animating the button closing up starting at the two-second mark. Experiment with the Graph Editor to alter the timing between the keyframes. To see a completed version, open the **02_Button_Done.aep** file inside the **02_Button_Animation** folder in **Chapter_05**. Save your project. Select **File > Save**.

Chapter Exercise 3:
Using Anticipation in Motion UI Design

In motion UI design, content panels can shrink or expand prior to their main action of revealing or hiding information. This next chapter exercise provides a step-by-step tutorial on how to animate a menu panel created in Adobe Illustrator. To see what you will build, locate and play the **Anticipation_Menu.mov** in the **Completed** folder inside **Chapter_05**. The animated prototype is for a fictitious weather app. It also uses the anticipation animation principle to provide a clue to the main movement that follows.

Anticipation provides a clue to the movement that follows, and without it the movement can appear unexpected and even jarring to the user. It is a subtle contrary movement just before the main move, such as a small backwards motion occurring before an object moves forward.

Before you begin, let's discuss the basic workflow in designing a UI prototype. It follows a similar iterative process as a motion design project. Sketches are drawn first to get a sense of the content hierarchy and button placement. **Wireframes** organize the sketches through the use of structural grids and simple graphics to represent interactive controls. A wireframe is a **low-fidelity** representation of the design. It groups the content and visualizes the basic structure of the interface.

Low-fidelity sketches and wireframes typically consist of boxes that represent buttons and other UI controls. Typefaces, images, color, and texture are not represented at this preproduction stage.

A **prototype** takes the wireframes to the next level and introduces the content, images, color, texture, functionality and motion. In contrast to wireframes, prototypes are **high-fidelity** representations that are used for formal user testing and evaluations. Motion designers often receive the UI assets from clients in the form of a high-fidelity **mockup** created in either Adobe Illustrator or Photoshop. For this exercise, a layered Illustrator file was created. Artboards were used to show what the panels look like in their normal, closed state and expanded state.

Mockups are computer-based files that visualize the content and demonstrate the basic functionality and user feedback in a static format. Motion designers use these files to build the motion UI prototype.

1. Open the **03_Anticipation_Menu_Start.aep** file inside the **03_Menu** folder in **Chapter_05**. The Project panel contains the footage needed to complete this exercise. The Illustrator file was imported with the Composition – Retain Layer Sizes option selected.

2. If the **Pre-comp: Menu_Assets** composition is not open, double-click on it in the Project panel. It contains the five vector layers.

The composition matches the layer structure in the Illustrator file.

3. Move the **Current Time Indicator** (CTI) to **one second (01:00)**.

4. Select the **Sunday - Monday** layer.

5. Type **P** on the keyboard to open the Position property. Click on the **stopwatch** icon next to Position.

6. Move the **Current Time Indicator** (CTI) to the **one-second** and **frame 5** mark (**0:00:01:05**).

7. Set the Position numeric values to **375.0, 350.0**. This will move the layer down slightly creating the visual clue (anticipation) for the main movement of the panel expanding.

8. Move the **Current Time Indicator** (CTI) to the **one-second** and **frame 20** mark (**0:00:01:20**).

9. Set the Position numeric values to **375.0, 200.0**.

10. Click and drag a marquee selection around all of the Position keyframes to select them. Select **Animation > Keyframe Assistant > Easy Ease** to smooth the animation.

Import the background animation and add it as a layer in the Timeline panel.

11. Click on the **Play/Stop** button to see the animation in action. Save your project. Select **File > Save**.

12. Let's do a similar animation for the second layer. Move the **Current Time Indicator** (CTI) to **one second** (**01:00**).

13. Select the **Wednesday - Thursday** layer. Type **P** on the keyboard to open the Position property. Click on the **stopwatch** icon next to Position to start recording keyframes.

14. Move the **Current Time Indicator** (CTI) to the **one-second** and **frame 5** mark (**0:00:01:05**).

15. Set the Position numeric values to **375.0, 1150.0**. This will move the layer up slightly creating the visual clue (anticipation) for the main movement of the panel expanding.

16. Move the **Current Time Indicator** (CTI) to the **one-second** and **frame 20** mark (**0:00:01:20**).

17. Set the Position numeric values to **375.0, 1300.0**.

18. Apply an Easy Ease to all the new Position keyframes.

Create a keyframe animation for the first part of the panel expanding. The second keyframe creates the anticipation by moving the layer slightly in the opposite direction before the main movement.

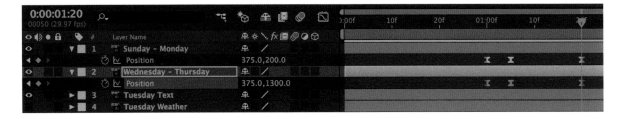

Animate the Panel's Content

Create a keyframe animation for the second part of the panel expanding.

1. Move the **Current Time Indicator** (CTI) to **one second** and **5 frame** mark (**0:00:01:05**).

2. Select the **Tuesday Text** layer. Type **P** on the keyboard to open the Position property. Click on the **stopwatch icon** next to Position.

3. Move the **Current Time Indicator** (CTI) to the **one-second** and **frame 20** mark (**0:00:01:20**).

4. Set the Position numeric values to **299.5, 600.0**.

5. Turn on the visibility for the **Tuesday Weather** layer. Click on the **Video** switch (**eyeball icon**) to show the layer.

6. Move the **Current Time Indicator** (CTI) to the **one second** and **5 frame** mark (**0:00:01:05**).

7. Select the **Tuesday Weather** layer.

- Type **P** on the keyboard to open the Position property.

- Type **Shift + T** on the keyboard to open the Opacity property.

- Scrub through the Opacity value and set it to **0%**.

- Click on the **stopwatch** icons next to Position and Opacity.

8. Move the **Current Time Indicator** (CTI) to the **one-second** and **20-frame** mark (**0:00:01:20**).

- Set the Position numeric values to **453.5, 800.0**.

Create a keyframe animation to move the panel's content into position.

- Scrub through the Opacity value and set it to **100%**.

- Apply an Easy Ease to both the Position and Opacity keyframes.

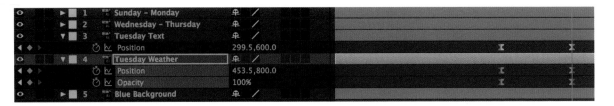

9. Click on the **Play/Stop** button to see the animation in action.

Use the Graph Editor to Refine the Animation

1. Select the **Sunday - Monday** layer in the Timeline. Type **U** on the keyboard to reveal its keyframed properties.

2. With the layer selected, click on the **Graph Editor** icon 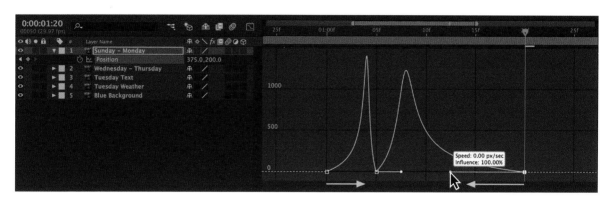 along the top of the Timeline.

3. Click on the **Position** property name to display its speed graph.

4. Click on the first Position keyframe. Drag its Bezier handle to the right until the Influence value is at **100%**. Release the mouse.

5. Click on the last Position keyframe. Drag its Bezier handle to the left until the Influence value is at **100%**. Release the mouse.

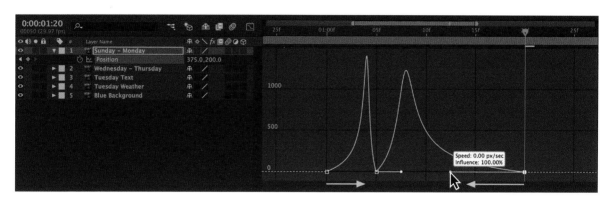

6. Select the **Wednesday - Thursday** layer. Type **U** on the keyboard to reveal its keyframed properties.

Adjust the timing of the animation.

7. Click on the **Position** property name to display its speed graph.

8. Repeat the same changes as you did with the previous layer.

- Click on the first Position keyframe. Drag its Bezier handle to the right until the Influence value is at **100%**. Release the mouse.

- Click on the last Position keyframe. Drag its Bezier handle to the left until the Influence value is at **100%**. Release the mouse.

9. Select the **Tuesday Text** layer in the Timeline. Click on the **Position** property name to display its speed graph.

10. Click on the first Position keyframe. Drag its Bezier handle to the left until the Influence value is at **100%**. Release the mouse.

11. Select the **Tuesday Weather** layer in the Timeline. Click on the **Position** property name to display its speed graph.

12. Click on the first Position keyframe. Drag its Bezier handle to the left until the Influence value is at **100%**. Release the mouse.

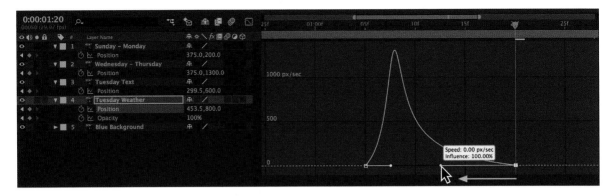

Adjust the timing for both the text and weather content. Drag the second keyframe to the left to alter its speed.

13. Click on the **Graph Editor** icon 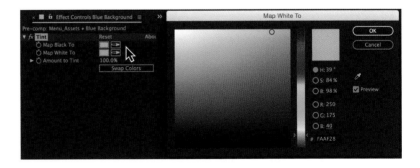 to hide the graph and bring back the colored bars in the Timeline.

14. Click on the **Play/Stop** button to see the animation in action. The project is almost done. The next step is to change the panel's color to show feedback to the user. Save your project. Select **File > Save**.

Change the Color of the Panel

1. Select the **Blue Background** layer in the Timeline.

2. Select **Effect > Color Correction > Tint.**

3. Go to the Effect Controls panel and click on the **Map Black To** color swatch. Change the RGB color to **R: 250**, **G: 175**, **B: 40**. Click **OK**.

4. Click on the **Map White To** color swatch. Change the RGB color to **R: 250**, **G: 175**, **B: 40**. Click **OK**.

The Tint effect replaces the pixel color values with a value you specify. If the Effect Controls panel is not visible, select **Effect > Effect Controls**.

5. Move the **Current Time Indicator** (CTI) to the **one-second** and **5-frame** mark (**0:00:01:05**).

6. Change the Amount to Tint value to **0%**. Click on its **stopwatch** icon.

7. Move the **Current Time Indicator** (CTI) to the **one-second** and **frame 20** mark (**0:00:01:20**).

8. Change the Amount to Tint value to **100%**.

9. Click on the **Play/Stop** button to see the animation in action. The anticipation sets the user up for the main action of the panel expanding. The Graph Editor changes make the movement for dynamic. Save your project. Select **File > Save**.

Final motion UI animation.

Animate the Cursor

Let's create a virtual "cursor" that represents a user's finger tapping on the menu items. The cursor graphic will be created using a Shape Layer. Before you do that, first create a new composition to hold this animation.

1. Select **Composition > New Composition**. Make the following settings in the dialog box that appears:

- Composition Name: **Pre-comp_CursorAnimation**
- Width: **750**
- Height: **1334**
- Pixel Aspect Ratio: **Square Pixels**
- Frame Rate: **29.97**
- Duration: **0:00:03:00** (3 seconds)
- Click **OK**.

2. Click and drag the **Pre-comp: Menu_Assets** comp from the Project panel to the Timeline. You have just nested the composition.

Nest the menu animation composition inside the new composition.

Create a Shape Layer to act as a cursor.

3. Deselect the layer in the Timeline. Click in the gray area below the layer, or use the keyboard shortcut of **Command/Control + Shift + A**.

4. Press and hold on the **Rectangle** Tool to open the pop-up menu. Select the **Ellipse** Tool from the pop-up menu. Make sure no layers are selected in the Timeline.

5. Go to the Comp panel. Hold down the **Shift** key and draw a circle at the bottom-left corner of the interface.

• Set the Shape Layer's Fill color to white.

• Set the Shape Layer's Stroke mode to None.

6. Go to the Timeline. Rename **Shape Layer 1** by selecting it and pressing the **Return/Enter** key on the keyboard. Rename the layer **Cursor**.

7. Twirl open the contents for **Ellipse 1** and the **Ellipse Path 1** property. Scrub through the Size numeric value and set it to **150.0**.

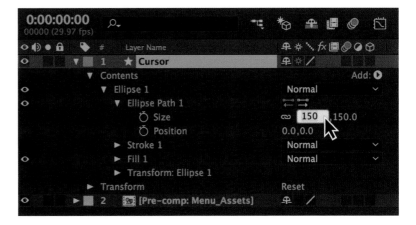

8. Select the **Cursor** layer. Hold down the **Command/Control** key and double-click on the **Pan Behind** (Anchor Point) Tool in the Tools panel. This is a shortcut that moves the Anchor Point to the center of the Shape Layer.

9. Click on the **Selection** (Arrow) Tool in the Tools panel.

10. Make sure the **Cursor** layer is still selected. Type **P** on the keyboard to open the Position property.

- Set the Position numeric values to **106.0, 1450.0**.

- Click on the **stopwatch** icon 🎬 next to Position to start recording keyframes at the beginning of the Composition (**00:00**).

11. Move the **Current Time Indicator** (CTI) to **frame 20 (0:00:00:20)**.

12. Set the Position numeric values to **106.0, 675.0**.

13. Click and drag a marquee selection around the Position keyframes to select them. Select **Animation > Keyframe Assistant > Easy Ease** to smooth the animation.

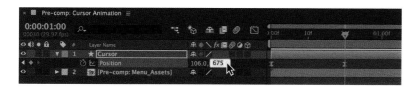

14. Press the **Home** key on the keyboard. This moves the **Current Time Indicator** (CTI) to the beginning of the composition (**00:00**).

Animate the cursor's position to move it up to the expanded panel.

15. Type **Shift + T** on the keyboard to open the Opacity property.

- Scrub through the Scale and Opacity values and set them to **0%**.

- Click on the **stopwatch** icon 🎬 next to Opacity.

16. Move the **Current Time Indicator** (CTI) to **frame 20 (0:00:00:20)**.

17. Scrub through the Opacity numeric value and set it to **100%**.

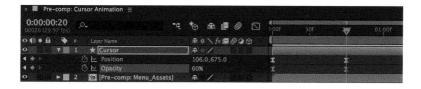

Keyframe the layer's opacity property to fade it in as it moves up the interface.

18. Move the **Current Time Indicator** (CTI) to **frame 25 (0:00:00:25)**. Use the Scale transform property to simulate tapping on the screen.

19. Type **Shift + S** on the keyboard to open the Scale property. Click on the **stopwatch** icon ⏱ next to Scale.

20. Move the **Current Time Indicator** (CTI) to **one second (01:00)**.

21. Scrub through the Scale numeric value and set it to **80.0**.

22. Move the **Current Time Indicator** (CTI) to the **one-second** and **frame 10** mark (**0:00:01:10**).

- Scrub through the Scale numeric value and set it to **130.0**.

- Scrub through the Opacity value and set it to **0%**.

- Apply an Easy Ease to the Scale keyframes.

Keyframe the layer's scale property to simulate the user tapping on the screen.

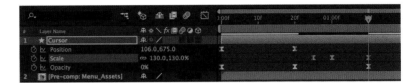

23. Click on the **Play/Stop** button to see the cursor animation in action. Save your project. Select **File > Save**.

Frame the Motion UI Prototype

To really showcase the motion UI prototype, let's place the animation inside an image of a mobile phone. This is a great way to finish the project and show a client what the end product will look like. There are many ways to do this. For this exercise, you will use a static Photoshop image of a mobile phone. The screen area on the phone has been removed, leaving a transparent area to frame the motion UI prototype.

The screen on the mobile phone was removed leaving a transparent area to frame the motion UI prototype.

Transparency ⟶

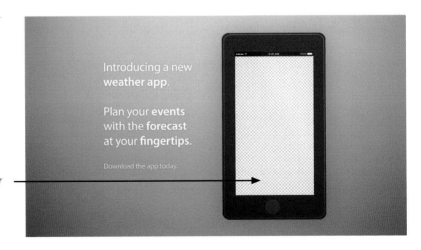

1. Go to the Project panel and double-click in the empty gray area. This is a shortcut that opens the import dialog box.

2. From within the Import File dialog box, locate the **Footage** folder. From within the **Footage** folder, select the **Phone_Frame.psd** file.

3. Choose **Import As > Composition**. Click **Open**.

4. In the **Phone_Frame.psd** dialog box that appears, click **OK**.

5. In the Project panel, move the new composition into the **Comps** folder. Rename the composition by selecting it and pressing the **Return/Enter** key on the keyboard. Rename the layer **Main Comp: Anticipation Menu**.

6. Double-click on the **Main Comp: Anticipation Menu** composition to open its Timeline and Comp panels.

7. Click and drag the **Pre-comp_CursorAnimation** composition from the Project panel to the Timeline. Position it under the **Phone_Frame** layer. You have just nested another composition.

Import a Photoshop file as a composition.

Add the motion UI prototype layer.

8. Select the **Pre-comp_CursorAnimation** layer. Type **S** on the keyboard to open the Scale property. Scrub through the Scale numeric value and set it to **53.0**.

9. Go to the Comp panel and reposition the composition to fit inside the screen on the mobile phone.

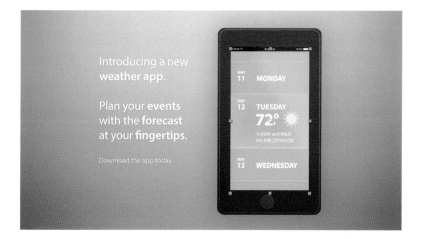

Reposition the motion UI prototype layer to fit inside the screen on the phone.

10. Click on the **Play/Stop** button. This completes this exercise. Experiment with the project.

11. When you are done, select **Composition > Add to Render Queue**.

- Click on **Lossless** next to Output Module.

- Set the Format to **QuickTime**.

- Click on **Format Options** and set the video codec to **H.264**. Click **OK**.

- Click **OK** again. Click on **Output To** and select your hard drive.

- Click the **Render** button.

12. Save your project file. Select **File > Save**.

Chapter Exercise 4: Replacing a UI Screen Using Corner Pins

The previous exercise showed you how to frame your motion UI prototype inside an image of a mobile phone. That technique was pretty straightforward since the image contained no perspective. What happens if the image was at captured at an angle? The **Corner Pin** effect can help in these situations.

The effect distorts an image by repositioning each of its four corners. It is often used to stretch or skew an image to simulate perspective. The Corner Pin effect works with static images and digital video footage. You can use it to attach a layer to a moving rectangular region tracked by a motion tracker in After Effects. We will explore that concept in a later chapter. For this exercise, you will apply and move the corner pins in the Comp panel to replace a static screen with a motion UI prototype.

The Corner Pin stretches, shrinks, skews, or twists an image to simulate perspective.

To see what you will build, locate and play the **Slideout_Menu.mov** in the **Completed** folder inside **Chapter_05**. The animated prototype is for a fictitious design studio. Let's deconstruct the motion design project.

The final motion design project is for a fictitious design studio.

The motion UI prototype was created using a layered Photoshop file. Each menu item was created on a separate layer. The image size was set to 750 x 1334 pixels (iPhone 6). The content was designed in a separate file to allow for the image to simulate a **scroll**. This navigational model delivers the content vertically in one continuous linear structure.

SCROLL

The vertical scroll model is commonly used for most HTML web pages.

1. Open the **04_Slideout_Menu_Start.aep** file inside the **04_Corner_Pin** folder in **Chapter_05**. The Project panel contains the footage needed to complete this exercise. The Photoshop file was imported with the Composition - Retain Layer Sizes option selected.

2. If the **Precomp: UI_SlideoutMenu** composition is not open, double-click on it in the Project panel. The raster layers have already been animated. A Shape Layer was created as a cursor to simulate the user tapping on the screen. Select each layer and press the **U** key on the keyboard to see how the keyframes were created.

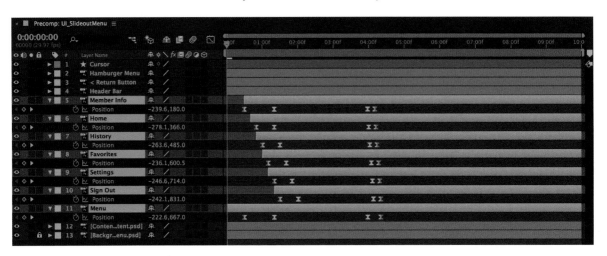

Each menu item layer was offset by five frames to create the cascading animated effect. The Graph Editor was used to alter the timing between the keyframes.

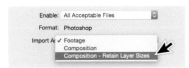

3. Go to the Project panel and double-click in the empty gray area. This is a shortcut that opens the import dialog box.

4. From within the Import File dialog box, locate the **Footage** folder. From within the **Footage** folder, select the **DigitalStudio_Ad.psd** file.

5. Choose **Import As > Composition - Retain Layer Sizes**. Click **Open**.

6. In the **DigitalStudio_Ad.psd** dialog box that appears, click **OK**.

7. In the Project panel, move the new composition into the **Comps** folder. Rename the composition by selecting it and pressing the **Return/Enter** key on the keyboard. Rename the layer **Main Comp: DigitalStudio_Ad**.

8. Double-click on the **Main Comp: Anticipation Menu** composition to open its Timeline and Comp panels.

9. Click and drag the **Precomp: UI_SlideoutMenu** composition from the Project panel to the Timeline. Position it under the **Expertise Text** layer. You have just nested another composition.

Add the motion UI prototype layer.

10. Type **S** on the keyboard to open the Scale property. Scrub through the Scale numeric value and set it to **75.0**.

11. Select **Effect > Distort > Corner Pin**. The effect is added to the layer and the Effect Controls panel opens with four properties: Upper Left, Lower Left, Upper Right, Lower Right.

12. Go to the Comp panel. Notice that each of the four corners has a corner pin. Click and drag each corner pin to align with the corresponding corners of the mobile screen in the image.

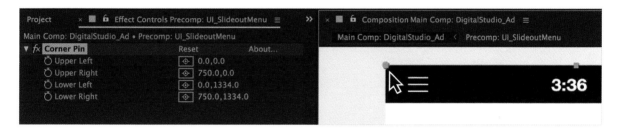

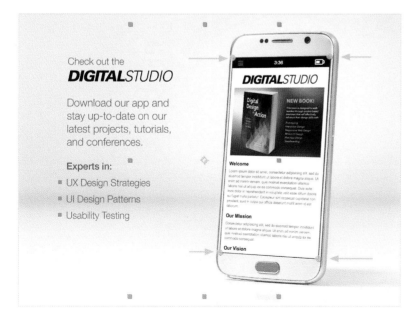

Click and drag each corner pin to align with the corners of the mobile screen.

13. Click on the **Play/Stop** button to see the animation in action. The project is almost done. The last step is to simulate a subtle glare on the UI screen to match it better with the lighting in the image. Save your project. Select **File > Save**.

Simulating Lighting Effects

1. Make sure the Timeline panel is highlighted. Select **Layer > New > Solid**. The keyboard shortcut is **Command/Control + Y**. The Solid Settings dialog box appears.

• Enter **Light Effect** for the solid name.

• Click on the **Make Comp Size** button.

• Set the color of the solid layer to white.

• Click **OK**.

All solid layers are stored in a **Solids** folder in the Project panel. This folder is automatically generated when you create your first solid layer. Any new solid layers you create will also be stored in the same folder.

2. The solid layer is added to the Timeline and fills the Comp panel with a white color. You only need the white color to appear inside the UI screen. To do this, you will create a track matte.

3. Select the **Precomp: UI_SlideoutMenu** layer. Duplicate the layer by selecting **Edit > Duplicate**. The keyboard shortcut is **Command/Control + D**.

4. Rename the duplicated layer by selecting it and pressing the **Return/Enter** key on the keyboard. Rename the layer **Track Matte**.

5. Click and drag the **Track Matte** layer. Reposition it above the **Light Effect** layer.

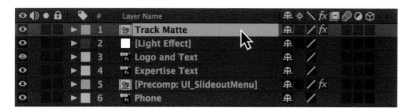

Duplicate the motion UI layer and reposition the duplicated composition in the Timeline panel. This will be used as a track matte for the solid layer.

6. Select the **Light Effect** layer.

7. Click on the **Toggle Switches / Modes** button at the bottom of the Timeline panel.

Toggle Switches / Modes

8. Define the transparency for the track matte by choosing the **Alpha Matte "Track Matte"** option from the Track Matte menu for the **Light Effect** layer.

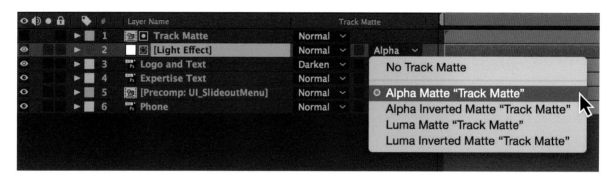

9. Make sure the **Light Effect** layer is still selected. Select **Effect > Transition > Linear Wipe**. The Linear Wipe effect wipes away a layer in a specified direction. The **Wipe Angle** property allows you to specify the direction that the wipe travels.

The track matte layer must be above the layer it is revealing. The end result reveals the white solid layer only in the UI screen.

10. Go to the Effect Controls panel. Make the following changes:

- Set the Transition Complete value to **60%**.

- Set the Wipe Angle to **0x+70.0°**.

- Set the Feather amount to **150.0**.

These settings will help simulate the light glare on the UI screen. The only problem is that the color is still too opaque. The layer's transparency needs to be lowered in order for the effect to work.

11. Make sure the **Light Effect** layer is still selected. Type **T** on the keyboard to open the Opacity property.

12. Scrub through the Opacity values and set it to **40%**.

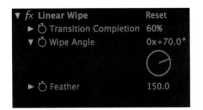

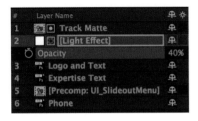

The final lighting effect uses the solid layer with a linear wipe effect.

13. Click on the **Play/Stop** button. Save your project. Select **File > Save**. This completes this exercise. Experiment with the project.

14. When you are done, select **Composition > Add to Render Queue**.

- Click on **Lossless** next to Output Module.
- Set the Format to **QuickTime**.
- Click on **Format Options** and set the video codec to **H.264**. Click **OK**.
- Click **OK** again. Click on **Output To** and select your hard drive.
- Click the **Render** button.

Summary

This completes the chapter on UI in motion. The exercises provided different methods in preparing and animating user interface elements created in Photoshop and Illustrator. This chapter also introduced you to the Graph Editor. You can view and edit the temporal interpolation through the Graph Editor. It visually displays the change in value between keyframes in the form of a graph. You can select keyframes and adjust their Bezier handles to affect the rate of change or speed.

The next chapter focuses on information design in motion.

6

Information in Motion

Words, shapes, and images work together to visualize and communicate information. Motion can further enhance this integration by depicting change to the viewer. This includes manipulating an object's appearance, such as its size, color, or position, over time. This chapter examines how motion can be useful in communicating data.

At the completion of this chapter, you will be able to:

- Discuss the different types of data visualization
- Animate a pie chart using a transition effect
- Create Shape Layers to animate a vertical bar chart
- Use parenting in After Effects to animate multiple layers together
- Add code-driven expressions to simplify complex animation
- Track motion in digital video
- Apply tracked data to animate another layer

What is an Infographic?

An **infographic** is an image that creatively combines statistical data with graphics and text. The data is sorted, arranged, and presented visually. Its purpose is to easily let the viewer understand the message or story being communicated. There are three main components:

- **Data:** This is all the facts and figures. It refers to content that comes from quantitative statistics, chronological events, spatial relationships, or the categorization of information.
- **Knowledge:** This is the overall message or story that needs to be communicated to the viewer using the data.
- **Visuals:** This includes the colors, shapes, and symbols used to visualize the data to the viewer in order to facilitate acquiring the knowledge.

Infographics provide a means to take data and communicate it visually for a viewer to interpret the content and understand it.

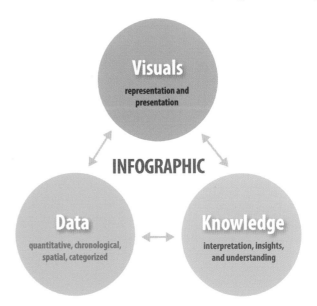

Visualizing Data

A visual presentation of facts and figures is still just a pile of data. Designers must first decode the data and understand it. Only then can they achieve their goal to construct a visual display that translates the data into information in a precise, functional, easy-to-use, and aesthetically pleasing form.

At the highest level, data can either be quantitative or qualitative. **Quantitative** data deals with numbers or something measurable such as amount, dimensions, temperature, prices, and volume. If you

measure something and give it a numeric value, you create quantitative data. **Qualitative** data can't be easily measured, but can be observed subjectively, such as smells, tastes, tactile contact, and attractiveness. If you classify or judge something, you create qualitative data.

Quantitative data can be **discrete**, where the numerical data has a finite value, such as the number of days in a week. Data that is not restricted to defined values, but can occupy any value over a specific range is referred to as **continuous**. A good example of continuous data is the amount of rainfall in a year.

Discrete
(Counted)

Continuous
(Measured)

Quantitative data can be discrete (counted) or continuous (measured).

Objects can be grouped into either ordered or unordered categories based on some qualitative trait. **Ordered categorical data** defines the values representing rank or fall into a natural order, such as "Short, Medium, or Tall." **Unordered categorical data** does not have a ranking system. For example, objects can be grouped based on their color.

SHORT MEDIUM TALL

Unordered
(Categorized by Color)

Ordered
(Categorized by Rank)

Qualitative data can be grouped into either ordered or unordered categories.

What are some basic strategies for displaying complex data? Some strategies seem rather simple, that is only because we take their utility and explanatory power for granted. Tables, charts, graphs, diagrams, and maps are essential cognitive tools in the world of infographics.

Let's explore some basic forms of graphical representation:

- **Tables:** Even the plainest table, properly organized and neatly laid out, can be an effective showcase for information that might otherwise take pages of cumbersome verbal description. A simple grid matrix, for example, is usually an appropriate format for presenting many types of data, from baseball standings to airline schedules.

A table uses a simple grid matrix to format and present data. Type size, weight, alignment and spacing should be used to keep the information in a clear hierarchy and easy to read.

- **Charts:** There are several different types of charts. Flow charts depict movement through a system or stages in a process. Organization charts portray structural relationships within a corporation or organizational hierarchy. Bar charts show change over time or can compare different categories. Pie charts are best used to show a subset of data compared to the larger whole.

Bar charts visualize data using rectangular shaped bars with each bar's length being proportional to the values they represent. Bar charts can be designed vertically or horizontally to show comparisons among categories. One axis of the chart shows the specific categories being compared, and the other axis represents a discrete value.

- **Diagrams:** A diagram shows how pieces work together. Instructional diagrams are used to demonstrate how to put together a do-it-yourself furniture product. Or a step-by-step process in a cookbook.
- **Maps:** There is probably no better-known or more widely used example of a two-dimensional figure being used to represent complex, multi-dimensional data than a map. Every successful map as a powerful,

imaginative, and often ingenious solution to a difficult communication problem. Maps of course come in a number of shapes and styles and serve a multitude of purposes.

Maps can visualize complex, multi-dimensional data in a two-dimensional format.

Designers can reproduce any data into visual road maps of information. How do you start? Prioritize what you want to highlight in the data. This will assist you in choosing the best visual representation. Common relationships within data include the following:

- **Comparisons:** Bar charts work well for this type of relationship and can highlight the differences between the values.
- **Time series:** Line charts can show time series for continuous data, or a vertical bar graph can visualize discrete data. Time measurements are typically displayed along the horizontal x-axis (from left to right), with quantitative values plotted along the vertical y-axis.
- **Ranking:** Bar charts (vertical and horizontal) visually rank relationships; use ordering to highlight the highest values (descending order) or the lowest values (ascending order).
- **Part-to-whole:** Pie charts are the most common graph types used to show a subset of data compared to the larger whole.

Types of charts used for data relationships:
1. Vertical Bar Chart - Comparison
2. Horizontal Bar Chart - Ranking
3. Line Chart - Time Series
4. Pie Chart - Part-to-whole Comparison

Chapter Exercise 1: Animating a Pie Chart

Now that you've got some working knowledge on the most common data types and relationships you'll most likely have to work with, let's dive into the different ways you can animate that data. The first exercise deals with a pie chart, which is one of the most popular chart types for illustrating part-to-whole comparisons.

Some helpful tips to remember when designing a pie chart include:

- **Limit to a maximum of 5 categories:** Too many slices in the chart will decrease the impact of the data visualization. It may also affect the readability of the content.
- **Verify total is 100%:** All slices in the pie chart must add up to 100%.
- **Proportionally scale:** Scale the pie slices proportionate to their corresponding value.
- **Order slices logically:** Start the largest section at 12 o'clock, going clockwise. Place remaining sections in descending order, going clockwise.

The following chapter exercise provides a step-by-step tutorial on how to animate a pie chart created in Adobe Photoshop. Before you begin, download the **Chapter_06.zip** file to your hard drive. It contains all the files needed to complete the chapter exercises. To see what you will build, locate and play the **Coffee_Pie_Chart.mov** in the **Completed** folder inside **Chapter_06**.

Download the **Chapter_06.zip** file at *www.routledge.com/cw/jackson*. It contains all the files needed to complete the chapter exercises.

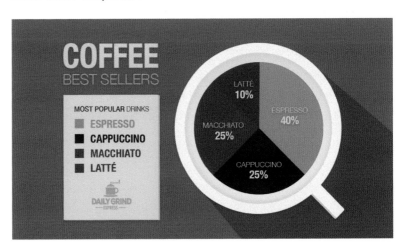

The animated pie chart identifies the best selling coffee for a fictitious cafe called "Daily Grind Express." The artwork was designed in Adobe Photoshop. Each piece of the pie chart was created on a different layer so that it could be animated separately in the motion design project.

1. Open the **01_Pie_Chart_Start.aep** file inside the **01_Pie_Chart** folder in **Chapter_06**. The Project panel contains the footage needed to complete this exercise. The Photoshop file was imported with the Composition – Retain Layer Sizes option selected.

2. If the **Main Comp: Daily Grind Express** composition is not open, double-click on it in the Project panel. It contains the five layers from the Photoshop file.

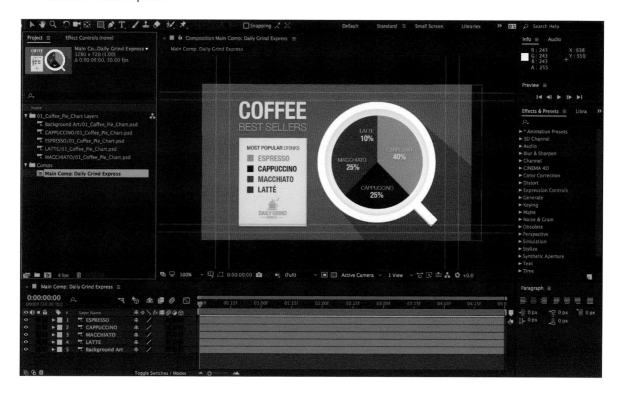

3. Select the **ESPRESSO** layer in the Timeline.

4. Select **Effect > Transition > Radial Wipe**. The Effect Controls panel opens as a new panel in front of the Project panel. It contains a list of properties associated with the effect. The Radial Wipe effect reveals an underlying layer using a wipe that circles around a specified point. The start angle determines where the transition starts. With a start angle of 0°, the transition starts at the top.

5. Go to the Effect Controls panel. Change the coordinates for the Wipe Center to **0.0, 215.0**. This repositions the center of the effect to the center of the pie chart graphic.

The composition matches the layer structure in the Photoshop file. The Title Safe and Action Safe guides are also imported into After Effects.

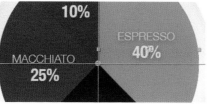

Reposition the center of the Radial Wipe effect to the center of the pie chart.

Change the wipe direction. The circular movement created by the Radial Wipe works perfectly for animating pie charts.

6. Change the Wipe direction to **Counterclockwise**.

7. Move the **Current Time Indicator** (CTI) to **frame 20 (0:00:00:20)**.

8. Set the Transition Completion to **100%**. This wipes the layer off the screen. Click on the **stopwatch** icon 🕐 next to Transition Completion to start recording keyframes.

9. Move the **Current Time Indicator** (CTI) to the **one-second** and **frame 20** mark (**0:00:01:20**).

10. Set the Transition Completion to **60%**. This reveals the pie slice.

11. Go to the Timeline. Click and drag a marquee selection around both of the Transition Completion keyframes to select them. Select **Animation > Keyframe Assistant > Easy Ease**.

Set keyframes for the Transition Completion property to reveal the slice.

12. Click on the **Play/Stop** button. The first pie slice wipes onto the screen. Normally, the Radial Wipe effect wipes a layer off to reveal an underlying layer. For this exercise, you worked backwards in setting the keyframes for the transition effect. Now the Radial Wipe reveals the layer using a counterclockwise wipe.

13. Save your project. Select **File > Save**.

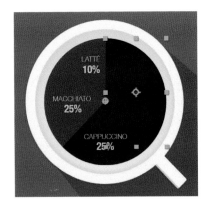
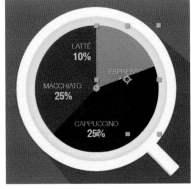
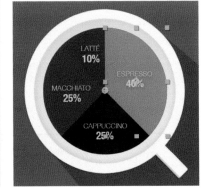

14. Select the **CAPPUCCINO** layer in the Timeline.

15. Select **Effect > Transition > Radial Wipe**. Go to the Effect Controls panel and make the following changes:

- Change the Start Angle to **0x+120.0°**.

- Change the coordinates for the Wipe Center to **153.0, 0.0**.

- Change the Wipe direction to **Counterclockwise**.

16. Move the **Current Time Indicator** (CTI) to the **one-second** and **frame 20** mark (**0:00:01:20**).

17. Set the Transition Completion to **100%**. Click on the **stopwatch** icon next to Transition Completion.

18. Move the **Current Time Indicator** (CTI) to the **two-seconds** and **frame 20** mark (**0:00:02:20**).

19. Set the Transition Completion to **70%**. This reveals the pie slice.

20. Apply an Easy Ease to the Transition Completion keyframes.

21. Click on the **Play/Stop** button. The second pie slice wipes onto the screen. Save your project. Select **File > Save**.

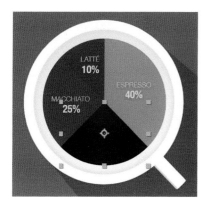 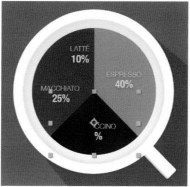 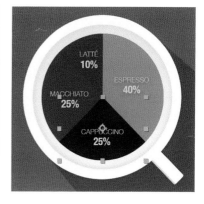

22. Select the **MACCHIATO** layer in the Timeline.

23. Select **Effect > Transition > Radial Wipe**. Go to the Effect Controls panel and make the following changes:

- Change the Start Angle to **0x+220.0°**.

- Change the coordinates for the Wipe Center to **217.0, 152.0**.

- Change the Wipe direction to **Counterclockwise**.

24. Move the **Current Time Indicator** (CTI) to the **two-seconds** and **frame 20** mark (**0:00:02:20**).

Animate the second pie slice.

25. Set the Transition Completion to **100%**. Click on the **stopwatch** icon next to Transition Completion.

26. Move the **Current Time Indicator** (CTI) to the **three-seconds** and **frame 20** mark (**0:00:03:20**).

27. Set the Transition Completion to **73%**. This reveals the pie slice.

28. Apply an Easy Ease to the Transition Completion keyframes.

29. Click on the **Play/Stop** button. The third pie slice wipes onto the screen. Save your project. Select **File > Save**.

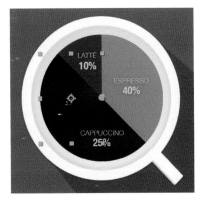 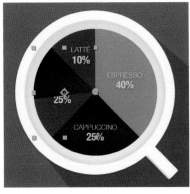 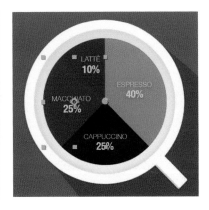

Animate the third pie slice.

30. Select the **LATTE** layer in the Timeline.

31. Select **Effect > Transition > Radial Wipe**. Go to the Effect Controls panel and make the following changes:

- Change the Start Angle to **0x+312.0°**.
- Change the coordinates for the Wipe Center to **154.0, 215.0**.
- Change the Wipe direction to **Counterclockwise**.

32. Move the **Current Time Indicator** (CTI) to the **three-seconds** and **frame 20** mark (**0:00:03:20**).

33. Set the Transition Completion to **100%**. Click on the **stopwatch** icon next to Transition Completion.

34. Move the **Current Time Indicator** (CTI) to the **four-seconds** and **frame 20** mark (**0:00:04:20**).

35. Set the Transition Completion to **85%**. This reveals the pie slice.

36. Apply an Easy Ease to the Transition Completion keyframes.

37. Click on the **Play/Stop** button. The last pie slice wipes onto the screen. Save your project. Select **File > Save**.

Animate the fourth pie slice.

38. This completes the exercise. Experiment with the project. Since all the pie pieces are separate layers, try scaling them up as they wipe on the screen. When you are done, select **Composition > Add to Render Queue**.

- Click on **Lossless** next to Output Module.
- Set the Format to **QuickTime**.
- Click on **Format Options** and set the video codec to **H.264**. Click **OK**.
- Click **OK** again. Click on **Output To** and select your hard drive.
- Click the **Render** button.

Chapter Exercise 2:
Animating a Vertical Bar Chart

The next exercise deals with a bar chart. Bar charts are very useful in visualizing data. They are often used to show change over time or compare different categories. The bars can either be oriented vertically or horizontally. Vertical bars work best for chronological data. Horizontal bars are often used for ranking data with long titles.

Bar charts show change over time or can compare different categories.

Some helpful tips to remember when designing a bar chart include:

- **Keep type horizontal:** Never use diagonal or vertical type as it slows down readability.

- **Provide enough space between bars:** Use up to half of the bar's width for spacing between bars.

- **Start with zero (0):** Numeric values are typically plotted along the vertical y-axis. Always start with zero to avoid any confusion reading and interpreting the data.

The following chapter exercise provides a step-by-step tutorial on how to animate a vertical bar chart created in Adobe Illustrator. To see what you will build, locate and play the **Revenue_Bar_Chart.mov** in the **Completed** folder inside **Chapter_06**.

The x-axis (horizontal) of the bar chart shows the years being compared, and the y-axis (vertical) represents the discrete monetary value.

The animated bar chart visualized the total revenue generated for a fictitious company over the span of four years. The artwork was designed using several layers in Adobe Illustrator. The Illustrator file was imported into After Effects with the Composition – Retain Layer Sizes option selected.

1. Open the **02_Bar_Chart_Start.aep** file inside the **02_Bar_Chart** folder in **Chapter_06**. The Project panel contains the footage needed to complete this exercise.

2. If the **Main Comp: Revenue Bar Chart** composition is not open, double-click on it in the Project panel. It contains the five layers from the Illustrator file.

3. Select the **Rectangle** Tool in the Tools panel to create a Shape Layer. Make sure no layers are selected in the Timeline.

4. Click on the Fill's **color swatch** to open the Shape Fill Color dialog box. Click on the **eye dropper** icon. Go to the Comp panel and click on one of the green colored bars to set the Shape Layer's fill color.

Set the Shape Layer's fill color to match the green colored bars in the chart. Set the Stroke to **None**.

5. Click **OK** to close the dialog box. Make sure the Stroke is set to **None**.

6. Go to the Timeline and turn off the visibility for the **Green Bars** layer. Click on the **Video** switch (**eyeball icon**) to hide the layer.

7. Instead of using the Illustrator artwork, you will create and animate a Shape Layer for each bar. Go to the Comp panel. Click and drag to create a rectangle that covers the entire first gray bar.

Make sure no layers are selected in the Timeline. Create a Shape Layer that matches the height and width of a gray bar.

8. The Shape Layer's Anchor Point needs to be adjusted so that it can scale correctly. To move the layer's anchor point without moving the layer, select the **Pan Behind** (Anchor Point) Tool in the Tools panel.

9. Go to the Comp panel. Click and drag the layer's anchor point ✛ to the bottom center. Hold down the **Command** key while you are dragging the anchor point to have it snap to the bottom center.

Click and drag the layer's anchor point to the bottom center using the Pan Behind (Anchor Point) Tool.

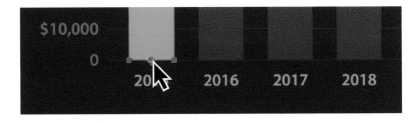

10. Click on the **Selection** (Arrow) Tool in the Tools panel.

11. Rename the Shape Layer to **2015**. To do this, select the layer's name and press the **Return/Enter** key.

Rename the Shape Layer to match its corresponding year.

12. Press the **Home** key to move the **Current Time Indicator** (CTI) to the beginning of the composition (**00:00**).

13. Make sure the **2015** layer is still selected. Type **S** on the keyboard to open the Scale property.

- Click on the **Constrain Proportions** icon 🔗 to the left of the Scale numeric values to turn off proportional scaling.

- Scrub through the second Scale numeric value and set it to **0%**.

- Click on the **stopwatch** icon next to Scale.

Scale only the green bar's height.

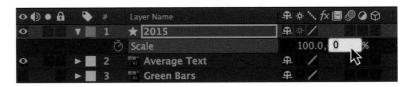

14. Move the **Current Time Indicator** (CTI) to **frame 20 (0:00:00:20)**.

15. Scrub through the second Scale numeric value and set it to **50%** to match the Illustrator artwork.

16. Click and drag a marquee selection around both of the Scale keyframes to select them. Select **Animation > Keyframe Assistant > Easy Ease** to smooth the animation.

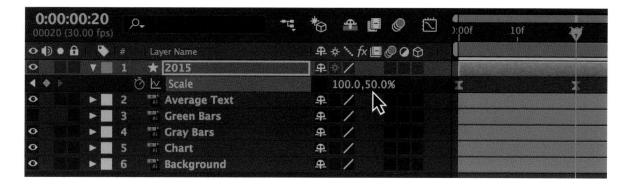

17. Click on the **Play/Stop** button. The green bar scales up 50%. Now that you have animated the first green bar, it can be duplicated for the remaining bars in the bar chart. Save your project.

Duplicate and Animate

1. Make sure the **2015** layer is still selected. Duplicate the layer by selecting **Edit > Duplicate**. The keyboard shortcut is **Command/ Control + D**. This will also duplicate the scale keyframes. Notice that After Effects conveniently names the duplicated layer **2016**.

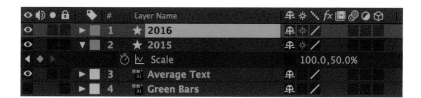

Duplicate the Shape Layer.

2. Go to the Comp panel and drag the duplicated Shape Layer to the right. Align it over the "2016" gray bar in the bar chart.

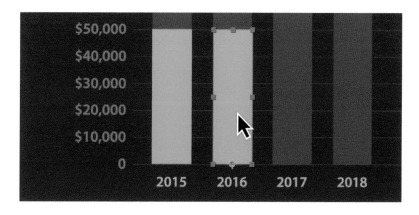

Move the duplicated Shape Layer in the Comp panel.

3. Move the **Current Time Indicator** (CTI) to **frame 20 (0:00:00:20)**.

4. Make sure the **2016** layer is still selected. Type **S** on the keyboard to open the Scale property. Change the second Scale's keyframe value to **40%**.

Scale only the green bar's height.

5. Duplicate the **2016** layer by selecting **Edit > Duplicate**. The keyboard shortcut is **Command/Control + D**.

6. Go to the Comp panel and drag the duplicated Shape Layer to the right. Align it over the "2017" gray bar in the bar chart.

7. Make sure the **2017** layer is still selected. Type **S** on the keyboard to open the Scale property. Change the second Scale's keyframe value to **80%**.

8. Duplicate the **2017** layer by selecting **Edit > Duplicate**.

9. Go to the Comp panel and drag the duplicated Shape Layer to the right. Align it over the "2018" gray bar in the bar chart.

10. Make sure the **2018** layer is still selected. Type **S** on the keyboard to open the Scale property. Change the second Scale's keyframe value to **70%**.

Scale only the green bar's height.

11. Click on the **Play/Stop** button to see the animated green bars in action. Next, let's animate the bar for the "average" revenue in the bar chart. Save your project. Select **File > Save**.

Preview the animated bar chart.

Animate the Average Revenue Bar

1. Duplicate the **2018** layer by selecting **Edit > Duplicate**.

2. Rename the Shape Layer to **Average**. To do this, select the layer's name and press the **Return/Enter** key.

Duplicate the Shape Layer and rename the duplicated layer **Average**.

3. Move the **Current Time Indicator** (CTI) to **frame 20 (0:00:00:20)**.

4. Go to the Comp panel and drag the duplicated Shape Layer to the right. Align it over the gray money bag graphic in the bar chart.

5. Make sure the **Average** layer is still selected. Type **S** on the keyboard to open the Scale property. You will need to change both the width and height of the layer.

6. Change the Scale values to **450.0, 60.0%**. The width of the Shape Layer will expand to cover the width of the money bag.

Scale the Shape Layer's width and height.

7. Press the **Home** key to move the **Current Time Indicator** (CTI) to the beginning of the composition (**00:00**).

8. Change the Scale values to **450.0, 0.0%** to match the width of the second keyframe.

Scale the Shape Layer's width to match the second keyframe.

9. Click on the **Play/Stop** button to see the animated green bar. The only problem is the bar's shape is a rectangle and does not match the organic shape of the bag. You will have to use a track matte.

10. Select the **Gray Bars** layer in the Timeline. Duplicate the layer by selecting **Edit > Duplicate**.

11. Rename the duplicated layer by selecting it and pressing the **Return/Enter** key on the keyboard. Rename the layer **Track Matte**.

12. Click and drag the **Track Matte** layer. Reposition it above the **Average** layer.

Duplicate and rename the **Gray Bars** layer. Position it above the Shape Layer. The duplicated layer will be used as a track matte to reveal the bar animation.

Toggle Switches / Modes

13. Select the **Average** layer.

14. Click on the **Toggle Switches / Modes** button at the bottom of the Timeline panel.

15. Define the transparency for the track matte by choosing the **Alpha Matte "Track Matte"** option from the Track Matte menu for the **Average** layer.

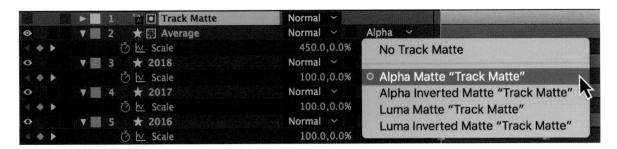

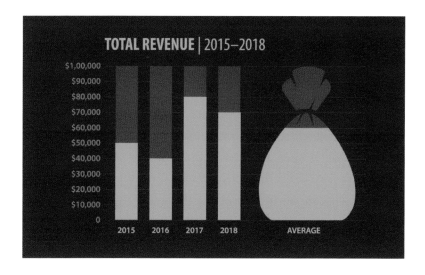

Preview the animated bar chart. The Alpha Matte reveals the animated bar layer inside the shape of the money bag.

16. Click on the **Play/Stop** button to see the track matte in action. Save your project. Select **File > Save**.

Animate the Average Amount Text

1. Click and drag the **Average Text** layer. Reposition it above the **Track Matte** layer in the Timeline.

2. Move the **Current Time Indicator** (CTI) to **frame 20 (0:00:00:20)**.

3. Make sure the **Average Text** layer is still selected in the Timeline.

- Type **P** on the keyboard to open the Position property.

- Type **Shift + T** on the keyboard to open the Opacity property.

- Click on the **stopwatch** icons ⏱ next to Position and Opacity.

4. Move the **Current Time Indicator** (CTI) back to **frame 10 (0:00:00:10)**. Make the following changes:

- Set the Position numeric values to **892.0, 480.0**.

- Set the Opacity property to **0%**.

5. Click and drag a marquee selection around both of the Position and Opacity keyframes to select them. Select **Animation > Keyframe Assistant > Easy Ease** to smooth the animation.

6. Click on the **Play/Stop** button to see the animated bar chart in action. The project is almost complete. The only thing that remains to be done is to offset the timing for each animated bar so that they do not appear at the same time. Save your project. Select **File > Save**.

Offset the Timing

1. Move the **Current Time Indicator** (CTI) to **frame 20 (0:00:00:20)**.

2. Click anywhere inside the colored bar for the **2015** layer and drag to the right. Align the left edge of the bar with the CTI.

Drag the Shape Layer's bar in the Timeline to offset the animation. This provides time for the user to take in the information being communicated.

3. Move the **Current Time Indicator** (CTI) to the **one-second** and **frame 10** mark (**0:00:01:10**).

4. Click anywhere inside the colored bar for the **2016** layer and drag to the right. Align the left edge of the bar with the CTI.

5. Move the **Current Time Indicator** (CTI) to **two seconds (02:00)**.

6. Click anywhere inside the colored bar for the **2017** layer and drag to the right. Align the left edge of the bar with the CTI.

7. Move the **Current Time Indicator** (CTI) to the **two-seconds** and **frame 20** mark (**0:00:02:20**).

8. Click anywhere inside the colored bar for the **2018** layer and drag to the right. Align the left edge of the bar with the CTI.

9. Move the **Current Time Indicator** (CTI) to the **three-seconds** and **frame 10** mark (**0:00:03:10**).

10. Click anywhere inside the colored bar for the **Average** layer and drag to the right. Align the left edge of the bar with the CTI.

11. Repeat the same for the **Track Matte** and **Average Text** layers. Align the left edges of the bars with the CTI.

12. Click on the **Play/Stop** button. Save your project. Select **File > Save**. This completes this exercise. Experiment with the project.

13. When you are done, select **Composition > Add to Render Queue**.

- Click on **Lossless** next to Output Module.

- Set the Format to **QuickTime**.

- Click on **Format Options** and set the video codec to **H.264**. Click **OK**.

- Click **OK** again. Click on **Output To** and select your hard drive.

- Click the **Render** button.

Offset each layer's timing to reveal the animated bars one at a time. It is always a good idea to stagger or offset the timing for an animated chart so that the user does not become overwhelmed with too much information up front.

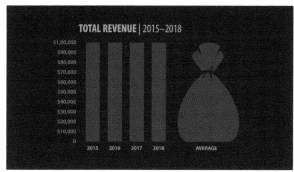

Animated bars also work well at providing user feedback for user interface design. An animated progress bar depicts what the system is currently doing. It is the focus of the next chapter exercise.

Offsetting the timing allows the user to focus and understand the data better.

Chapter Exercise 3:
Animating a Progress Indicator Bar

Another form of information design that is critical in UI design is the progress bar. Users need some visible indicator for the system status. It is one of the most important human factor rules of UI design. An animated progress bar helps minimize user anxiety or frustration by providing information about what is currently happening with the app or web page. When designing a digital system, never forget to include some visual mechanism that tells the user what's happening.

There are two types of indicators you can design. A **determinate indicator** clearly shows how long an operation will take. This is typically displayed as a horizontal bar animating from left to right. Adding a percentage amount reinforces the progress. It communicates how much has already been accomplished, and how much is left to the user.

Never use a static loading screen. Motion clearly communicates progression over time. A horizontal bar illustrates a linear function and displays the proportional amount of work a task has completed.

An **indeterminate indicator** is displayed as a spinning graphic that loops. This feedback communicates that the system is working, but doesn't provide information on how long the user will have to wait. Only use this type of indicator for quick system actions that are less than five seconds in duration.

A looping animation communicates a task is in progress, but the time remaining cannot be expressed as a percentage.

1. Open the **03_Progress_Bar_Start.aep** file inside the **03_Progress_Bar** folder in **Chapter_06**. The Project panel contains the footage needed to complete this exercise.

2. If the **Main Comp: RacingGame** composition is not open, double-click on it in the Project panel. It contains five layers.

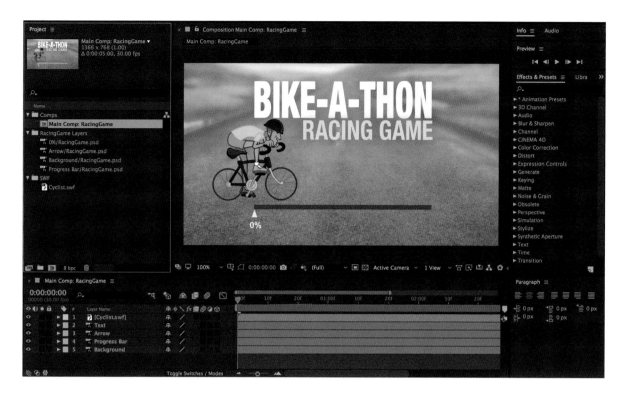

3. Press the **Home** key to move the **Current Time Indicator** (CTI) to the beginning of the composition (**00:00**).

4. Select the **Progress Bar** layer in the Timeline. Type **S** on the keyboard to open the Scale property.

- Click on the **Constrain Proportions** icon 🔗 to the left of the Scale numeric values to turn off proportional scaling.

- Scrub through the first Scale numeric value and set it to **0%**.

- Click on the **stopwatch** icon next to Scale.

This project is a loading screen for a fictitious online racing game. The cyclist animation was created in Adobe Animate and exported as a SWF file.

Scale only the progress bar's width.

5. Press the **End** key to move the **Current Time Indicator** (CTI) to the end of the composition.

6. Scrub through the first Scale numeric value and set it to **100%**.

7. Click and drag a marquee selection around both of the Scale keyframes to select them. Select **Animation > Keyframe Assistant > Easy Ease** to smooth the animation.

8. Click on the **Play/Stop** button to see the animated progress bar in action. Next, let's animate the arrow graphic to follow along with the progress bar. Save your project. Select **File > Save**.

Animate the Arrow Graphic

1. Press the **Home** key to move the **Current Time Indicator** (CTI) to the beginning of the composition (**00:00**).

2. Select the **Arrow** layer in the Timeline. Type **P** on the keyboard to open the Position property. Currently, the arrow is in the correct position, so click on the **stopwatch** icon next to Position.

3. Press the **End** key to move the **Current Time Indicator** (CTI) to the end of the composition.

4. Scrub through the first Position numeric value and set it to **1069.0**. This will align the arrow to the end of the progress bar.

Animate the horizontal position of the arrow graphic to follow the movement of the progress bar.

5. Click and drag a marquee selection around both of the Position keyframes to select them. Select **Animation > Keyframe Assistant > Easy Ease** to smooth the animation.

6. Click on the **Play/Stop** button to see the arrow graphic follow along with the animated progress bar. Next, let's link the arrow's change in position to the cyclist and text. To do this, you will use parenting in After Effects. Save your project. Select **File > Save**.

Preview the animated progress bar.

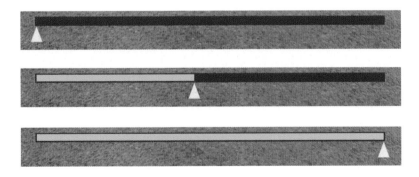

Parenting Layers in After Effects

After Effects offers a technique called **parenting**. This method attaches one or more layers to a parent layer. If a parent layer moves across the Comp panel, the child layers follow. With the exception of opacity, any changes made to the parent layer's transform properties are inherited by the child layers. Child layers can have their own animation, but these do not affect the parent. In this part of the exercise, you will learn how to assign parenting to a couple of layers. Welcome to parenthood!

1. To set up the parenting structure, you need to open the Parent column in the Timeline panel. If it is not already visible, you can right-click on the **Layer Name** column header and select **Columns > Parent**. Now it is time to figure out which layers are going to be the parents and which are the children.

Open the Parent column in the Timeline.

2. Press the **Home** key to move the **Current Time Indicator** (CTI) to the beginning of the composition (**00:00**).

3. Let's start by connecting the **Text** layer (child) to the **Arrow** layer (parent). There are a couple of ways to attach a child to a parent. You can use the Parent pop-up menu to select the appropriate parent. You can also use the Pick Whip Tool located to the left of the pop-up menu. Click on the **spiral icon** ⟲ (pick whip) for the **Text** layer and drag it to the name column of the **Arrow** layer. Release the mouse. You just linked the two layers together.

Use the Pick Whip to link the child layer to the parent layer.

4. Click on the **Play/Stop** button to see the text (child) follow along with the animated arrow (parent). The **Text** layer inherited the keyframed animation of the **Arrow** layer. Save your project. Select **File > Save**.

5. Press the **Home** key to move the **Current Time Indicator** (CTI) to the beginning of the composition (**00:00**).

6. Link the **Cyclist.swf** layer using the same technique. Click on the Parent pick whip for the child layer and use it to point to its parent layer (**Arrow** layer).

Use the Pick Whip to link the child layer to the parent layer.

7. Click on the **Play/Stop** button to see the cyclist inherit the movement of the arrow and text graphics. The project is almost done. The last thing to do is animate the text to reflect the percentage loaded. Save your project. Select **File > Save**.

Preview the parented layers in action. The changes to the parent's position results in the child layers moving along to follow without having to set any new keyframes.

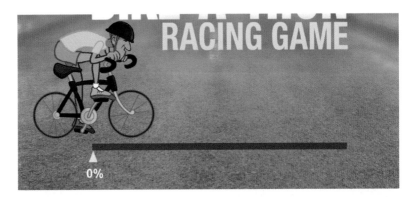

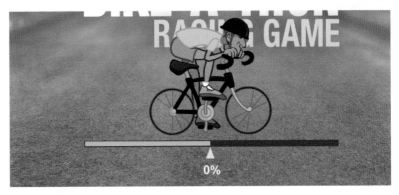

Using Expressions

This next part of the exercise introduces expressions, which are JavaScript-based instructions that can streamline complex animation in After Effects. You will use an expression to change the source text.

1. Press the **Home** key to move the **Current Time Indicator** (CTI) to the beginning of the composition (**00:00**).

2. Select the **Text** layer in the Timeline. Currently, the text layer imported from Photoshop is being displayed as a raster-based graphic. Select **Layer > Convert to Editable Text**. This converts the layer into a Text layer and allows you to edit it in After Effects.

3. Select **Effect > Expression Controls > Slider Control**. The Effect Controls panel opens to display the slider properties. You will create a keyframe animation using this slider to change the text from 0% to 100%. Make sure the Slider's numeric value is set to **0.00**. Click on the **stopwatch** icon ⏱ next to the Slider.

Set the starting value of the slider to 0.

4. Press the **End** key to move the **Current Time Indicator** (CTI) to the end of the composition.

5. Scrub through the Slider numeric value and set it to **100.00**. Nothing visible will happen in the Comp panel. The numeric value for the slider increases from 0 to 100. The resulting value need to be linked to the source text of the **Text** layer using an expression.

Set the ending value of the slider to 100.

6. Twirl open the **Text** layer to reveal its properties. Twirl open the **Text** property to get to the Source Text.

7. Hold down the **Option** key (Mac) or the **Alt** key (Windows) and click on the **stopwatch** icon ⏱ next to Source Text. This enables expressions to control the property.

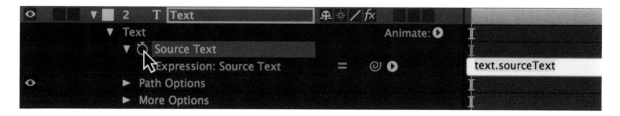

8. Click on the **arrow** icon ▶ to the right of Expression: Source Text. This opens a pop-up Expression Language menu. Select **JavaScript Math > Math.round(value)**. This will make sure that any numeric value linked to the source text will be a whole number.

Hold down **Option/Alt** and click on the stopwatch icon next to Source Text. This enables expressions to control the text.

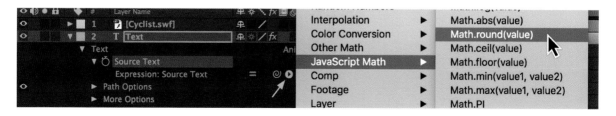

9. Twirl open the **Effects** property for the **Text** layer. Twirl open **Slider Control** to reveal the keyframed Slider property.

10. Go to the generated code in the Timeline. Select the word "value."

When expressions are enabled, they take over for keyframes. Select the word "value" in the expression.

11. Click on the **spiral icon** ⊚ (pick whip) to the right of the Expression: Source Text and drag it to the **Slider** property. Release the mouse. You just linked the slider control's numeric value to the source text.

Use the Pick Whip to link the slider control value to the source text.

12. Press the **Enter** key on the numeric keypad to accept the expression. Click on the **Play/Stop** button. The text increases numerically from 0 to 100. The last thing to do is add the percentage symbol.

13. Click on the generated code in the Timeline. Type **+ "%"** to the end of the expression. In coding, this is referred to as **concatenation**. Press the **Enter** key on the numeric keypad to accept the expression.

String concatenation is the operation of joining character strings end-to-end.

```
Math.round(effect("Slider Control")("Slider")) + "%"
```

14. Click on the **Play/Stop** button. This completes the exercise. The next exercise focuses on tracking motion in a digital video.

The final motion project incorporates parenting and expressions to create an animated progress indicator bar.

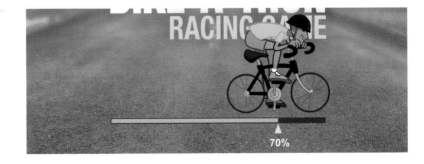

Chapter Exercise 4:
Moving Call Outs with Motion Tracking

Designers use **call outs** to emphasize important facts of an article or illustration. Its goal is to direct the viewer's attention to a specific area on screen or printed page to facilitate clear communication. Call outs can be designed in many ways from circles to speech bubbles. Arrows are also commonly used as call outs.

This next exercise focuses on linking an animated call out to a specific point in a digital video. To do this, you will learn how to **motion track** objects in After Effects. With motion tracking, you track the movement of an object and then apply the tracked data for that movement to another layer. The end result allows images and effects to follow the motion in a digital video. Let's see how it works.

To see what you will build, locate and play the **Scrooge_Callout.mov** in the **Completed** folder inside **Chapter_06**. The animated call out provides information about the object in the digital video. The call out artwork was designed in Adobe Photoshop. Notice how the call out's line tracks with the object in the video.

The movement in the video is tracked and its tracked data is applied to another layer to have it follow the motion.

1. Open the **04_Callout_Start.aep** file inside the **04_Callout** folder in **Chapter_06**. The Project panel contains the footage needed to complete this exercise. The Photoshop file was imported with the Composition – Retain Layer Sizes option selected.

2. If the **Main Comp: Scrooge** composition is not open, double-click on it in the Project panel. It contains the nine layers which are a combination of Photoshop layers, Shape Layers and a video.

The animated call out has already been built in the composition.

A separate composition was built for the circular markers used in the call out.

3. Click on the **Play/Stop** button. Since the goal of this exercise is motion tracking, the call out has already been animated. Take a look at the layers and keyframes to see how it was built.

• A composition was built for the small animated circles. It was nested inside this main composition to provide a visual anchor point for where the call out touches the figurine in the video.

• The line that connects the call out information to the object was created using a Solid Layer with a Beam effect added to it. The Beam effect allows you to create a wand-like stroke with a start and end point. These points can be animated over time which is ideal for this type of project.

4. Select the **Scrooge.mov** layer. Select **Animation > Track Motion**. This opens the video in a new Layer panel with a single track point in the center of the image. The Tracker panel also appears in the lower right corner of the After Effects workspace.

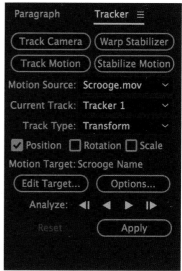

Take a look at the Tracker panel options. Motion tracking can be used to animate an image or effect to match the motion of video footage. You can also stabilize footage to hold a moving object stationary in the frame or to remove any camera shakes resulting from a handheld camera. For this exercise you will use a single 2D motion tracker. It has three components:

- **Feature Region:** The smaller square is used to define the area in the layer to be tracked.

- **Search Region:** The larger square defines the area that After Effects will search in the next frame to locate the tracked feature.

- **Attach Point:** The cross hair in the middle designates the anchor point for the target. This point is used to synchronize other linked layers with the moving object in the tracked layer.

5. Position the cursor inside the Feature Region's square, not on the bounding box line. It will change to a black cursor with four arrows at its tail. Click and drag the track point to the money bag. As you drag, the track point turns into a magnifier. Position the Attach Point directly over a highlighted area. Release the mouse.

The video opens in a new Layer panel and the Tracker panel appears in the lower right corner of the After Effects workspace.

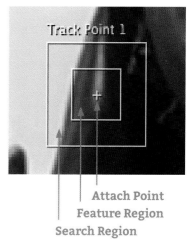

Attach Point
Feature Region
Search Region

Click and drag the track point to the area in the video you wish to track. Select an area with a high-contrast region so that After Effects can easily follow the motion from frame to frame.

6. Go to the Tracker panel. Click on the **Edit Target** button. The Motion Target dialog box appears. Select layer **8: Pre-comp: Circle Marker Scrooge** from the pop-up menu as the intended target. Click **OK**.

Select the motion target in the Tracker panel. Assign the circle animation composition as the intended target.

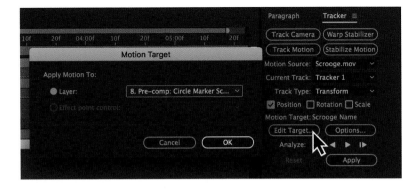

7. You perform the actual motion tracking step by clicking one of the Analyze buttons in the Tracker panel. Click on the **Analyze Forward** button ▶. After Effects will analyze one frame at a time looking for the area you defined with the track point. When it is finished, a motion path is created for Track Point 1.

After Effects analyzes the video frame by frame searching for the area defined by the track point. When it is finished a motion path is generated with keyframes set for each frame.

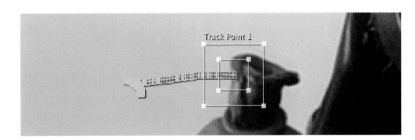

8. Make sure the correct target appears next to Motion Target. It should be the **Pre-comp: Circle Marker Scrooge** layer.

9. Click on **Apply**. The Motion tracker Apply Options dialog box appears. Click **OK** to apply the tracked data to the position of the target. The main composition opens back up to show the results.

Apply the tracked data to the position of the motion target..

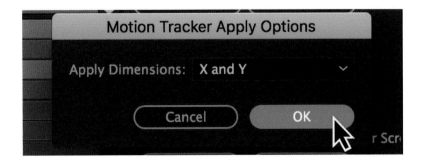

10. Click on the **Play/Stop** button. The small circle marker follows along with the motion in the video. The last thing that needs to be done is connect the line to the marker. Save your project. Select **File > Save**.

The motion target follows along with the movement in the video.

Use an Expression to Link the Tracked Motion Data

1. Select the **Pre-comp: Circle Marker Scrooge** layer in the Timeline. Type **P** on the keyboard to open the Position property. Notice all the keyframes that were added from the motion tracking.

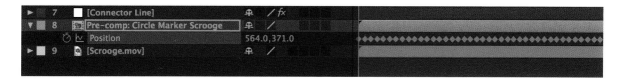

2. Twirl open the **Connector Line** properties. Twirl open **Effects** and then twirl open **Beam** to see all of its properties.

The tracked motion data appears as keyframes in the Position property.

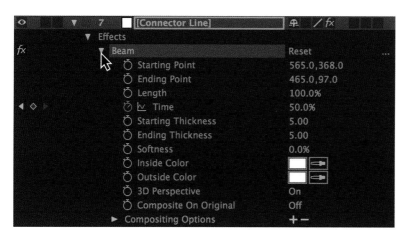

3. Hold down the **Option** key (Mac) or the **Alt** key (Windows) and click on the **stopwatch** icon ⏱ next to Starting Point. This enables expressions to control the property.

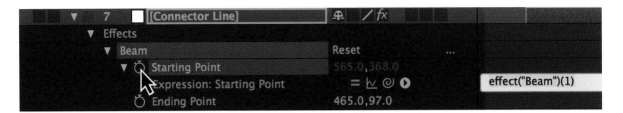

Hold down **Option/Alt** and click on the **stopwatch** icon next to Starting Point. This enables expressions to control the text.

Use the Pick Whip to link the tracked motion data to the Beam's starting point.

4. Click on the **spiral icon** ◎ (pick whip) to the right of the Expression: Starting Point and drag it to the **Position** property for the **Pre-comp: Circle Marker Scrooge** layer. Release the mouse. You just linked the tracked motion data to the Beam's starting point.

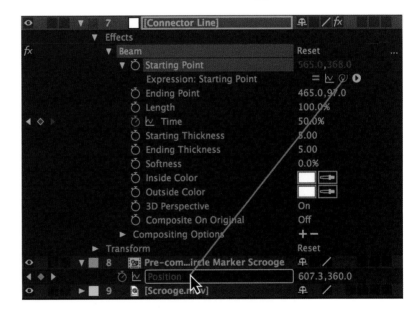

5. Click on the **Play/Stop** button. The Beam's starting point moves with the small circle marker. Experiment with the project.

6. When you are done, select **Composition > Add to Render Queue**.

- Click on **Lossless** next to Output Module.
- Set the Format to **QuickTime**.
- Click on **Format Options** and set the video codec to **H.264**. Click **OK**.
- Click **OK** again. Click on **Output To** and select your hard drive.
- Click the **Render** button.

The final motion design project uses motion tracking and expressions to create an animated call out.

7. Save your project. Select **File > Save**.

Chapter Exercise 5:
Using the Perspective Corner Pin Tracker

The previous chapter showed you how to frame a motion UI prototype inside a still image of a mobile phone using the Corner Pin effect. You can use the Corner Pin effect in conjunction with motion tracking. This last exercise is a step-by-step tutorial focusing on the Perspective Corner Pin motion tracker. Let's get started.

1. Open the **05_Corner_Pins_Start.aep** file inside the **05_Corner_Pins** folder in **Chapter_06**. The Project panel contains the previous animated progress bar project and a new video of a laptop.

2. If the **Main Comp: Prototype** composition is not open, double-click on it in the Project panel.

3. Select the **Pre-Comp: RacingGame** layer. Select **Effect > Distort > Corner Pin**. The effect is added to the layer and the Effect Controls panel opens with four properties.

4. Click on each of the **stopwatch** icons for the four properties: Upper Left, Lower Left, Upper Right, Lower Right.

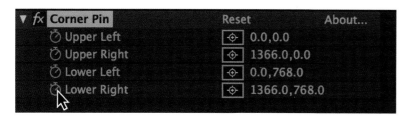

Add the Corner Pin effect and activate keyframe recording for all four properties.

5. Go to the Timeline and turn off the visibility for the **Pre-Comp: RacingGame** layer. Click on the **Video** switch (**eyeball icon**) to hide the layer.

Hide the nested composition layer.

6. Select the **Laptop.mov** layer in the Timeline. Select **Animation > Track Motion**. This opens the video in a new Layer panel with a single track point in the center of the image.

7. Go to the Tracker panel. Change the Track Type from **Transform** to **Perspective Corner Pin**. This mode uses four track points in the Layer panel and sets keyframes for four corner points in a Corner Pin effect property group, which was added to the nested composition.

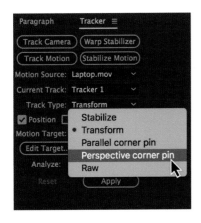

Add a Perspective Corner Pin tracker. This mode has four track points.

8. Position the cursor inside the **Track Point 1**'s Feature Region's square. Click and drag the track point to the top left corner of the laptop screen. Release the mouse.

Click and drag the first track point to the area in the video you wish to track. Position the Attach Point directly over a screen's corner on the laptop.

Chapter 6 | Information in Motion

9. Repeat the process for the three remaining track points. Click and drag each track point to a corner on the laptop screen.

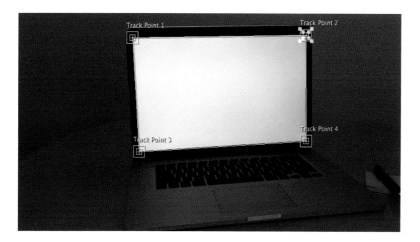

Position each of the track points in a corner of the laptop screen.

10. Click on the **Analyze Forward** button ▶. When After Effects is finished, four motion paths are created.

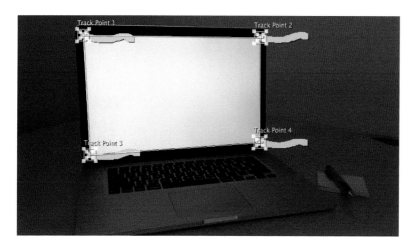

After Effects analyzes the video frame by frame searching for the area defined by each track point. When it is finished four motion paths are generated.

11. Make sure the correct target appears next to Motion Target. It should be the **Pre-Comp: RacingGame** layer.

12. Click on **Apply**. The main composition opens back up to show the results. All the motion tracked data is added as keyframes to the Corner Pin effect property group.

13. Go to the Timeline and turn on the visibility for the **Pre-Comp: RacingGame** layer. Click on the **Video** switch (**eyeball icon**) to show the layer.

14. Click on the **Play/Stop** button to see the Corner Pins in action.

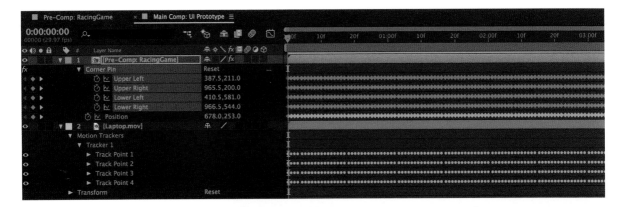

The Perspective Corner Pin mode uses four track points to skew, rotate, and create perspective changes in the target layer. The tracked data is applied to the Corner Pin effect property group.

15. This completes the exercise. Select **Composition > Add to Render Queue**. Make the following changes.

- Click on **Lossless** next to Output Module.
- Set the Format to **QuickTime**.
- Click on **Format Options** and set the video codec to **H.264**. Click **OK**.
- Click **OK** again. Click on **Output To** and select your hard drive.
- Click the **Render** button.

16. Save your project. Select **File > Save**.

Summary

This completes the chapter on information in motion. Different types of data visualization were explored from pie charts to animated call outs. The next chapter focuses on title designs in motion. It also explores advanced compositing techniques in After Effects.

7

Title Sequences in Motion

Animated title sequences are the prelude to a film or television show. They can engage an audience by hinting at what is about to happen. Good compositions arrange visual elements into a harmonious whole. This chapter explores how compositing layers and adding visual effects in After Effects can provide a sense of the genre for a film or television show and can focus the audience's attention to the significant area of interest in a shot.

At the completion of this chapter, you will be able to:

- Discuss how effective title sequences engage and excite an audience
- List where title sequences can be positioned within a movie
- Incorporate design principles into compositions
- Simulate three-dimensional movement using multiple layers
- Use layer blending modes to enhance the visual look
- Composite green screen footage within a composition

Setting the Mood

Film and TV title sequences not only introduce the title and principle actors, they set the mood and tone for an audience. Successful film titles become part of the visual narrative and establish a sense of place, communicate the story's theme, and even hint at a few plot points.

The **plot** is not the story itself; it is all of the action that takes place during the story. How the action affects the characters physically and emotionally builds a good story. The fundamental components to any story involve a character or characters in a setting, a conflict that causes change, and a resolution that depicts the consequences of the character's actions. A title sequence's visual narrative can fall into one of two modes:

- A **diachronic narrative** uses the basic elements of the plot, "what comes after what," in establishing the setting and what will happen to the main characters. The sequencing of images mimics the plot by showing a cause and effect relationship. The opening title sequence to *Catch Me if You Can* (2002) mimics the entire plot for the movie.

- A **synchronic narrative** uses editing in the form of a montage to build tension, anticipation, and curiosity in the viewer. A **montage** is a series of related shots that can be presented non-sequentially. The sequencing of images focuses more on design principles such as proximity, contrast, repetition and patterns. The title sequence to *Se7en* (1995) not only establishes the tone but puts the viewer in the mind of the antagonist.

Title Positioning

Opening credits can be used to foreshadow what roughly will happen in the movie or television show, while end credits can summarize what has happened. Keep this in mind as it will affect how you design your title sequence. A title sequence could be positioned:

- At the beginning of the movie
- In the middle of the movie, typically after the first scene
- At the end of the movie
- At the beginning and at the end of the movie

No matter where the title sequence is placed, a designer needs to incorporate the design principles such as balance, proximity, emphasis, and space in the composition. Visual properties such as color, value, and texture establish a pictorial consistency. Let's start with color.

A good online resource for title designs is located at *www.artofthetitle.com*.

There are several pioneers of title design that all designers should know:

1. Saul Bass
2. Richard Greenberg
3. Maurice Binder
4. Robert Brownjohn
5. Pablo Ferro
6. Kyle Cooper

Color Dominance and Interpretation

Audiences naturally seek out the most dominant element in a composition. Color serves as a dominant element. It can separate one object from others to attract the audience's attention. In the film *Schindler's List* (1993), director Steven Spielberg photographed much of the film in black and white. About half way through the film a girl is shown in a red coat. Spielberg costumed her in red to visually reinforce her as a dominant element. The audience immediately focuses its attention due to the contrast in color.

Color establishes dominance in the frame.

You can also tap into a viewer's psychological interpretation of color. Your audience members will have different reactions to different colors. The color red is a good example; it can be perceived as meaning power, strength, or passion, but it can also be associated with anger, violence, or danger. Each color has distinctive emotions attached to it based on the viewer's personal experiences.

Cultures share common opinions about color, for example:

- **Red** = hot, power, anger, violence, love, fire
- **Yellow** = warm, joyful, sickness
- **Blue** = cold, tranquil, peace, water, sadness
- **Orange** = courage, cheerful, energy
- **Green** = growth, healthy, greed, envy, good luck

Color can be manipulated to reflect the mood of a scene and personality of its occupants. The image below shows a woman standing next to an open door. She is holding a letter. Even though we cannot read the letter's content, the use of the color blue establishes a mood of melancholy. We can deduce through the color that the letter did not bring good news.

The color blue helps establish a mood of melancholy in the scene.

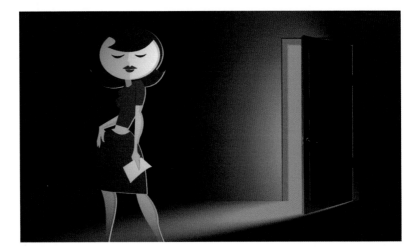

Value refers to the lightness and darkness of a color. Contrast between light and dark can also create compositional dominance in a scene. Every element within the frame has a specific brightness. By increasing the light in one area or on a subject you create an area of dominance within a composition. A bright object or area in a frame gives it extra weight and attracts the viewer's eye.

Framing with Forms and Shapes

Forms can be very effective in visual storytelling. Cinematographers sometimes add forms and shapes to "frame" the focal point in the composition. This framing device can be anything from a rectangular doorway or window, to more organic shapes such as a tree branch that hangs into the shot. Using a frame within the frame breaks up the space in interesting ways. It also allows the audience to focus on two separate events in the same frame.

In order for the frame to read as a frame, you need to provide enough negative space between the frame edge and the subject inside the frame. These frames tend to be positioned in the foreground with the

Add forms or shapes to "frame" the focal point in the composition.

subject matter placed behind it. In addition to adding more interest to the composition, the resulting image illustrates a three-dimensional space within a two-dimensional frame.

Having Some Depth

The world around us has three physical dimensions: height, width, and depth. The images you create in Photoshop or Illustrator have only two dimensions: height and width. Motion can create the illusion of depth within a two-dimensional space. How?

Remember the last time you were riding in a car looking out at the passing landscape. The car was moving at a consistent speed, but different parts of the landscape appeared to be moving at different speeds. Objects farthest away, such as rolling hills, appear smaller and move slower when compared to objects in the foreground that race past the car. How does this happen?

Stereoscopic vision is the way our brain interprets depth. Similar to a camera lens, our eyes adjust themselves to bring something into focus.

It all relates to our perception of depth. If we change our vantage point from looking straight down to eye level, we see more of the space surrounding objects. Each object moves relative to the space they occupy. Objects closer to us will appear to travel farther and move more quickly than objects farther away. In After Effects you can animate layers at different speeds which simulate this depth illusion. This is referred to as **parallax scrolling** and is the focus of the first chapter exercise.

Parallax scrolling simulates depth by animating several layers at different speeds in After Effects.

Chapter Exercise 1: Animating a Scrolling Title Sequence

How do artists achieve depth in their paintings? They paint objects in the foreground, middle ground, and background. Think of each ground as a separate layer in After Effects. To achieve parallax scrolling, each layer must move at a different speed.

Download the **Chapter_07.zip** file at *www.routledge.com/cw/jackson*. It contains all the files needed to complete the chapter exercises.

The Walt Disney Studios perfected this technique for its animated films by inventing a **multiplane camera**. This camera used stacked planes of glass each painted with different background elements. The movements for each plane were photographed frame-by-frame. The illusion of depth was achieved by moving each plane of glass at different speeds.

In this exercise, you will animate a scrolling title sequence for a fictitious television show called "Wicked Woods." Before you begin, download the **Chapter_07.zip** file to your hard drive. It contains all the files needed for the exercise. Let's discuss how you should go about designing the artwork for this type of cinematic effect. The artwork's height must be at least twice the height of the final composition in After Effects.

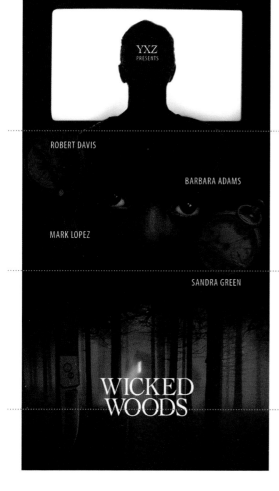

Composition 1:
Meet the Hero

Composition 2:
**The Journey
and Goal**

Composition 3:
**The Setting
and Conflict**

The height of the Photoshop artwork was designed over three times the size of the height used for the final composition.

The composition has a symmetrical balance with its use of typography and metaphorical imagery. There are numerous focal points strategically placed to create a repeating pattern of type and image.

Plot points are hinted at through imagery. The compass represents the journey the hero must take in searching for a missing girl who may have been kidnapped. The broken timepiece symbolizes time running out. The knife represents danger.

The monochromatic use of purple and blue colors help symbolize the mystery and thriller genre for the television show. The white text provides the contrast needed for readability.

The areas of shadow (value) is used to create a sense of visual cohesiveness that will not be distracting as it scrolls vertically.

1. Open the **01_Scroll_Start.aep** file inside the **01_Title_Scroll** folder in **Chapter_07**. The Project panel contains three compositions that were created from a layered Photoshop file. Video footage of static white noise has also been imported and added as a layer.

2. If the **Main Comp: Wicked Woods** composition is not open, double-click on it in the Project panel.

3. Press the **Home** key to move the **Current Time Indicator** (CTI) to the beginning of the composition (**00:00**).

4. Select the **Background Art** layer. Type **P** on the keyboard to open the Position property. Currently, the artwork is in the correct position, so click on the **stopwatch** icon ⏱ next to Position.

5. Press the **End** key to move the **Current Time Indicator** (CTI) to the end of the composition.

6. Scrub through the second Position numeric value and set it to **-464.0**. This will move the layer up vertically to reveal the bottom of the artwork. The keyframes create the background scrolling effect.

Move the layer up by changing its Position property in the Timeline.

7. Click and drag a marquee selection around both of the Position keyframes to select them. Select **Animation > Keyframe Assistant > Easy Ease** to smooth the animation.

8. Click on the **Play/Stop** button to see background image scroll up. Next, let's link the video layer's position to the background using parenting. Save your project. Select **File > Save**.

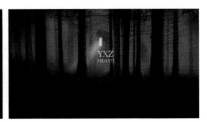

The background image contains the three main compositions for the title sequence.

9. As you learned in the previous chapter, parenting is a method for attaching one or more layers to a parent layer. To set up the parenting structure, you need to open the Parent column in the Timeline panel. If it is not already visible, right-click on the **Layer Name** column header and select **Columns > Parent**.

10. Press the **Home** key to move the **Current Time Indicator** (CTI) to the beginning of the composition (**00:00**).

11. Click on the **spiral icon** (pick whip) for the **WhiteNoise.mp4** layer and drag it to the name column of the **Background Art** layer. Release the mouse. You just linked the two layers together.

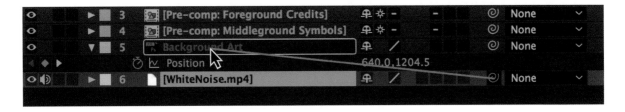

Animate the Middle Ground Artwork

1. Move the **Current Time Indicator** (CTI) to **four seconds (04:00)**.

2. Select the **Pre-comp: Middleground Symbols** layer. Type **P** on the keyboard to open the Position property. Currently, the artwork is in the correct position, so click on the **stopwatch** icon ⏱ next to Position.

3. Move the **Current Time Indicator** (CTI) to **twenty-six seconds (26:00)**.

4. Scrub through the second Position numeric value and set it to **-464.0**. This will move the layer up vertically to reveal the bottom of the artwork. The keyframes create the middle ground scrolling effect.

5. Apply an Easy Ease to the Position keyframes.

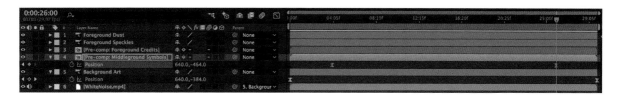

6. Click on the **Play/Stop** button to see middle ground images (compass, watch, and knife) scroll up slightly faster than the background art. This provides a subtle illusion of depth. Save your project. Select **File > Save**.

The space between the middle ground layer's keyframes is smaller than the space between the background layer's keyframes. As a result, the middle ground layer will animate slightly faster scrolling up.

Parent the Fore Ground Layer to the Background Layer

1. Press the **Home** key to move the **Current Time Indicator** (CTI) to the beginning of the composition (**00:00**).

2. Select the **Pre-comp: Foreground Credits** layer. You are going to parent this layer to the **Background Art** layer.

3. Click on the **spiral icon** 🔵 (pick whip) for the **Pre-comp: Foreground Credits** layer and drag it to the name column of the **Background Art** layer. Release the mouse. You just linked the two layers together.

4. Click on the **Play/Stop** button to see foreground layer scroll up. Since the credits' layer (child) is linked to the background layer (parent), they both animate at the same speed. Shouldn't the foreground layer move faster than the background layer? The answer is yes, and you will animate each actor's name and the title later in the exercise to achieve this.

5. Save your project. Select **File > Save**.

Animate the Dust and Speckle Artwork

1. Press the **Home** key to move the **Current Time Indicator** (CTI) to the beginning of the composition (**00:00**).

2. Select the **Foreground Speckles** layer. Type **P** on the keyboard to open the Position property. Click on the **stopwatch** icon next to Position.

3. Press the **End** key to move the **Current Time Indicator** (CTI) to the end of the composition.

4. Scrub through the second Position numeric value and set it to **300.0**.

Move the speckle layer up by changing its position property in the Timeline.

5. Apply an Easy Ease to the Position keyframes.

6. Click on the **Play/Stop** button to see the speckles of dust scroll up slightly faster than the background art. This provides a subtle illusion of depth. Save your project. Select **File > Save**.

7. Press the **Home** key to move the **Current Time Indicator** (CTI) to the beginning of the composition (**00:00**).

8. Select the **Foreground Dust** layer. Type **P** on the keyboard to open the Position property. Click on the **stopwatch** icon next to Position.

9. Press the **End** key to move the **Current Time Indicator** (CTI) to the end of the composition.

10. Scrub through the second Position numeric value and set it to **500.0**.

11. Apply an Easy Ease to the Position keyframes.

12. Click on the **Play/Stop** button to see the parallax scrolling in action. Let's fine tune the animation starting with the credits.

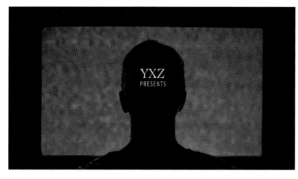
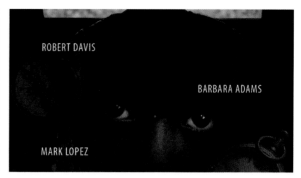

Animate the Opacity for the Credits

1. Double-click on the **Pre-comp: Foreground Credits** layer. Since this is a nested composition, it will open its own Comp panel and Timeline. Each credit is on its own separate layer. For this next part of the exercise, you will animate each layer's opacity to fade it on and fade it off the screen.

2. Press the **Home** key to move the **Current Time Indicator** (CTI) to the beginning of the composition (**00:00**).

3. Select the **XYZ Presents** layer. Type **T** on the keyboard to open the Opacity property. Scrub through the Opacity value and set it to **0%**. Click on the **stopwatch** icon 🕐 next to Opacity.

4. Move the **Current Time Indicator** (CTI) to **one second** (**01:00**).

5. Scrub through the Opacity value and set it back to **100%**.

6. Move the **Current Time Indicator** (CTI) to **five seconds** (**05:00**).

7. Click on the **gray diamond** to the left of the word Opacity to record a keyframe without having to change the layer's opacity manually.

Preview the parallax scroll effect.

8. Move the **Current Time Indicator** (CTI) to **six seconds (06:00)**.

9. Scrub through the Opacity value and set it to **0%**.

10. Click and drag a marquee selection around all four of the Opacity keyframes to select them.

• Apply an Easy Ease to the Opacity keyframes.

• Copy the selected keyframes by selecting **Edit > Copy**. The keyboard shortcut is **Command/Control + C**.

11. Move the **Current Time Indicator** (CTI) to **five seconds (05:00)**.

12. Select the **Robert Davis** layer. Type **T** on the keyboard to open the Opacity property. Paste the keyframe animation by selecting **Edit > Paste**. The keyboard shortcut is **Command/Control + V**.

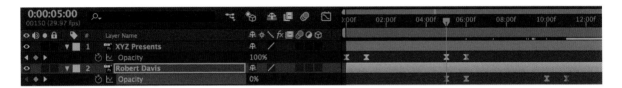

Copy and paste the Opacity keyframes from one layer to another.

13. Move the **Current Time Indicator** (CTI) to **eight seconds (08:00)**.

14. Select the **Barbara Adams** layer. Type **T** on the keyboard to open the Opacity property. Paste the keyframe animation.

15. Move the **Current Time Indicator** (CTI) to **eleven seconds (11:00)**.

16. Select the **Mark Lopez** layer. Type **T** on the keyboard to open the Opacity property. Paste the keyframe animation.

17. Move the **Current Time Indicator** (CTI) to **fourteen seconds (14:00)**.

18. Select the **Sandra Green** layer. Type **T** on the keyboard to open the Opacity property. Paste the keyframe animation.

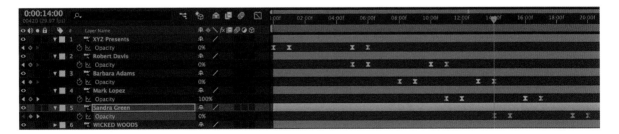

Copy and paste the Opacity keyframes from one layer to another.

19. Move the **Current Time Indicator** (CTI) to **twenty-six seconds (26:00)**.

20. Select the **WICKED WOODS** layer. Type **T** on the keyboard to open the Opacity property. Scrub through the Opacity value and set it to **0%**. Click on the **stopwatch** icon ⏱ next to Opacity.

21. Move the **Current Time Indicator** (CTI) to **twenty-nine seconds** (**29:00**). Scrub through the Opacity value and set it back to **100%**.

22. Apply an Easy Ease to the Opacity keyframes.

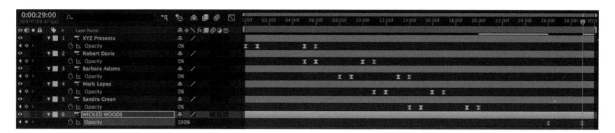

23. Save your project. Select **File > Save**.

Animate the Position for Each Actor's Name

1. Move the **Current Time Indicator** (CTI) to **five seconds (05:00)**.

2. Select the **Robert Davis** layer. Type **P** on the keyboard to open the Position property. Click on the **stopwatch** icon ⏱ next to Position.

3. Move the **Current Time Indicator** (CTI) to **eleven seconds (11:00)**.

4. Scrub through the second Position numeric value and set it to **574.0**.

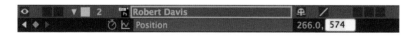

5. Apply an Easy Ease to the Position keyframes.

6. Move the **Current Time Indicator** (CTI) to **eight seconds (08:00)**.

7. Select the **Barbara Adams** layer. Type **P** on the keyboard to open the Position property. Click on its **stopwatch** icon.

8. Move the **Current Time Indicator** (CTI) to **fourteen seconds (14:00)**.

9. Scrub through the second Position numeric value and set it to **752.0**.

10. Apply an Easy Ease to the Position keyframes.

11. Move the **Current Time Indicator** (CTI) to **eleven seconds (11:00)**.

12. Select the **Mark Lopez** layer. Type **P** on the keyboard to open the Position property. Click on its **stopwatch** icon.

Change the title's opacity to fade it on the screen.

Move the layer up by changing its Position property in the Timeline. This change in position over time will enhance the figure and ground relationship

13. Move the **Current Time Indicator** (CTI) to **seventeen seconds (17:00)**.

14. Scrub through the second Position numeric value and set it to **1022.0**.

15. Apply an Easy Ease to the Position keyframes.

16. Move the **Current Time Indicator** (CTI) to **fourteen seconds (14:00)**.

17. Select the **Sandra Green** layer. Type **P** on the keyboard to open the Position property. Click on its **stopwatch** icon.

18. Move the **Current Time Indicator** (CTI) to **twenty seconds (20:00)**.

19. Scrub through the second Position numeric value and set it to **1260.0**.

20. Apply an Easy Ease to the Position keyframes.

Animate each actor's position on screen.

Return to the main composition by clicking on its tab name at the top of the Timeline.

21. Click on the **Main Comp: Wicked Woods** tab name at the top of the Timeline panel to open its Comp panel and Timeline.

22. Press the **Home** key to move the **Current Time Indicator** (CTI) to the beginning of the composition (**00:00**).

23. Click on the **Play/Stop** button to see the parallax scrolling in action. Each actor's name fades on the screen and moves slightly faster than the background art producing a sense of depth. Each credit fades out as it approaches the top of the screen. The project is almost done. The last thing to do is animate the knife artwork falling through the scene. Save your project. Select **File > Save**.

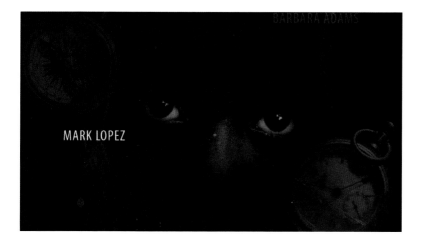

MARK LOPEZ

BARBARA ADAMS

Negative space assists the composition's overall balance and rhythm allowing the audience to focus on the movement. Color and contrast is also used to achieve balance and energize the picture plane.

Animate the Knife Artwork

1. Double-click on the **Pre-comp: Middleground Symbols** layer. The nested composition opens its own Comp panel and Timeline. Each image is on its own separate layer.

2. Move the **Current Time Indicator** (CTI) to **ten seconds (10:00)**.

3. Select the **Knife** layer. Type **P** on the keyboard to open the Position property. Set the Position numeric values to **256.0, -470.0**. This repositions the layer in the work area above the composition. Click on the **stopwatch** icon next to Position.

The metaphorical images are separated on their own layers in the nested composition.

4. Move the **Current Time Indicator** (CTI) to **twenty-six seconds (26:00)**.

5. Scrub through the second Position numeric value and set it to **2900.0**. This positions the layer in the work area below the composition and creates an animation of the knife falling through the scene.

6. Apply an Easy Ease to the Position keyframes.

7. Click on the **Main Comp: Wicked Woods** tab name at the top of the Timeline panel to open its Comp panel and Timeline.

8. Click on the **Play/Stop** button to see the parallax scrolling in action.

9. Go to the Project panel and twirl open the **Audio** folder. It contains a scratch track music clip. A **scratch track** is a sound recording used as a temporary placeholder during the post production of a film.

10. Click and drag **WickedWoods_Audio.mp3** footage from the Project panel to the Timeline. Position it at the bottom of the layers.

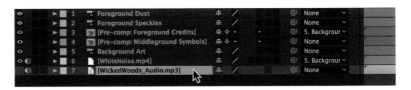

Add the audio footage to the Timeline. It doesn't matter where the audio is placed within the layer stacking order. Most often, the audio layers are grouped together at either the top or bottom of the stack.

11. Click on the **Play/Stop** button to see final title sequence. This completes the exercise. Experiment with the project.

12. When you are done, select **Composition > Add to Render Queue**.

- Click on **Lossless** next to Output Module.

- Set the Format to **QuickTime**.

- Click on **Format Options** and set the video codec to **H.264**. Click **OK**.

- Click **OK** again. Click on **Output To** and select your hard drive.

- Click the **Render** button.

13. Save your project. Select **File > Save**.

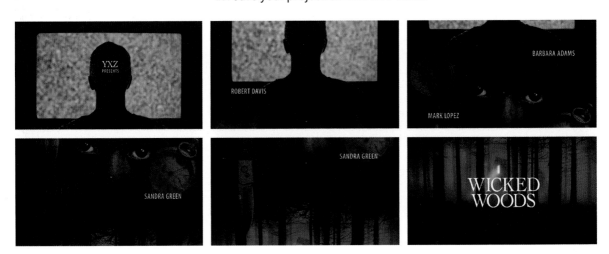

As you can see motion can enhance the sense of depth when used in conjunction with design principles such as unity, value, figure and ground, and negative space. Simulating spatial depth can be easily achieved through animating several layers at different speeds. The next exercise continues to explore how compositional principles are used to convey mood and evoke an emotional response.

Chapter Exercise 2:
Creating Spatial and Visual Continuity

One common mistake used in motion design projects is to contain all of the action to one shot. To convey a visual narrative in an interesting manner, you need a series of shots joined together; each shot being continuous like in a stage play. During postproduction on a film, an editor selects, cuts, and arranges various shots into narrative order.

An editor must determine:

- Which shots to use
- What order to put them into
- How long each shot will last on screen

Equally important to a shot's composition is the order in which it is placed. This is referred to as **continuity editing**. The action is generally presented in a logical, chronological sequence. Placing shots before or after other shots can create totally different meanings for the audience. To see what you will build, locate and play the **Titans_Title.mov** in the **Completed** folder inside **Chapter_07**. The animated title sequence is for a fictitious film about Greek mythology.

Top view

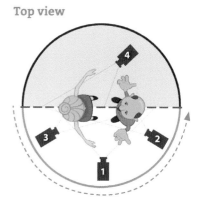

Use the 180° rule. The primary rule is to pick one side of the line of action and stay on it throughout the scene.

The plot of the film is echoed in the first two shots of the title sequence. Zeus, the god of the sky is at war with his brother, Hades who is lord of the underworld. Notice the screen direction between the two shots of the gods. Zeus is facing the right to take on Hades, who is defending his position looking to the left.

The third shot in the title sequence maintains the 180° rule showing two Greek warriors locked in battle. The camera stays on the front side of the line, Hades will be looking screen left and Zeus will be looking screen right. If you cross the line, they'll be looking in the opposite directions, although they haven't moved at all.

Note the screen direction from shot to shot. When using the line of action, the characters' position and direction also needs to match from one shot to another.

The third shot in the title sequence maintains the 180° degree rule through its spatial continuity. The previous two characters are metaphorically locked together in battle for the title screen.

Timing a Shot in a Sequence

What about a shot's duration? That depends on the type of visual story you are telling. The rhythm of a scene is determined by the length and frequency of its shots and the movement within each shot. For this title sequence, the same duration is given to each character to establish that both gods are equally matched against one another. Timing can vary.

Leading lines help the audience find the center of interest.

Watch any chase scene in a movie. These scenes start with a slow build-up with long establishing shots. As the chase reaches its climax, the shots get shorter and shorter in duration. They are presented to the audience in rapid succession to intensify the action.

Horror movies build suspense through skillful editing. A typical horror movie sequence starts with a series of tight close-ups revealing a character's anxiety. This is followed by a long continuous shot of the character walking down a dark path. The deliberately slow pacing heightens the audience's anticipation of what is to come next.

Contrasting movement draws attention to the title. Hades is composed of mainly diagonal lines to suggest movement that is more physical than a flat line.

Suddenly a quick cut jolts the audience right out of their seats. This is followed by slow reaction shots of the character laughing over the situation. The slower pace relaxes the audience allowing them to catch their breath. Just when the audience thinks they are safe, another explosion of quick cuts occurs as the sequence reaches its climax.

Building Sequences in After Effects

So how do you build a sequence in After Effects? One possible solution is to organize your shots into separate compositions. Sound familiar? This exercise will also explore blending operations for visual continuity.

Chapter 7 | Title Sequences in Motion

1. Open the **02_Titans_Title_Start.aep** file inside the **02_Compositing** folder in **Chapter_07**. The Project panel contains the footage needed to complete this exercise. A Photoshop file was imported with the Composition – Retain Layer Sizes option selected. The artwork consists of photographs that were stylized using the Oil Paint effect in Photoshop to create visual continuity.

2. If the **Pre-comp_01: Zeus** composition is not open, double-click on it in the Project panel. It contains four layers from the Photoshop file.

3. Press the **Home** key to move the **Current Time Indicator** (CTI) to the beginning of the composition (**00:00**).

4. Click on the **Play/Stop** button to see the animated composition. Keyframes have been set for the Position, Rotation, and Scale Transform properties. The slow movement is intended to reflect the great power that the Greek god has.

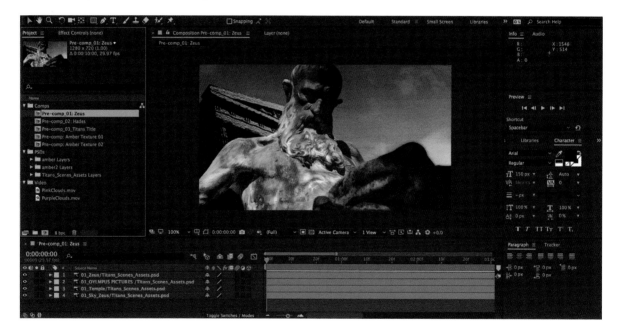

5. Let's add some more layers. Go to the Project panel. Click and drag **PurpleClouds.mov** video footage from the Project panel to the Timeline. Position it under the **01_OYLMPUS PICTURES** layer.

The composition matches the layer structure in the Photoshop file. Each folder in the Photoshop Layers panel is imported as a separate composition in After Effects.

The Set Matte effect uses the grayscale values in the layer's red (RGB) channel to create transparency in the composition.

6. Make sure the **PurpleClouds.mov** layer is still highlighted. Select **Effect > Channel > Set Matte**. The Effect Controls panel opens as a new panel in front of the Project panel. It contains a list of properties associated with the effect. The Set Matte effect allows you to use the alpha channel from another layer as the alpha channel of the current layer. Let's see how it works.

7. Go to the Effect Controls panel. Change the Use for Matte parameter to **Red Channel** using the pop-up menu. The grayscale values for the red channel are now creating transparency in the layer.

8. Click on the **Play/Stop** button to see the composited effect in action. Now the background is visible through the clouds creating the heavenly look of Mount Olympus, the home of Zeus.

Add a Particle Effect

As you know, effects are used to enhance a project in After Effects. In this part of the exercise you will apply Foam, the particle generator you used in Chapter 2. This effect will add animating ambers coming from a fire to represent at the war between the two gods.

Add the imported composition to the Timeline.

1. Click and drag the **Pre-comp: Amber Texture 01** composition from the Project Panel to the Timeline. Position it at the bottom of the stacked layers in the Timeline.

Chapter 7 │ Title Sequences in Motion

2. Make sure the Timeline panel is highlighted. Select **Layer > New > Solid**. The Solid Settings dialog box appears.

● Enter **Fire Ambers** for the solid name.

● Click on the **Make Comp Size** button.

● Click **OK**. The color of the solid layer doesn't matter.

All solid layers are stored in a Solids folder in the Project panel. This folder is automatically generated when you create your first solid layer. Any new layers you create will also be stored in the Solids folder.

The keyboard shortcut to create a new solid layer is **Command + Y** (Mac) or **Control + Y** (Windows).

3. Reposition the solid layer above the **PurpleClouds.mov** layer in the Timeline. Go to the Effects & Presets panel. Enter **Foam** into the Contains field. The item in the effects list that matches is displayed.

4. To apply the Foam effect to the solid layer, click and drag the effect to the **Fire Ambers** layer name in the Timeline panel. Release the mouse.

5. The effect is applied automatically. Notice that the solid color disappears and is replaced with wireframe circles in the center of the Comp panel. Let's experiment with the Foam properties.

6. Go to the Effect Controls panel. Click on the **twirler** to the left of Producer. This controls where the bubbles originate from. Make the following change:

● Producer Point: **1000.0, 720.0**. This lowers the vertical position of the producer point to the bottom-right corner in the composition.

● Increase the Production Rate value to **2.000**.

fx Foam	Reset	About
Ò View	Rendered	∨
► Producer		
► Bubbles		
▼ Physics		
► Ò Initial Speed	0.000	
► Ò Initial Direction	0x+90.0°	
► Ò Wind Speed	5.000	
► Ò Wind Direction	0x−45.0°	
► Ò Turbulence	0.700	
► Ò Wobble Amount	0.050	
► Ò Repulsion	1.000	
► Ò Pop Velocity	5.000	
► Ò Viscosity	0.300	
► Ò Stickiness	0.750	
► Ò Zoom	1.000	
► Ò Universe Size	1.000	
▼ Rendering		
Ò Blend Mode	Transparent	∨
Ò Bubble Texture	User Defined	∨
Bubble Texture Layer	7. Pre– ∨	Source ∨
Ò Bubble Orientation	Bubble Velocity	∨
Environment Map	None ∨	Source ∨
► Ò Reflection Strength	0.000	
► Ò Reflection Converge	0.800	
► Flow Map		
Ò Simulation Quality	Normal	∨
► Ò Random Seed	1	

Preview the Foam effect. This effect accepts other layers in the composition as a bubble texture.

7. Click on the **twirler** to the left of Bubbles. This controls the size and lifespan of the bubbles. Make the following changes:

- Decrease the Size value to **0.300**.

- Decrease the Size Variance value to **0.300**.

8. Click on the **twirler** to the left of Physics. This controls how fast the bubbles move and how close they stick together. Make the following changes:

- Initial Direction: **0x +90°**

- Wind Speed: **5.000**

- Wind Direction: **0x -45°**

- Turbulence: **0.700**

- Pop Velocity: **5.000**

- Viscosity: **0.300**

- Stickiness: **0.750**

9. Click on the **twirler** to the left of Rendering. This controls the visual look of the bubbles. Make the following changes:

- Bubble Texture: Change from **Default Bubble** to **User Defined**.

- Bubble Layer Texture: **Pre-comp: Amber Texture 01**.

- Bubble Orientation: **Bubble Velocity**.

10. To see the finished results, select **Rendered** from the View pop-up menu at the top of the Effect Controls panel.

11. Click on the **Play/Stop** button to see the final Foam effect. Save your project. Select **File > Save**.

Use the Blending Layer Modes

Blending modes allow you to mix hues, values, saturation, and brightness of stacked layers in Photoshop and After Effects. It is a fast way to create amazing looking compositions. Each blending mode changes the way that a layer reacts with the layer underneath it.

1. Go to the Project pane. Twirl open the **PSDs** folder and open the **Titans_Scenes_Assets Layers** folder. Click and drag the **Paper Texture** footage from the Project Panel to the Timeline. Position it at the top of the stacked layers in the Timeline.

Add the **Paper Texture** footage to the composition. Position the new layer at the top of the stacked layers.

2. Click on the **Toggle Switches / Modes** button at the bottom of the Timeline panel.

Toggle Switches / Modes

3. Choose **Overlay** as the blending mode for the **Paper Texture** layer. This produces saturated colors and pleasant contrast.

If the colors on the **Paper Texture** layer are darker than the base layers they are multiplied (darkened). If they are lighter they are screened (lightened).

Repeat Process on the Second Composition for Continuity

1. Double-click on the **Pre-comp_02: Hades** composition it in the Project panel. It contains four layers from the Photoshop file.

2. Press the **Home** key to move the **Current Time Indicator** (CTI) to the beginning of the composition (**00:00**).

3. Go to the Project panel. Click and drag **PinkClouds.mov** video footage from the Project panel to the Timeline. Position it under the **02_HERCULEAN** layer.

Add the video footage to the composition.

4. Select **Effect > Channel > Set Matte**. Go to the Effect Controls panel. Change the Use for Matte parameter to **Red Channel**.

5. Click on the **Play/Stop** button to see the composited effect in action.

The Set Matte effect uses the grayscale values in the layer's red (RGB) channel to create transparency in the composition.

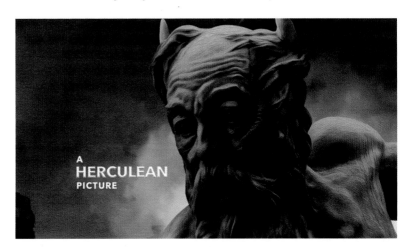

6. Click and drag the **Pre-comp: Amber Texture 02** composition from the Project Panel to the Timeline. Position it at the bottom of the stacked layers in the Timeline.

Add the imported composition to the Timeline.

7. Click and drag the **Fire Ambers** solid from the **Solids** folder in the Project panel to the Timeline. Position the solid layer below the **PinkClouds.mov** layer in the Timeline.

8. Go to the Effects & Presets panel. Enter **Foam** into the Contains field. To apply the Foam effect to the solid layer, click and drag the effect to the **Fire Ambers** layer name in the Timeline panel.

9. Go to the Effect Controls panel. Click on the **twirler** to the left of Producer. Change the Producer Point coordinates to **800.0, 720.0**.

10. Click on the **twirler** to the left of Bubbles. This controls the size and lifespan of the bubbles. Make the following changes:

- Increase the Size value to **0.600**.

- Decrease the Size Variance value to **0.600**.

11. Click on the **twirler** to the left of Physics. This controls how fast the bubbles move and how close they stick together. Make the following changes:

- Initial Direction: **0x +90°**

- Wind Speed: **3.000**

- Wind Direction: **0x -45°**

- Turbulence: **0.700**

- Pop Velocity: **5.000**

- Viscosity: **0.300**

- Stickiness: **0.750**

12. Click on the **twirler** to the left of Rendering. Change the following:

- Bubble Texture: Change from **Default Bubble** to **User Defined**.

- Bubble Layer Texture: **Pre-comp: Amber Texture 02**.

- Bubble Orientation: **Bubble Velocity**.

13. To see the finished results, select **Rendered** from the View pop-up menu at the top of the Effect Controls panel.

14. Click on the **Play/Stop** button to see the final Foam effect.

Preview the Foam effect.

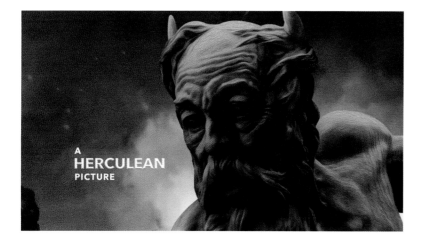

15. Go to the Project pane. Click and drag the **Paper Texture** footage from the Project Panel to the Timeline. Position it at the top of the stacked layers in the Timeline.

Add the **Paper Texture** footage to the composition. Position the new layer at the top of the stacked layers.

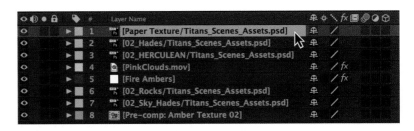

16. Choose **Overlay** as the blending mode for the **Paper Texture** layer.

The overlay blending mode produces saturated colors and pleasant contrast.

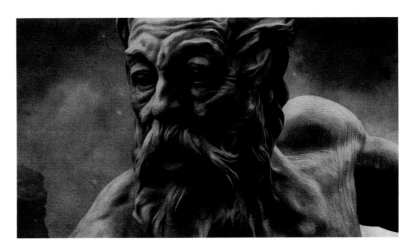

Put the Title Sequence Together

1. Select **Composition > New Composition**. Make the following settings in the dialog box that appears:

- Composition Name: **Main Comp: Titans Title**

- Preset: **HDV/HDTV 720 29.97**

- Duration: **0:00:30:00** (30 seconds)

- Click **OK**.

2. A new composition opens in the Composition and Timeline panel. The Project panel also lists the composition. Go to the Timeline. Move the **Current Time Indicator** (CTI) to **two seconds (02:00)**.

3. Click and drag the **Pre-comp_01: Zeus** comp from the Project panel to the Timeline. Click and drag the colored bat to align its left edge with the CTI.

4. Type **T** on the keyboard to open the Opacity property. Scrub through the Opacity value and set it to **0%**. Click on the **stopwatch** icon 🕐 next to Opacity.

5. Move the **Current Time Indicator** (CTI) to **four seconds (04:00)**.

6. Scrub through the Opacity value and set it back to **100%**.

7. Click and drag a marquee selection around both of the Position keyframes to select them. Select **Animation > Keyframe Assistant > Easy Ease** to smooth the animation.

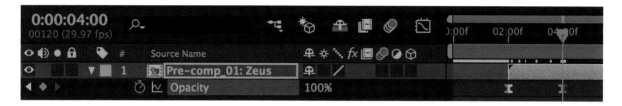

8. Move the **Current Time Indicator** (CTI) to **ten seconds (10:00)**.

9. Click and drag the **Pre-comp_02: Hades** comp from the Project panel to the Timeline. Position it at the bottom of the stacked layers. Click and drag the colored bat to align its left edge with the CTI.

10. Move the **Current Time Indicator** (CTI) to **eighteen seconds (18:00)**.

11. Click and drag the **Pre-comp_03: Titans Title** comp from the Project panel to the Timeline. Position it at the bottom of the stacked layers. Click and drag the colored bat to align its left edge with the CTI.

Fade in the nested pre-composition.

Add a Transition Effect

You will apply a transition effect to reveal the subsequent shot in the title sequence. A **fade** is a common transition used in early filmmaking at the start and end of every sequence. It increases or decreases the overall value of the scene into one color. One scene can fade out as another scene fades in. This is called a **dissolve** and is used frequently to indicate the passage of time. A **wipe** transition is visually apparent to the audience and clearly marks the change. One scene wipes across the frame and replaces the previous scene.

Add the two other nested pre-compositions. The three nested compositions are staggered in the Timeline so that they overlap during a certain span of time.

1. Move the **Current Time Indicator** (CTI) to **ten seconds (10:00)**.

2. Select the **Pre-comp_01: Zeus** layer the Timeline. Select **Effect > Transition > CC Image Wipe**.

3. Go to the Effect Controls panel. Click on the **stopwatch** icon 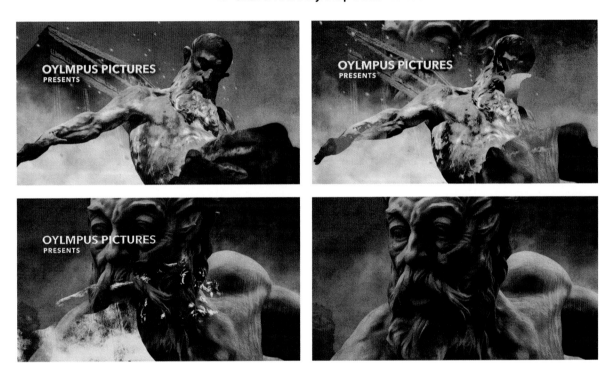 next to Completion.

4. Move the **Current Time Indicator** (CTI) to **twelve seconds (12:00)**.

5. Scrub through the Completion value and set it to **100%**.

6. Click on the **Play/Stop** button to see the transition effect.

The CC Image Wipe uses a gradient to reveal a layer. It is a combination of a dissolve and wipe added together.

7. Move the **Current Time Indicator** (CTI) to **eighteen seconds (18:00)**.

8. Select the **Pre-comp_02: Hades** layer the Timeline. Select **Effect > Transition > CC Image Wipe**.

9. Go to the Effect Controls panel. Click on the **stopwatch** icon next to Completion.

10. Move the **Current Time Indicator** (CTI) to **twenty seconds (20:00)**.

11. Scrub through the Completion value and set it to **100%**.

12. Click on the **Play/Stop** button to see the transition effect.

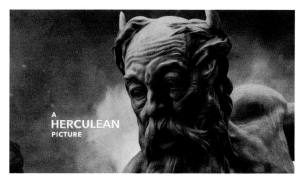

13. This completes the exercise. Experiment with the project. Try different blending modes to create different compositing effects.

14. When you are done, select **Composition > Add to Render Queue**.

- Click on **Lossless** next to Output Module.

- Set the Format to **QuickTime**.

- Click on **Format Options** and set the video codec to **H.264**. Click **OK**.

- Click **OK** again. Click on **Output To** and select your hard drive.

- Click the **Render** button.

15. Save your project. Select **File > Save**.

Preview the transition effect.

Chapter Exercise 3:
Keying Video for an End Title Sequence

Video can contain an alpha channel and After Effects can create this through keying. **Keying** takes a selected color (the key) in video and removes it from the shot. A prime example is your local weatherman on television. He is standing in front of a blue or green screen. The colored screen is removed, or keyed out, and a weather map is placed in the resulting transparent area.

Keylight is a keying effect designed for blue or green screen footage. With a couple of clicks of the mouse, you can key out a color from a video clip. This high-end keying plug-in is licensed from The Foundry, *www.thefoundry.co.uk*, a visual effects software company.

Before you use the Keylight plug-in, let's talk about what goes into setting up the shot to produce a clean key. It may seem quite simple; stand in front of a green screen and shoot some video. The actual setup is much more involved. The key, forgive the bad pun, starts with good lighting.

Good lighting is critical in producing a clean chroma key.

Lighting is critical. Typically two or more lights are used to light the green screen. Your background needs to be evenly and brightly illuminated. You want to set up your lights so that they remove as many shadows as possible. A preferred method involves lighting the background and the subject separately.

If your subject is framed waist-up have him/her stand at least six feet in front of the background. Make sure that they are not wearing a similar color in their clothing. These are general tips to follow. Learning what goes into setting up a green screen shoot is a subject for an entirely different book.

Keying begins with a video clip. Once you have shot your footage in front of the green screen, import the video into After Effects to remove the green color. The word "remove" may not be the best word to use. The keying process actually generates an alpha channel mask around your subject. This mask hides the green background.

To see what you will build in this exercise, locate and play the **Keylight_Credits.mov** in the **Completed** folder inside **Chapter_07**. The motion design project shows a **match frame**. This is a seamless transition from the titles to the film or vice versa. It matches the visual composition in the frame regardless of the visual style. The 2008 film, *RocknRolla*, used this effect to create stylish title cards for the main actors.

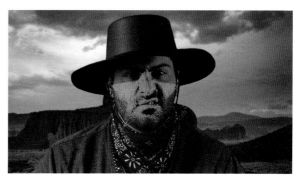

1. Open the **03_Keylight_Start.aep** file inside the **03_Keylight** folder in **Chapter_07**. The illustrator of the cowboy was created in Adobe Photoshop. A single frame was exported from the video. It was converted into a grayscale image in Photoshop and the Filter's Gallery was used to create the final graphic.

2. If the **Pre-comp: Cowboy Video** composition is not open, double-click on it in the Project panel. It contains two layers, a green screen video and a background image.

The match frame quickly transitions from the video to an illustrated wanted poster.

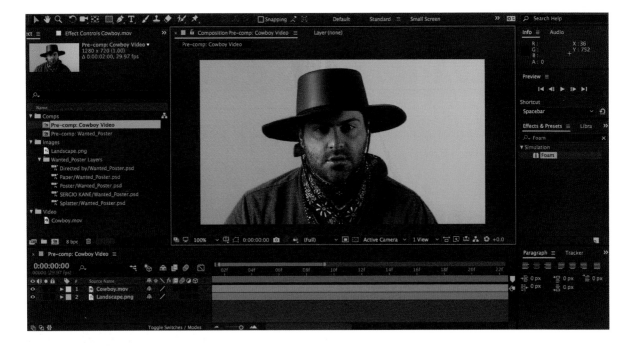

The outlaw was recorded in front of a green screen.

Select the color key using the Eye Dropper Tool to remove it.

3. Select the **Cowboy.mov** layer. Select **Effect > Keying > Keylight**. This applies the plug-in effect to the layer.

4. In the Effect Controls panel, go to the Screen Colour property and select the **eye dropper** icon to activate the tool.

5. Go to the Comp panel and click on the green area surrounding the outlaw. As soon as you click, the green screen background disappears revealing the background image. That was easy!

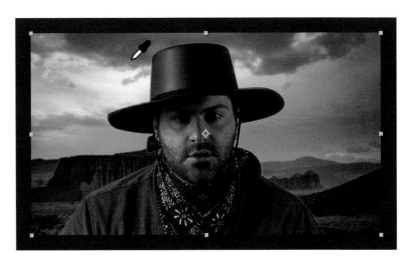

6. In the Effect Controls panel, select **Screen Matte** from the View pop-up menu. The Screen Matte displays the alpha channel mask in your keyed footage as a grayscale image. Remember, areas of black are transparent; areas of white are opaque. Notice that there are still shades of gray in the video. Although the Keylight plug-in is very effective at keying, you still need to help it out a little.

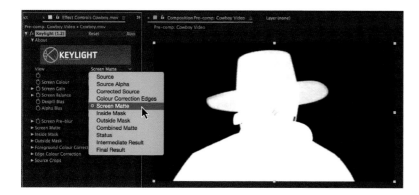

The Screen Matte view displays the alpha channel as a grayscale image.

7. Twirl open the Screen Matte properties in the Effect Controls panel.

• Change the Screen Pre-blur property to **1.0**. This smooths the edges.

• Change the Clip Black property to **15**. This increases the black levels.

• Change the Clip White property to **85**. This increases the white levels.

8. Select **Final Result** from the View pop-up menu. Now that you have keyed out the green background, there is still a slight halo fringe surrounding the edges of the cowboy.

9. With the **Cowboy.mov** layer still highlighted. Select **Effect > Matte > Simple Choker**. **Choking** refers to shrinking the matte to get rid of a halo of pixels around an image. Go to the Effect Controls panel and set the Choke Matte to **1.00**. This eliminates the halo.

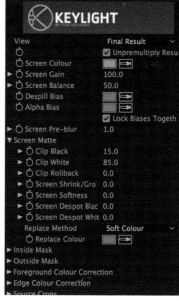

Use a combination of the Keylight and Simple Choker effects to remove the green background from the video.

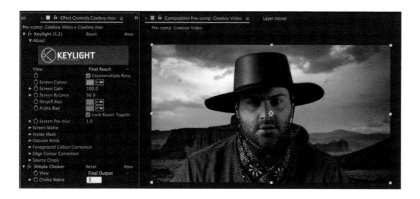

10. Click on the **Play/Stop** button to see the transition effect. Save your project. Select **File > Save**.

Preview the keying effect. In After Effects, the keying process actually generates an alpha channel mask around your subject.

The wanted poster composition has already been animated. Take a look at the keyframes that were created to wipe on the blood splatter graphic and the director's name.

11. Go to the Project panel. Double-click on the **Pre-comp: Wanted_Poster** composition. A layered Photoshop file was imported with the Composition – Retain Layer Sizes option selected. The dimensions of the artwork are larger than the final composition's height and width. This provides the freedom to reposition, scale and rotate the comp without having the images pixelate.

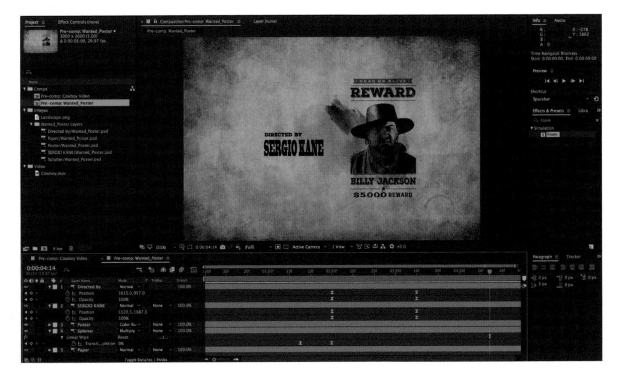

Put the End Title Sequence Together

1. Select **Composition > New Composition**. Make the following settings in the dialog box that appears:

- Composition Name: **Main Comp: End Credits**
- Preset: **HDV/HDTV 720 29.97**
- Duration: **0:00:06:00** (6 seconds)
- Click **OK**.

2. Click and drag the **Pre-comp: Cowboy Video** composition from the Project panel to the Timeline.

3. Move the **Current Time Indicator** (CTI) to the **one-second** and **frame 20** mark (**0:00:01:20**).

4. Click and drag the **Pre-comp: Wanted_Poster** composition from the Project panel to the Timeline. Position it at the top of the stacked layers. Click and drag the colored bat to align its left edge with the CTI.

5. Move the **Current Time Indicator** (CTI) to **two seconds (02:00)**.

Add the two nested pre-compositions.

6. Select the **Pre-comp: Wanted_Poster** layer in the Timeline.

- Type **P** on the keyboard to open the Position property.
- Set the Position numeric values to **83.0, 371.0**. These coordinates align the illustration of the cowboy with the video footage.
- Type **Shift + S** on the keyboard to open the Scale property.
- Type **Shift + R** on the keyboard to open the Rotation property.
- Click on the **stopwatch** icons next to Position, Scale, and Rotation.

Set keyframes for the layer's Position, Scale, and Rotation Transform properties.

7. Move the **Current Time Indicator** (CTI) to **three seconds (03:00)**.

• Set the Position numeric values to **436.0, 394.0**.

• Set Scale value to **60%**.

• Set the Rotation value to **0x -6.0°**.

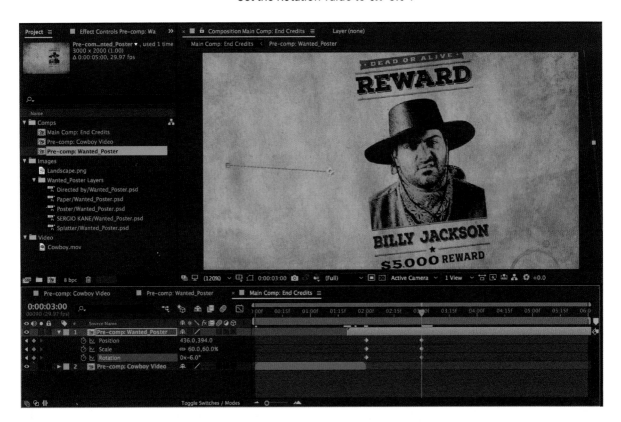

Animate the Position, Scale, and Rotation to reveal the wanted poster.

8. Move the **Current Time Indicator** (CTI) to **three seconds** and **10 frame** mark (**0:00:03:10**).

9. Click on the **gray diamonds** to the left of the word Position, Scale, and Rotation to record keyframes without having to change the layer's opacity manually.

Set keyframes for the Position, Scale, and Rotation Transform properties.

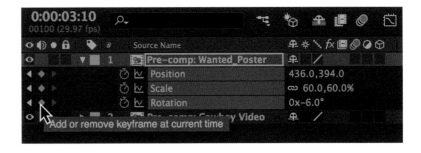

10. Move the **Current Time Indicator** (CTI) to the **five-seconds** and **frame 20** mark (**0:00:05:20**).

• Set the Position numeric values to **1230.0, 452.0**.

• Set Scale value to **100%**.

• Set the Rotation value to **0x +0.0°**.

11. Click and drag a marquee selection around all of the keyframes to select them. Select **Animation > Keyframe Assistant > Easy Ease** to smooth the animation.

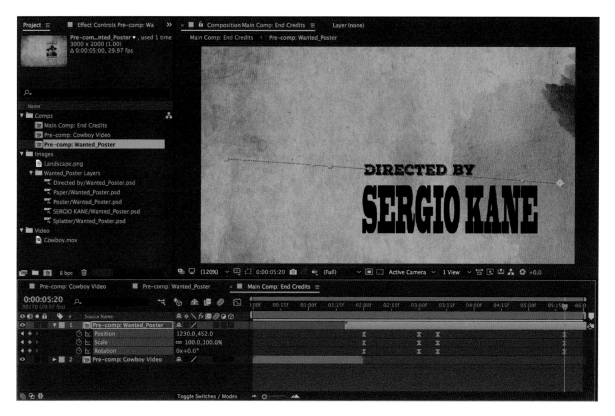

12. Click on the **Play/Stop** button to see the animation. The project is looking good. However, the current way the layers are editing together for the match frame creates a hard cut. A **cut** is one shot that allows you to easily change the length and/or order of the scene. Cutaways serve to enhance the story. Any shot can act as a cutaway, as long as it relates to and reinforces the main action. The goal in editing a scene is that you want the audience to presume that time and space has been uninterrupted. Save your project.

Preview the animation to see how the two shots are edited together.

Create a Track Matte

1. Move the **Current Time Indicator** (CTI) to **one second** and **20 frame** mark (**0:00:01:20**).

2. Deselect all the layers in the Timeline. Click in the gray area below the bottom layer, or use the keyboard shortcut of **Command/Control + Shift + A**.

3. Press and hold on the **Rectangle** Tool to open the pop-up menu. Select the **Star** Tool from the pop-up menu. Make sure no layers are selected in the Timeline.

4. Go to the Comp panel. Click and drag a star shape in the center of the composition.

- Set the Shape Layer's Fill color to white.

- Set the Shape Layer's Stroke mode to None.

Create a Shape Layer in the Comp panel.

5. Go to the Timeline. Rename **Shape Layer 1** by selecting it and pressing the **Return/Enter** key on the keyboard. Rename the layer **Track Matte**.

Rename the Shape Layer in the Timeline. Select the layer and press the **Return/Enter** key on the keyboard.

6. Select the **Track Matte** layer. Hold down the **Command/Control** key and double-click on the **Pan Behind** (Anchor Point) Tool in the Tools panel. This is a shortcut that moves the Anchor Point to the center of the Shape Layer.

7. Click on the **Selection** (Arrow) Tool in the Tools panel.

8. Type **S** on the keyboard to open the Scale property. Set Scale value to **0%**. Click on the **stopwatch** icon 🎯 next to Scale.

9. Move the **Current Time Indicator** (CTI) to the **one-second** and **frame 25** mark (**0:00:01:25**).

10. Set Scale value to **1500%**. This scales the Shape Layer to fill the entire screen.

11. Click and drag a marquee selection around the two Scale keyframes to select them. Select **Animation > Keyframe Assistant > Easy Ease** to smooth the animation.

12. Select the **Pre-comp: Wanted_Poster** layer in the Timeline panel.

13. Click on the **Toggle Switches / Modes** button at the bottom of the Timeline panel.

Scale the Shape Layer to cover the entire screen in the Comp panel.

14. Define the transparency for the track matte by choosing the **Alpha Matte "Track Matte"** option from the Track Matte menu for the **Pre-comp: Wanted_Poster** layer.

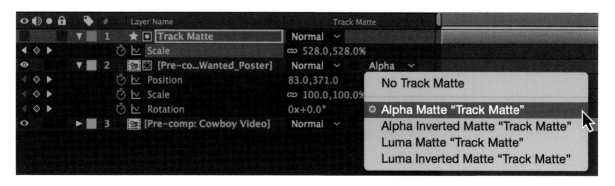

15. Click on the **Play/Stop** button to see the track matte in action. This completes the exercise. Experiment with the project.

16. When you are done, select **Composition > Add to Render Queue**.

- Click on **Lossless** next to Output Module.

- Set the Format to **QuickTime**.

- Click on **Format Options** and set the video codec to **H.264**.

- Click **OK**. Click **OK** again.

- Click on **Output To** and select your hard drive.

- Click the **Render** button.

17. Save your project. Select **File > Save**.

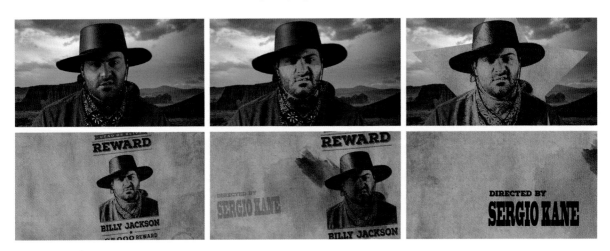

Render the final end title sequence. The sepia tones and typeface visually reinforce the old western theme for the film.

Summary

This completes the chapter on title sequences in motion. Successful film titles become part of the visual narrative and establish a sense of place, communicate the story's theme, and even hint at a few plot points. A designer needs to incorporate the design principles such as balance, proximity, emphasis, and space in the composition. Visual properties such as color, value, and texture establish a pictorial consistency.

This chapter also introduced you to simulating depth through parallax scrolling. Blending modes allow you to mix hues, values, saturation, and brightness of stacked layers in After Effects. Finally, the keying process generates an alpha channel mask around your subject. This mask hides the green or blue chroma background.

The next chapter focuses on 3D space in motion.

8

3D Space in Motion

Step into the third dimension. After Effects allow you to position and animate layers in 3D space. It also explores the workflow between After Effects and CINEMA 4D. This chapter introduces CINEMA 4D Lite and how to start integrating 3D models into your motion design projects using the CINEWARE plug-in. Continue your journey in creativity using the Z-axis as your guide.

At the completion of this chapter, you will be able to:

- Create and animate 3D layers in After Effects
- Model extruded type in CINEMA 4D Lite
- Apply materials in CINEMA 4D Lite
- Add Lights in CINEMA 4D Lite
- Use the 3D Camera Tracker in After Effects
- Composite a 3D Object with CINEWARE

Entering 3D Space in After Effects

Up to this point in the book, you have worked exclusively in two dimensions – X and Y. After Effects travels beyond 2D by allowing you to move layers along the Z-axis (depth). In addition, you can add cameras, and even lights that illuminate 3D layers, creating realistic cast shadows. Similar to any 3D modeling application, After Effects divides its screen coordinate system into three axes.

- The **X-axis** runs horizontally across the composition with its origin, or 0-point at the left edge.
- The **Y-axis** runs vertically, with its 0-point at the top edge of the composition.
- The **Z-axis** runs into and out of the plane of the composition (toward and away from the viewer), with its 0-point at the plane of the composition.

The 3D coordinate system in After Effects.

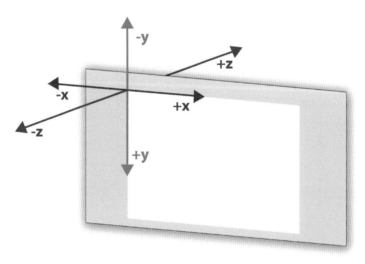

Download the **Chapter_08.zip** file at *www.routledge.com/cw/jackson*. It contains all the files needed to complete the chapter exercises.

Before you begin the exercises, download the **Chapter_08.zip** file to your hard drive. It contains all the files needed to complete the chapter exercises. The first exercise starts with the basics, converting text layers into 3D layers in After Effects. Any layer, other than an adjustment layer, can be positioned in 3D space as long as it contains content. The motion design project is a 3D title card for a fictitious television show called "Cabin Flip." To see what you will build, launch the **3D_Title.mov** file in the **Completed** folder inside **Chapter_08**.

Chapter Exercise 1:
Animated Text Layers in 3D Space

In Chapter 3, you were introduced to the text engine in After Effects. You animated characters in two-dimensional space. There is an option available to transform text along the X, Y, and Z-axis. Let's explore it.

1. Open the **01_3D_Text_Start.aep** file inside the **01_3D_Text** folder in **Chapter_08**. If the **3D Text** composition is not open, double-click on it in the Project panel.

2. Select the **CABIN** layer in the Timeline and twirl open the text layer to display the Text and Transform sections. In the **Text** section, click on the **arrow** next to the word **Animate**. The pop-up menu contains all the Text properties you can animate on a per-character basis. Select **Enable Pre-character 3D**.

The composition contains four layers.

Three of the layers are text layers.

Turn the text layer into a 3D layer.

When a layer is converted into a 3D layer, it acquires the Z-axis. There are now six Rotate properties to choose from. A new transform property called Orientation represents the layer's absolute rotational XYZ angles.

It is best to use the other XYZ Rotation properties for any type of 3D animation. Only use Orientation to set a 3D layer's rotation angle that does not animate.

X Rotation rotates the layer around the X-axis. A positive value for the X Rotation swings the text layer into the composition.

Two small boxes appear in the 3D Layer switch column. The red, green, and blue XYZ axis tool also appears at the anchor point for the text layer. Notice that the location of the anchor point has been repositioned to the top-center of the layer. This will allow the text to animate correctly.

3. Press the **Home** key to move the **Current Time Indicator** (CTI) to the beginning of the Timeline (**00:00**).

4. Type **R** on the keyboard to display the text layer's Rotation property. Select the **X Rotation** value. Scrub through the second value and set it to **0x-86°**. Click on the **stopwatch** icon for Rotation.

5. Let's use the follow-through animation principle to create an animation of the type swinging open. The motion will also reflect the concept of the television show's premise of house flipping.

- Move the **Current Time Indicator** (CTI) to **frame 15 (0:00:00:15)**.
- Set the X Rotation property to **0x+60.0°**.
- Move the **Current Time Indicator** (CTI) to **one second (01:00)**.
- Set the X Rotation property to **0x-40.0°**.
- Move the **Current Time Indicator** (CTI) to the **one-second** and **frame 15** mark (**0:00:01:15**).
- Set the X Rotation property to **0x+40.0°**.
- Move the **Current Time Indicator** (CTI) to **two seconds (02:00)**.
- Set the X Rotation property to **0x-20.0°**.
- Move the **Current Time Indicator** (CTI) to the **two-seconds** and **frame 15** mark (**0:00:02:15**).
- Set the X Rotation property to **0x+20.0°**.
- Move the **Current Time Indicator** (CTI) to **three seconds (03:00)**.
- Set the X Rotation property to **0x-10.0°**.
- Move the **Current Time Indicator** (CTI) to the **three-seconds** and **frame 15** mark (**0:00:03:15**).
- Set the X Rotation property to **0x+10.0°**.

- Move the **Current Time Indicator** (CTI) to **four seconds (04:00)**.

- Set the X Rotation property to **0x-5.0°**.

- Move the **Current Time Indicator** (CTI) to the **four-seconds** and **frame 15** mark (**0:00:04:15**).

- Set the X Rotation property to **0x+5.0°**.

- Move the **Current Time Indicator** (CTI) to **five seconds (05:00)**.

- Set the X Rotation property to **0x+0.0°**.

6. Apply an Easy Ease to all the Rotation keyframes to smooth the animation.

7. Click on the **Play/Stop** button to see the text animation and follow-through action. Save your project. Select **File > Save**.

A negative value for the X Rotation swings the text layer out from the composition.

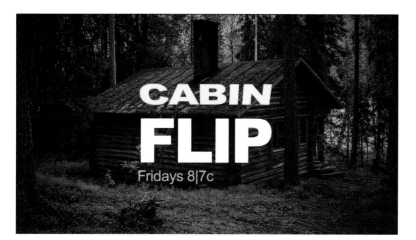

You may have noticed that the 3D layer does not contain any thickness to it. After Effects allows you to position flat 2D layers in three-dimensional space. Think of it as holding a sheet of paper up in front of you and turning it from side to side.

8. Click and drag a marquee selection around the all of the Rotation keyframes to select them. Copy them by selecting **Edit > Copy** or use the keyboard shortcut of **Command/Control + C**.

9. Press the **Home** key to move the **Current Time Indicator** (CTI) to the beginning of the Timeline (**00:00**).

10. Select the **FLIP** layer in the Timeline and twirl open the text layer. In the **Text** section, click on the **arrow** ▶ next to the word **Animate**. Select **Enable Pre-character 3D**.

11. Type **R** on the keyboard to display the text layer's Rotation property. Click on the **X Rotation** value and select **Edit > Paste** or use the keyboard shortcut of **Command/Control + V**. The copied keyframes appear starting at the beginning of the composition.

12.. Click on the **Play/Stop** button to see the text animation. Save your project. Select **File > Save**.

Copy and paste the rotation keyframes for the second text layer. Both layers now swing in unison.

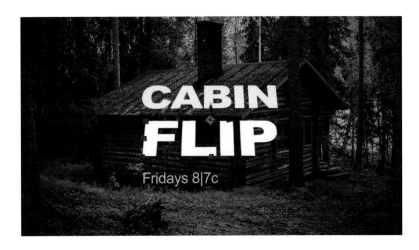

Use Parenting to Link the Layers

In Chapter 6, you learned about parenting in After Effects. The next part of the exercise will use this method to attach the **FLIP** layer (child) to the **CABIN** layer (parent). This will enhance the swinging text animation.

1. Press the **End** key to move the **Current Time Indicator** (CTI) to the end of the composition.

2. To set up the parenting structure, you need to open the Parent column in the Timeline panel. If it is not already visible, right-click on the **Layer Name** column header and select **Columns > Parent**.

3. Click on the **spiral icon** (pick whip) for the **FLIP** layer and drag it to the name column of the **CABIN** layer. Release the mouse. You just linked the two layers together.

Use the Pick Whip to link the two text layers together.

4. Press the **Home** key to move the **Current Time Indicator** (CTI) to the beginning of the composition (**00:00**).

5. Select the **FLIP** layer. Delete the **first keyframe** at the beginning of the Timeline (**00:00**). You are going to create the illusion that the title is unfolding on screen. The word "FLIP" will now only appear after the word "CABIN" has completed one swing movement.

6. Move the **Current Time Indicator** (CTI) to **frame 15 (0:00:00:15)**.

- Set the X Rotation property to **0x+33.0°**.

- Press **Option/Alt + [** on the keyboard to trim the layer's Set in Point.

Change the Rotation value to 33° and trim the layer's Set In Point. This flattens the 3D layer in the composition.

- Move the **Current Time Indicator** (CTI) to **four seconds (04:00)**.

- Set the X Rotation property to **0x-2.0°**.

- Move the **Current Time Indicator** (CTI) to the **four-seconds** and **frame 15** mark (**0:00:04:15**).

- Set the X Rotation property to **0x+2.0°**.

7. Turn on the **Motion Blur** switches for the text layers in the Timeline. In order to see the motion blur in the Comp panel, click on the master **Enable Motion Blur** button at the top of the Timeline.

Fade In the Time

1. Move the **Current Time Indicator** (CTI) to **three-seconds (03:00)**.

2. Select the **Fridays 8|7c** text layer and type **T** on the keyboard to open the Opacity property. Scrub through the Opacity numeric value and set it to **0%**. Click on the **stopwatch** icon next to Opacity.

3. Move the **Current Time Indicator** (CTI) to **four seconds (04:00)**. Scrub through the Opacity numeric value and set it back to **100%**.

4. Apply an Easy Ease to both of the Opacity keyframes.

Scale the Background Image

1. Press the **Home** key to move the **Current Time Indicator** (CTI) to the beginning of the composition (**00:00**).

2. Select the **Cabin.png** layer and type **S** on the keyboard to open the Scale property. Click on the **stopwatch** icon next to Scale.

3. Press the **End** key to move the **Current Time Indicator** (CTI) to the end of the composition.

4. Set the Scale value to **110%**. This will create a subtle zoom effect and make the composition a little more dynamic.

5. Apply an Easy Ease to both of the Scale keyframes.

6. Click on the **Play/Stop** button to see the 3D text animation and follow-through action. This completes this exercise. Experiment with the project.

7. When you are done, select **Composition > Add to Render Queue**.

- Click on **Lossless** next to Output Module.

- Set the Format to **QuickTime**.

- Click on **Format Options** and set the video codec to **H.264**. Click **OK**.

- Click **OK** again. Click on **Output To** and select your hard drive.

- Click the **Render** button.

8. Save your project. Select **File > Save**.

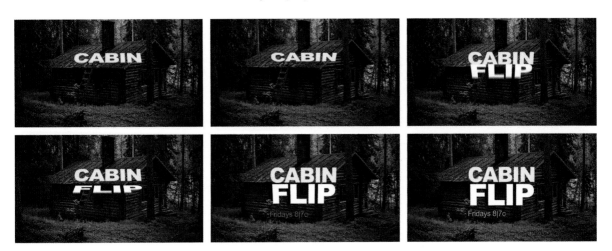

The composition matches the layer structure in the Illustrator file.

Chapter Exercise 2
Adding and Animating 3D Lights

Lighting is just as important to a 3D scene as its objects. Dramatic lighting and shadows can turn a dull scene into a masterpiece. This next exercise continues to explore transforming layers in 3D space and adds Light layers to create shadows to enhance the depth.

1. Open the **01_3D_Lights_Start.aep** file inside the **01_3D_Light** folder in **Chapter_08**. If the **Title Card** composition is not open, double-click on it in the Project panel. The composition is made up of four vector layers created in Adobe Illustrator.

2. Working in 3D often involves scaling layers above 100% which can affect image quality. Turn on the **Continuously Rasterize** switch (sunburst icon) for all the layers in the Timeline. This will maintain the crisp, vector path for each layer.

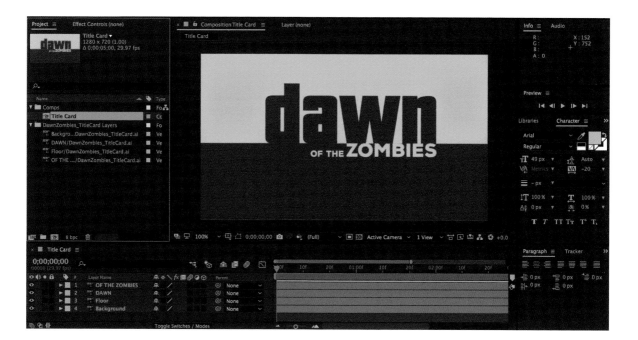

3. In the Timeline panel, locate the 3D Layer switch in the switches column. Its icon is a cube 🧊. Turn on the 3D Layer switches for all the layers. Nothing much happened in the Comp panel, but take a look at the transform properties.

The composition matches the layer structure in the Illustrator file.

Turn on the 3D Layer switches. With 3D enabled, the Z-axis is added to the Position Transform property with a default value of 0.0.

4. Press the **Home** key to move the **Current Time Indicator** (CTI) to the beginning of the composition (**00:00**).

5. Select the **Background** layer. Type **P** on the keyboard to open the Position property. The three numerical values represent the XYZ-axis. Changing the X-position of a layer moves it left or right. Changing the Y-position moves a layer up or down. The Z-axis moves a layer toward or away from the active camera.

6. Change the Position values to **640.0, 360.0, 500.0**. The last value moves the layer away from the active camera. This will provide space to place a light in between the background layer and the text.

7. Type **Shift + S** on the keyboard to open the Scale property.

8. Increase the Scale value to **140%** to fit the layer in the Comp panel.

9. Select the **Floor** layer. Type **P** on the keyboard to open the Position. Change the Position values to **640.0, 565.0, 0.0**.

10. Type **Shift + R** on the keyboard to open the Rotation properties. Set the X Rotation property to **0x-75.0°**. This will create a good angle for the layer to display any cast shadows.

11. Type **Shift + S** on the keyboard to open the Scale property. Increase the Scale value to **250%** to fit the layer in the Comp panel.

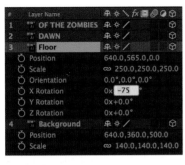

Rotate the **Floor** layer along the X-axis.

12. Select the **DAWN** layer. Type **P** on the keyboard to open the Position. Change the Position values to **660.0, 340.0, 360.0**.

13. Select the **OF THE ZOMBIES** layer. Type **P** on the keyboard to open the Position. Change the Position values to **750.0, 460.0, 280.0**.

14. The Comp panel currently displays a limited view of the new 3D positioning. Go to the Comp panel. From the 3D View pop-up menu, change the view from **Active Camera** to **Custom View 1**. The Comp panel now displays a better angle to see the 3D positioning. There are several views to choose from.

The Active Camera view is the default and the view that will be rendered when you export your final movie. Use the other views to position and align the 3D layers. Before you render, return to the Active Camera view the final composition.

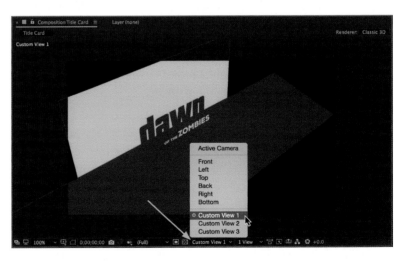

15. Return the 3D view to the **Active Camera** view. Now that you have composed the 3D scene, it is time to add some lights.

Add 3D Lights

1. Let's add a light to the composition. Select **Layer > New > Light**. The Light Settings dialog box appears.

- Enter **Sunlight** for the light name.
- Set the Light Type to **Point**.
- Increase the Intensity value to **150%**.
- Set the falloff to **Smooth**.
- Click **OK**. The default lighting is replaced by the new light layer.

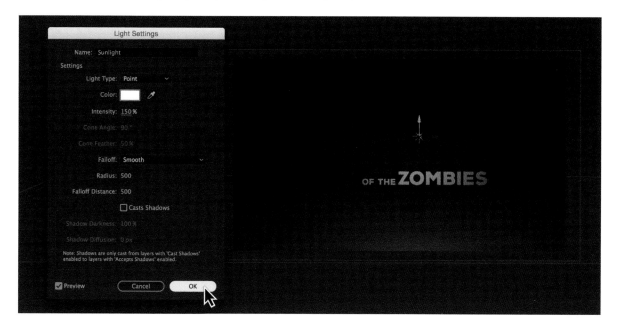

2. Select the **Sunlight** layer. Type **P** on the keyboard to open the Position property. Change the Position values to **655.0, 150.0, 250.0**.

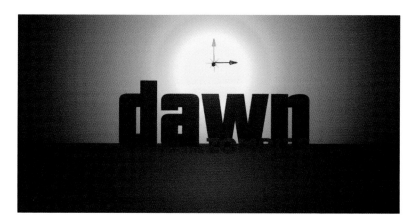

A **point light** is an omnidirectional light source. Think of it as a bare light bulb. When a light is added to a composition, the default lighting turns off. Lights only affect 3D layers.

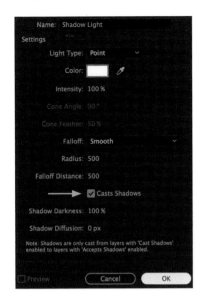

Add another light to the composition. This light will cast shadows onto the **Floor** layer.

Material Options define the surface properties for a 3D layer, including shadows and light transmission.

The text now casts shadows based on the positioning of the lights in the scene.

3. Let's add another light. Select **Layer > New > Light**. The Light Settings dialog box appears. Make the following changes:

- Enter **Shadow Light** for the light name.
- Set the Light Type to **Point**.
- Set the Intensity value to **100%**.
- Set the falloff to **Smooth**.
- Turn on Casts Shadows by clicking in its check box.
- Click **OK**.

4. Select the **Shadow Light** layer. Type **P** on the keyboard to open the Position property. Change the Position values to **655.0, 220.0, 500.0**. In order to see any shadows, you need to enable which 3D layers will cast shadows and which 3D layers will accept shadows.

5. Select the **OF THE ZOMBIES** layer. Type **A twice (AA)** on the keyboard to open the Material Options for the layer.

- Turn **On** the Casts Shadows property.
- Turn **Off** the Accepts Lights property.

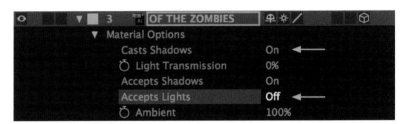

6. Select the **DAWN** layer. Type **A twice (AA)** on the keyboard to open the Material Options for the layer. Turn **On** the Casts Shadows property.

Animate the 3D Layers and Lights

1. Move the **Current Time Indicator** (CTI) to **four seconds (04:00)**.

2. Make sure the **DAWN** layer is still selected. Type **P** on the keyboard to open the Position property. Click on the **stopwatch** icon next to Position to start recording keyframes.

3. Select the **OF THE ZOMBIES** layer. Type **P** on the keyboard to open the Position property. Click on the **stopwatch** icon next to Position.

4. Select the **Sunlight** layer. Twirl open its Transform and Light Options properties. Click on the **stopwatch** icons next to Position and Intensity to start recording keyframes.

The text now casts shadows based on the positioning of the lights in the scene.

5. Move the **Current Time Indicator** (CTI) to **two seconds (02:00)**.

6. Select the **OF THE ZOMBIES** layer. Change the Position values to **750.0, 525.0, 280.0**. This lowers the text underneath the floor layer.

Lower the text layer underneath the **Floor** layer. Note that 3D layers will move in front of other layers based on their higher Z Position value, regardless of their stacking order in the Timeline.

7. Press the **Home** key to move the **Current Time Indicator** (CTI) to the beginning of the composition (**00:00**).

8. Select the **DAWN** layer. Change the Position values to **660.0, 630.0, 360.0**. This lowers the text underneath the floor layer.

9. Select the **Sunlight** layer. Change the Position values to **655.0, 800.0, 250.0**. Lower the Intensity value to **30%**.

10. Apply an Easy Ease to all the new keyframes to smooth the animation.

11. Click on the **Play/Stop** button to see the 3D animation and shadow effect. Save your project. Select **File > Save**.

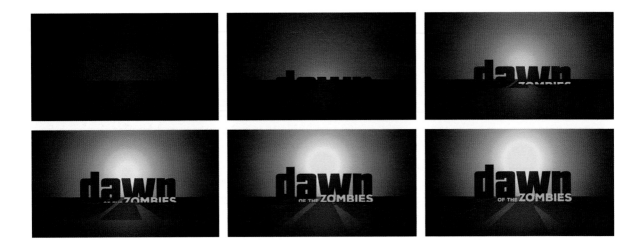

The completed project demonstrates how lighting can affect 3D layers in After Effects.

12. This completes this exercise. Experiment with the project. Try animating the other light to change the shadows over time.

13. When you are done, select **Composition > Add to Render Queue**.

- Click on **Lossless** next to Output Module.

- Set the Format to **QuickTime**.

- Click on **Format Options** and set the video codec to **H.264**. Click **OK**.

- Click **OK** again. Click on **Output To** and select your hard drive.

- Click the **Render** button.

14. Save your project. Select **File > Save**.

What is CINEMA 4D Lite and CINEWARE?

MAXON CINEMA 4D is one of the leading 3D software packages used today to create stunning 3D motion graphics, product visualizations, video game assets, and much more. It provides an intuitive, user-friendly interface and set of tools for 3D modeling, texturing, lighting, animation, and rendering. After Effects CC includes a Lite version of CINEMA 4D.

In CINEMA 4D Lite, you create a 3D scene using wireframe objects that can be viewed from any angle by a virtual camera. The basic 3D workflow consists of creating and arranging 3D objects; applying color and texture; lighting the scene; viewing the scene with cameras; setting keyframes for animation; and rendering an image or animation.

CINEWARE is a plug-in and integral part of the entire After Effects and CINEMA 4D Lite workflow. The plug-in serves as a bridge, connecting the two software packages together. CINEWARE displays in the Effect Controls panel in After Effects and acts as a real-time interface between a composition in After Effects and the CINEMA 4D render engine.

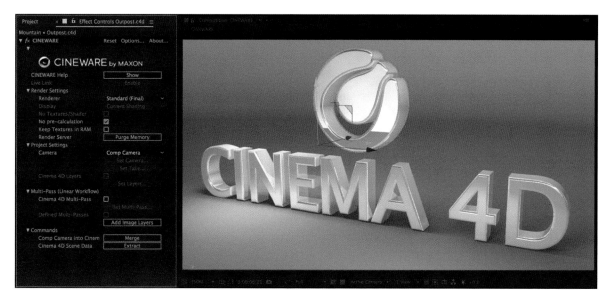

Chapter Exercise 3:
Using a 3D Tracker with CINEWARE

After Effects provides a 3D Camera Tracker effect that analyzes each frame of a video and extracts the camera motion and 3D scene data. This data allows you to accurately composite 3D objects from CINEMA 4D Lite over your 2D video footage. In this exercise, you will explore how to use the 3D Camera Tracker with CINEWARE.

CINEMA 4D Lite provides an extensive set of tools, features, and functions to create 3D content for After Effects. If you have the professional version of CINEMA 4D, you can use that directly as CINEWARE will open native CINEMA 4D files.

1. Open the **03_Cinema4D_Start.aep** file inside the **03_CINEWARE** folder in **Chapter_08**. If the **Mountain** composition is not open, double-click on it in the Project panel. The composition contains one layer created from a QuickTime movie footage.

2. To track the motion, make sure the **Mountain.mov** layer is selected in the Timeline. Select **Animation > Track Camera**. The 3D Camera Tracker effect is applied to the layer and it automatically begins analyzing each frame of the video. After Effects does all the hard work for you. The status of the tracker analysis appears as a banner on the footage in the Composition panel.

The 3D Camera Tracker examines each frame in the video footage.

3. Once the automatic analysis is complete, tiny cross track points appear on top of the video. These track points are scaled to reflect their relative distance from the camera. Move the mouse cursor over the points and you will see a red bullseye target that reveals their orientation in the moving scene.

3D track points display the tracked motion in the Comp panel.

4. Move the **Current Time Indicator** (CTI) to **five seconds (05:00)**.

5. To position the target, you need to select at least three track points. You can also drag a selection around specific points. For this exercise, hold down the Shift key and Shift-select six green track points near in the middle of the landscape.

Select at least three track points to position the bullseye target.

6. You can define a ground plane and origin (the 0-0-0 point) of the coordinate system within the 3D Camera Tracker effect. **Right-click** (Windows) or **Control-click** (Mac OS) on the bullseye target and choose **Set Ground Plane and Origin**.

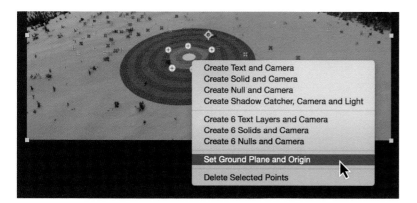

Record a ground plane and origin point for the 3D Camera Tracker effect. You will not see any visible results, but the reference plane and origin of the coordinate system are saved for this scene. This is a very important step as it will allow you to correctly place a CINEMA 4D object on top of the video using this plane and origin point.

7. Go to the Effect Controls panel and click on the **Create Camera** button. This creates the 3D Camera Tracker layer in the Timeline.

8. Save your project. Select **File > Save**.

Create a 3D Model in CINEMA 4D Lite

As you can see, tracking 3D motion in a 2D video is rather simple. The next step is to create the 3D text in CINEMA 4D Lite. This 3D object will be positioned in After Effects using both the saved 3D camera tracking data and the CINEWARE Project Settings.

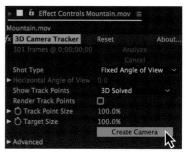

Create a camera using the 3D Camera Tracker effect.

1. To create a CINEMA 4D layer, make sure the Timeline panel is active and highlighted. Select **Layer > New > MAXON CINEMA 4D File**.

2. Save the project as **TrackText.c4d** in the **Footage** folder inside the **03_CINEWARE** folder. Click **Save**.

After saving the file, CINEMA 4D Lite automatically launches and opens the new file. CINEMA 4D Lite's user interface consists of menus, icon panels that contain shortcuts to frequently used commands, a main viewport that displays the 3D scene, and managers that "manage" all aspects of your 3D content. The four main managers include:

- **Objects Manager:** This lists all of the elements in the scene. It is formatted as a tree-based structure displaying objects and their hierarchy in a scene.

- **Attributes Manager:** This provides contextual information and properties for selected objects and tools. When you create a new file,

the Attributes Manager displays information about the document file including its frame rate and number of frames in the timeline.

- **Coordinates Manager:** This is used for precision modeling or manipulation as it provides numerical data on a selected object's position, size, and rotation that can be used as information or modified to change the object.

- **Materials Manager:** This contains all of the shaders and materials used in the 3D scene. Materials define the surface texture of a 3D object and include several parameters such as color, reflectivity, refraction, and transparency.

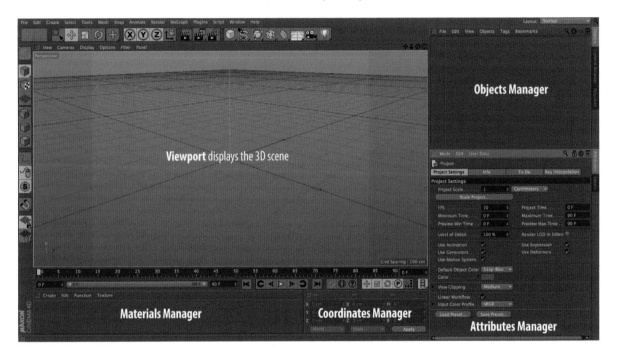

The four main managers and viewport in CINEMA 4D Lite.

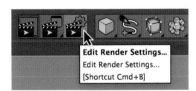

3. Locate the three **clapboard** icons in the top center of the user interface. Click on the icon to the right that has the sprocket. This will open the Render Settings dialog box. Since this CINEMA 4D file will be rendered out of After Effects, you need to set the output to match the video's resolution.

4. Click on the **arrow** icon under Output. From the preset pop-up menu, select **Film/Video> HDV/HDTV 720 29.97**. When you are done, close the Render Settings dialog box.

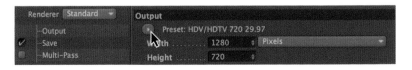

5. Go to the Timeline Ruler under the viewport window editor. The default duration for an animation in CINEMA 4D Lite is 90 frames. Type in **300** in the text entry dialog box. To see all frames in the Timeline Ruler, click on the right arrow icon next to **300 F** and drag to the right.

The first step in a 3D modeling workflow is the creation of a model. Basically, a **model** is a collection of 3D objects arranged together in a scene. CINEMA 4D provides a set of objects to start the 3D modeling process. In this exercise you will build 3D text using a **spline** object and a **NURB generator**.

Change the duration of the Timeline Ruler to 300 frames.

Splines are vertices (dots) connected by lines in 3D space. A spline has no three-dimensional depth, but with the combination of NURBS you can create complex 3D objects. NURBS are generators. Common types of NURBS are extrude, lathe, loft, and sweep.

An extruded NURB takes a 2D spline and extends it along a path.

6. Locate the spline icon above the viewport window. Click and hold the icon to reveal the pop-up palette of spline shapes. While this palette is open, left-click on the **Text** icon to add a text spline.

Locate the spline icon in the icon panel above the viewport.

7. Make sure the Text spline is selected. Go to the Attributes Manager and make the following changes:

- Change the text to **YUKON**.
- Change the font to **Impact**.
- Increase the Height to **300 cm**.
- Change the Align property to **Middle.**
- Decrease the value of the Horizontal Spacing property to **-5 cm**.

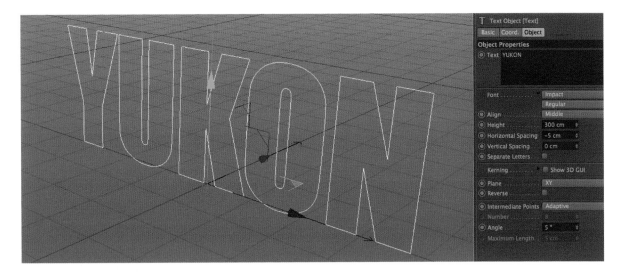

Use the Attributes Manager to modify the Text spline object.

Add an Extrude NURB to the 3D scene.

8. Select the **Extrude** NURBS from the Generators object palette above the viewport. In the Objects Manager, an Extrude NURBS object appears above the Text spline.

9. Go to the Objects Manager. Click and drag the **Text** spline into the **Extrude** NURBS object. In the viewport, the 2D text becomes a 3D extruded object. The NURB automatically extends the Text spline along its Z-axis.

10. Make sure the **Extrude** NURBS is selected. Go to the Attributes Manager and increase the Z-Movement value to **50**.

11. Go to the Materials Manager. Select **Create > New Material**. A preview of the new material appears in the manager's panel.

12. Double-click on the **Mat** icon to open the Material Editor dialog box. Each material in CINEMA 4D has several channels that you can turn on and modify. While the **Color** channel is selected, make the following changes:

- Click on the **Texture** arrow and select **Load Image** from the pop-up menu.

- Locate the **Concrete.psd** file in the **tex** folder inside the **Footage** folder.

- Click **Open**.

13. Click on the checkbox for the **Bump** channel. To give the concrete texture a more tactile look, you will import a grayscale version of it.

- Click on the **Texture** arrow and select Load Image from the pop-up menu.

- Locate the **ConcreteBump.psd** file in the **tex** folder.

- Click **Open**.

- Increase the Strength value to **50%**.

- When you are done, close the Material Editor dialog box.

Textures give a model color, highlights, and other important surface properties.

Load a raster image as the texture.

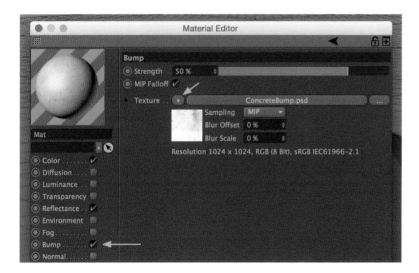

Load a raster image into the Bump channel. A **bump map** creates a tactile look and feel for a surface. Bump maps use a grayscale bitmap to generate the bumps and divots. This channel only affects the texture's appearance not the object's geometry.

CINEMA 4D allows you to apply a material to an object by dragging the material onto the object in the viewport. You can also drag a material onto the name of an object in the Objects Manager.

14. Click and drag the new material from the Materials Manager and drop it onto the **Extrude** name in the Objects Manager. The object changes color in the viewport. A Texture Tag appears to the right of the **Extrude** object in the Objects Manager.

15. Click on the **Texture Tag** 🔲 for the **Extrude** object in the Objects Manager. Go to the Attributes Manager and change the following settings to adjust the placement of the texture on the 3D object:

 - Increase the Offset V to **50%**.

 - Increase the Length V value from **100%** to **150%**.

 - Change the Projection to **Cubic**.

Materials are applied to the wireframe surface of a 3D object. Cubical mapping applies the material from six directions and the texture is on each side.

Add Lights to the 3D Scene

Lighting is just as important to a 3D scene as its objects. CINEMA 4D provides several different types of lights including omni and spot lights. The default light is an omni light which acts like a light bulb. It is positioned slightly to the left of the default camera. This light is completely white and doesn't cast any shadow.

1. Let's add some new lights to the scene. Click on the **Light** icon to add a new light source. Notice that the default lighting is turned off as soon as you add the Light object.

2. With the Light object selected in the Objects Manager, go to the Attributes Manager and click on the General tab.

 - Change the RGB Color values to R = **170**, G = **165**, B = **140**.

 - Keep the Intensity value at **100%**.

 - Set the Shadows property to **Shadow Maps (Soft)**.

Modify the Light object's parameters in the Attributes Manager. Use the tabs along the top of the manager to change different properties such as shadows and light emission.

3. In the Attributes Manager, click on the **Details** tab.

- Set the Falloff property to **Inverse Square (Physically Accurate)**. This will simulate realistic falloff of the light over the extruded text.

- Change the Radius/Decay of the falloff to **1500 cm**.

4. In the Attributes Manager, click on the **Coord.** tab.

- Set the X-Position to **-400 cm**.

- Set the Y-Position to **950 cm**.

- Set the Z-Position to **100 cm**.

5. The goal is to create lighting that matches the color and position of the lights in the video. Click on the **Light** icon again to add a second light to the 3D scene. With the **Light.1** object selected in the Objects Manager, go to the Attributes Manager and click on the General tab.

- Change the RGB Color values to R = **255**, G = **210**, B = **255**. This matches the pink hue in the QuickTime video.

- Decrease the Intensity value at **75%**.

- Set the Shadows property to **Shadow Maps (Soft)**.

6. In the Attributes Manager, click on the **Coord.** tab.

- Set the X-Position to **-600 cm**.

- Set the Y-Position to **150 cm**.

- Set the Z-Position to -**1000 cm**.

7. Copy (**Command/Control + C**) and paste (**Command/Control + V**) the **Light.1** object in the Object Manager.

8. In the Attributes Manager, click on the **Coord.** tab.

- Set the X-Position to **900 cm**.

- Set the Y-Position to **600 cm**.

- Set the Z-Position to -**700 cm**.

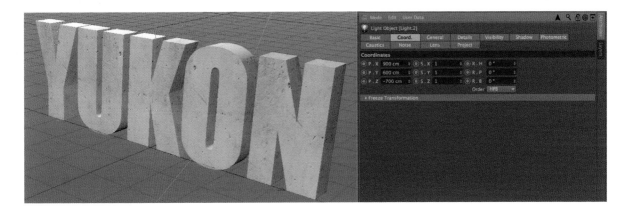

The final lighting for the 3D scene uses a three-point lighting system. The primary light source comes from the **key light**. A **fill light** is a weaker light source that helps soften and extend the lighting created by the key light. It is generally positioned at an angle opposite that of the key light. The last light positioned is the **rim light**. The rim light (also called back light) highlights the edges of the object.

9. Select the **Extrude** object in the Objects Manager. In the Attributes Manager, click on the **Coord.** tab. Set the **R. H** value to **10°**. It is important to understand the rotational coordinate system used within CINEMA 4D. The software works exclusively with the **HPB** system. HPB is an abbreviation for Heading, Pitch, and Bank.

- **Heading** is the direction axis. This axis tells you where your object is pointing, or following its nose.

- **Pitch** is the up and down axis of rotation, like nodding your head yes.

- **Bank** is the rotate along the center (heading) axis, like a plane lifting one wing and lowering the other.

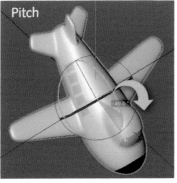
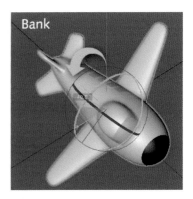

The composition matches the layer structure in the Illustrator file.

Create Darker Shadows with Ambient Occlusion

Before you jump back to After Effects, let's add ambient occlusion to a 3D scene. **Ambient occlusion** is a shading method. It simulates shadows without having to add extra lights that cast shadows. You can use ambient occlusion to emphasize geometry that contains a lot of detailed surfaces, or to add soft shadows to the entire scene. Let's see how it works.

10. Open the Render Settings dialog box in CINEMA 4D Lite. Click on the **render** icon that has the sprocket.

11. Click on the **Effect** button and select **Ambient Occlusion** from the drop-down menu. Close the Render Settings dialog box.

Add the Ambient Occlusion effect in the Render Settings dialog box.

12. Save your CINEMA 4D file. Jump back to After Effects and you will see the 3D extruded text update in the Comp panel. When working between CINEMA 4D and After Effects, all you need to do is save the 3D file and it automatically updates in real time through CINEWARE in After Effects.

In After Effects, CINEWARE updates the saved CINEMA 4D file in the Comp panel.

Use CINEWARE to Composite the 3D Model

CINEWARE is an integral part of the entire After Effects and CINEMA 4D Lite workflow. It displays in the Effect Controls panel in After Effects and acts as a real-time interface between a composition in After Effects and the CINEMA 4D render engine. Let's explore the Render Settings provided and how they can be used to speed up the workflow.

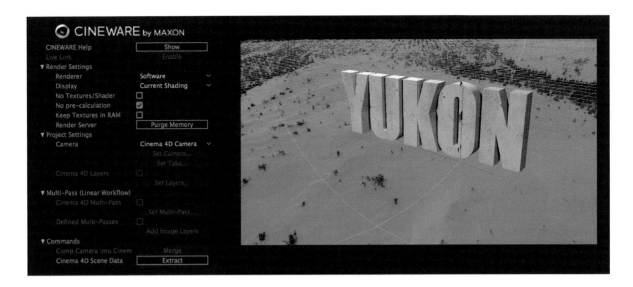

The default **Software** render mode displays a low resolution image. If the Effect Controls panel is not visible, select **Effects > Effect Controls**.

The Wireframe display setting provides a simplified representation.

The CINEWARE Renderer controls how the CINEMA 4D file is displayed in the Composition panel in After Effects. The default setting is **Software**. This mode is the quickest to render in After Effects and displays a low resolution version of the 3D scene. Use this mode for quick previews of complex 3D models and animation while you work in the composition.

The Software renderer also allows you to change the **Display** mode. The default setting is **Current Shading**. In this mode, CINEWARE uses the viewport's display settings from CINEMA 4D Lite. There are two other display modes, **Wireframe** and **Box**, that can be selected through a drop-down menu. These modes provide a simplified representation of the 3D scene and render even faster than the Current Shading mode.

Directly under the Display settings are three checkboxes. The **No Textures/Shader** option will speed up your render by not rendering any textures and shaders. The **No Pre-calculation** option disables memory intensive calculations needed for CINEMA 4D's MoGraph objects and effectors or particle simulations. The last option, **Keep Textures in RAM**, caches textures in the RAM so that they are not reloaded every frame during rendering and can be accessed more quickly.

Make sure the **Display** mode is **Current Shading**. The **Standard (Draft)** render mode provides a better image of the 3D scene but turns off slower settings like anti-aliasing for faster rendering. The **Standard (Final)** render mode uses the render settings from the CINEMA 4D file. It provides the best resolution for the final rendering in After Effects.

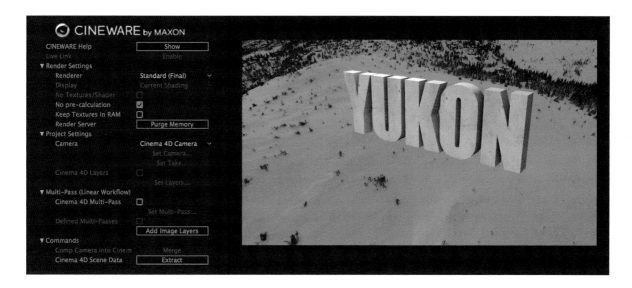

Directly under the render settings are the **Project Settings** which allow you to choose the camera used for rendering. The last part of this exercise focuses on using these settings to track and composite 3D objects into live footage.

The **Standard (Final)** render mode uses the CINEMA 4D render settings to provide the best image for the final rendering.

1. Set the render mode to **Standard (Final)**. The extruded text appears in the Composition panel. Its position and orientation does not match the video footage.

2. Make sure the CINEMA 4D layer is selected in the Timeline.

3. Go to the CINEWARE panel and change the Project Settings Camera option from **CINEMA 4D Camera** to **Comp Camera** using the drop-down menu. The 3D text instantly snaps to where the bullseye target recorded the origin point.

The Comp Camera option is used for cameras that are added to After Effects by using either **Layer > New > Camera** command or through the 3D Camera Tracker effect.

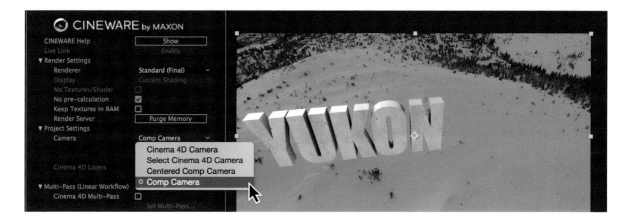

4. Press the **End** key on the keyboard. This moves the **Current Time Indicator** (CTI) to the end of the composition.

5. Select the **TrackText.c4d** layer. After you changed the frame duration in the CINEMA 4D file, a ghosted bar now extends to the end of the composition in the Timeline. Retrim its Out Point by typing **Option/Alt +]**.

Retrim the Out Point to extend to the end of the composition.

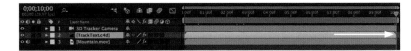

6. Click on the **Play/Stop** button. The goal of this exercise was to demonstrate a quick and efficient workflow for placing a 3D object on an origin point that was tracked in After Effects.

The 3D text tracks the camera movement in the rendered video.

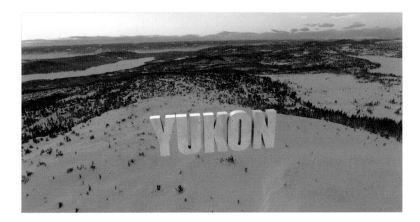

7. Save your project file. Select **File > Save**.

Summary

After Effects provides 3D capabilities. This acts as a hybrid between the 2D and 3D worlds. In After Effects you place a 2D object in 3D space by turning on its layer's 3D switch. Even though the layer can now be positioned and rotated in 3D space, it still remains a flat 2D object.

In CINEMA 4D Lite, you create a 3D scene using wireframe objects that can be viewed from any angle by a virtual camera. You also learned how to use the 3D camera tracking effect in After Effects. This provides a relatively easy workflow to composite 3D objects from CINEMA 4D onto 2D video footage in After Effects. The CINEWARE render and project settings make working between the two applications extremely flexible.

Moving Forward in Motion Design

Previous chapters explored composition and layout, visual hierarchy, typography, logo design, animation principles applied to user interfaces and interactive designs, 3D media integration, and compositing with live-action. This last chapter offers some tips and best practices to continue your journey into motion design.

At the completion of this chapter, you will be able to:

- Create a visual presentation to pitch to a client
- Define an efficient naming convention for your motion project files
- Render projects using Adobe Media Encoder
- Access additional online video tutorials

Pre-production: The Pitch

As previously discussed in Chapter 2, designers must pre-visualize their ideas through sketches, storyboards, style frames, and animatics. This helps communicate to the client a clear and unified visual direction before production begins. These solutions are presented to the client in the form of a pitch to sell the designer's ideas and get them hired.

A pitch is usually done by the art director using a visual presentation. The actual pitch may not be done in person, but instead delivered over the phone with a digital PDF of the presentation sent to the client. So, it is vital to clearly communicate your creative ideas in the most effective way possible. A visual presentation must address the client's needs, support the designer's message, and showcase the design solution.

The best rule to follow is to keep the visual presentation simple and to the point. On average, most people will only remember three items at a time, so make sure to include only the critical content required. Review the client's content brief and focus on the key concepts and ideas that are being presented. This will help in narrowing down the amount of information on each slide. Presentations leave a lasting impression. So, how do you make it a good one?

- **Limit the number of typefaces:** Designers should not overload the presentation or design solution with too many typefaces. Limit the number of typefaces to two or three. Think about the message you are communicating and match it with appropriate typography choices. Remember, serif typefaces evoke a feeling of classical, romantic, elegant, or formal. Sans serif typefaces signify something being modern, clean, minimal, or friendly.

Typefaces can evoke a mood or feeling and compliment the overall visual theme.

classic (Garamond) modern (Helvetica)

romantic (Caslon) clean (Tahoma)

elegant (Baskerville) minimal (Avenir)

formal (Times) friendly (Gill Sans)

- **Be consistent with the layout:** Use a grid to visually organize your slides. The grid structure maintains consistency, unity, and hierarchy throughout the presentation layout. It is the most effective way to organize content.

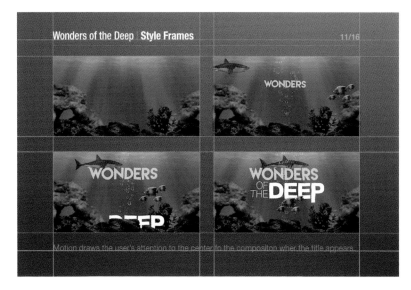

Grids are an integral part of visual organization systems.

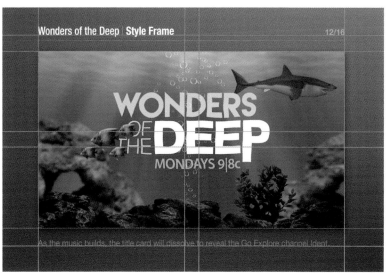

Use neutral colors for the presentation template to allow your creative solutions to stand out.

- **Use a neutral color scheme for the presentation template:** Colors can be used to focus attention. They can also be distracting. Keep in mind what is the main focus of the slide. Neutral colors for the presentation allow your design solutions to stand out and be the focal point.

- **Create a narrative flow:** Remember, you are telling a story with the presentation. Think of the slide sequence and how it will be presented to the client. Divide the content into smaller "chunks" of information. Provide no more than three key points on the slide at one time.

- **Proofread and spell check:** Typos and grammatical errors do not communicate professionalism to a client.

What to Include in the Pitch Presentation

Each slide must adhere to the grid system you built. Descriptive text, such as headers, footers, and page numbers should be included on each slide. At minimum, you should include the following slides:

- Title slide with the name of the project, date, and client logo
- Summary of the motion design project
- Visual inspirations
- Color palette
- Typography/logo treatment
- Storyboards to illustrate the shot-by-shot flow of the project
- Style frames with descriptive text to illustrate the visual look
- Thank you slide with your company's logo and contact information

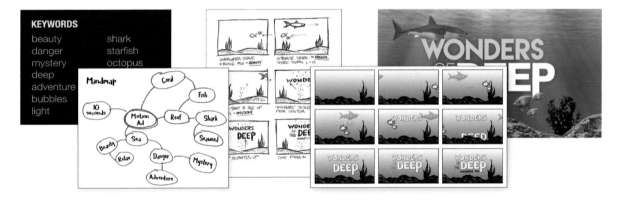

Pre-visualization determines the look and narrative design. It should be included in the pitch presentation to the client.

Practice. Practice. Practice

Presenting to a client for the first time can be extremely nerve-racking. Proper planning can help. Rehearse the presentation in front of a group of people, co-workers, family, etc. Seeing their reactions is a great way to test your material and delivery as well as boost your confidence. Timing is also crucial in presentations. Practice trimming your message to include only the relevant information. Finally, don't forget to breathe.

Production: Naming Conventions

Once you connect with the client, production begins. You create your assets, and import and arrange the media elements on layers within a timeline in After Effects. Most often designers work on a team for a motion design project. Defining a consistent naming convention is crucial from a time management perspective.

Have you ever saved a file and used the word "final" in its name? That is probably the worst word to use in a naming scheme. When working in After Effects try using a naming convention that everyone can agree on, such as the following:

* Client's name or acronym
* Project name, or truncated version of the name
* Type of motion project it is
* Date the file was saved
* Version number

Defining a naming convention is crucial from a time management perspective.

Save and Increment

After Effects provides an option to save a copy of the project with a new automatically generated name. Select **File > Increment And Save**, or use the keyboard shortcut of **Command/Control + Option/Alt + Shift + S**. This can be a lifesaver if the project file becomes corrupted and cannot open properly. You simply go back to a previous version without having to start all over.

After Effects provides an option to save a copy of the project with a new automatically generated name.

Each motion design project should have a consistent folder structure that organizes the pre-production, production, and post-production content.

A consistent naming structure should also be used within the After Effects project. Get into the habit of naming all of your layers in the Timeline. Group related content into folders in the Projects panel.

Organize the After Effects project. Create folders to hold related content in the Project panel.

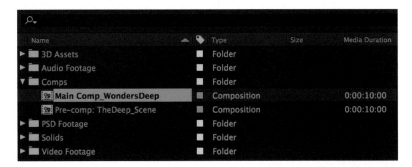

Post-Production: Adobe Media Encoder

Even though After Effects can easily render QuickTime files and image sequences, it is not always the best choice. Adobe Media Encoder offers a lot of options to fine-tune the encoding process and often produces better results. You can open a project in Adobe Media Encoder by selecting **Composition > Add to Adobe Media Encoder Queue**. Adobe Media Encoder will launch with the imported After Effects composition added to the Queue.

You can add an After Effects project directly to Adobe Media Encoder.

Adobe Media Encoder provides a long list of presets for different delivery scenarios. Each preset automatically sets the appropriate encoding options for the video and audio. You can also customize these options. Click on the **H.264** preset to open the Export Settings.

Adobe Media Encoder provides a variety of presets for different devices, frame sizes, and frame rates.

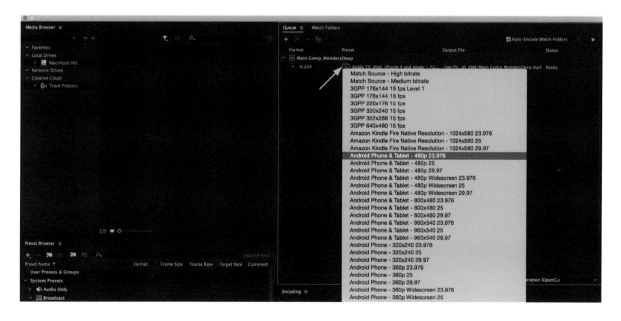

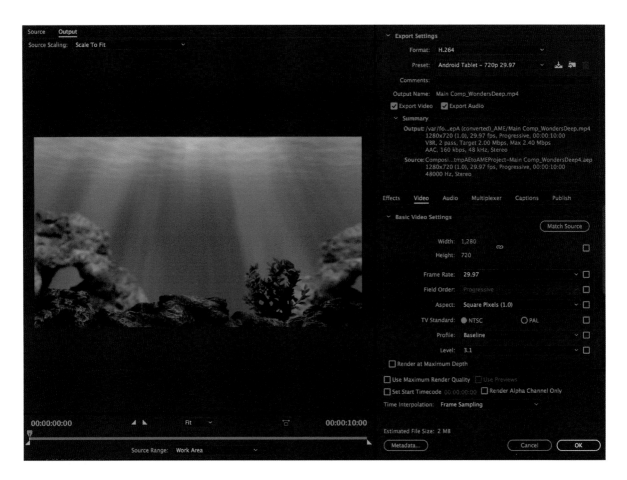

The Export Settings panel allows you to customize the video and audio compression settings.

The Export Settings panel opens. It is divided into four quadrants. The top-left area displays a preview of the video. The lower-left area allows you to trim and add cue points. The top-right area summarizes the export settings. The lower-right area provides options to customize the export settings for both video and audio.

The video settings are divided into three sections: basic video settings, bit rate settings, and advanced settings. Let's focus on bit rate. **Bit rate** is the number of "bits per second" (bps) at which the data in a video is being delivered. Video can be encoded with a constant bit rate (CBR) or a variable bit rate (VBR).

A **constant bit rate** (CBR) compresses each frame in the video to a fixed limit. A **variable bit rate** (VBR) compresses complex frames less and compresses simple frames more. A VBR file tends to have a higher image quality, because VBR tailors the amount of compression to the image content.

Use the Bitrate Encoding to VBR, 2 Pass. The encoder makes two passes through the file ensuring greater encoding efficiency and quality.

Click on the **Audio** tab. It is important to understand that the bit rate contains two tracks: a video track and an audio track. The total bit rate for a video file is the sum of the video and the audio bit rates. To reduce the overall file size, choose **Mono** instead of **Stereo** for the Output Channels options. You will not notice too much of an audio difference from the built-in speakers on your computer. Click **OK** to close the Export Settings dialog box.

You can create multiple outputs from a single After Effects composition by clicking on the **Duplicate** button 🖫 . Change the preset for each duplicated item. Click on the **Start Queue** button ▶ . Adobe Media Encoder starts encoding the files in the video encoding list. While the files are being encoded, the Status column of the video encoding list provides information on the status of each video.

The Encoding panel displays the time remaining for each video in the queue.

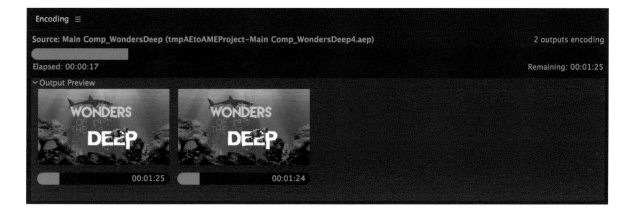

Additional Tutorials and Resources

In addition to the chapter exercises in this book, there are several video tutorials available to download. Download the **VideoTutorials.zip** file at the following URL: *www.routledge.com/cw/jackson*. Inside each folder you will find the material needed to complete each tutorial. Completed versions for each motion design project are provided.

A video tutorial is provided on an advanced animated logo design.

A video tutorial is provided on synchronizing audio clips to kinetic typography using markers.

Other online resources that may be helpful include:

- **Saul Bass:** www.notcoming.com/saulbass/index2.php
- **Title Sequence Design:** www.artofthetitle.com
- **Adobe:** forums.adobe.com/community/aftereffects_general_discussion
- **After Effects Expressions:** motionscript.com
- **CINEMA 4D:** greyscalegorilla.com/cineware/

A video tutorial is provided on using the Puppet tools in creating a stop motion animated effect for a title sequence.

A video tutorial is provided on using the Extract effect which creates transparency based on the luminance of a layer and the histogram associated with it.

A video tutorial is provided on using audio keyframes and Shape Layers to create abstract visual music.

Thank you

Your journey has come full-circle. You started your quest by learning about the workspace and workflow in After Effects. In this final chapter you dug deeper into the three main stages of the workflow. Along the way you created visual effects and animation for a variety of motion design projects. Hopefully you have been inspired to explore more uncharted territories in motion design.

Index

180° rule, 20-21, 249
16:9 aspect ratio, 25, 116
3D Space, 274-288
 in After Effects, 274–280
 X-Y-Z coordinates, 274
4:3 aspect ratio, 24

A

Academy Flat, 25
Academy Standard, 25
Action Safe area, 28, 143
Active Camera view, 282
Adobe Illustrator, 45, 117-118
Adobe Media Encoder, 307-309
Adobe Typekit, 74, 89-91, 101, 107
After Effects
 3D Space and, 274-280
 applying effects, 60-63
 parenting layers, 219–220
 Composition panel, 47
 effects & presets panel, 61
 keying in, 262-265
 Project panel, 42-45
 project workflow, 32-40
 rendering a project, 68-69
 setting keyframes, 50-59
 spatial interpolation, 55
 temporal interpolation, 59
 text animation, 80-110
 along a path, 85-88
 tracking, 101-106
 text animation presets, 89-95
 using text animators, 95-110
 Timeline panel, 42, 48
AIFF (Audio Interchange File Format), 31
Anamorphic Scope, 25
Animatic, 40
Animation codec, 30
Animation principles, 6-10

Antialiasing, 75
Anticipation, 8, 177
Arcs, 9
Audio Basics, 31
Audio Sampling, 31

B

Bezier handles, 53
Bezier path, 86, 152
Bird's-eye view, 15
Broadcast Colors, 29
Broadcast design, 24-31
 color management, 29
 frame aspect ratio, 24-26
 frame rates, 27
 title safe and safe action areas, 28

C

Camera angles,14-15
 bird's-eye view, 15
 canted shot, 15
 Dutch angle, 15
 eye-level shot, 14
 high-angle shot, 14
 low-angle shot, 14
 worm's-eye, 15
Camera movements,16
 pan, 16
 tracking, 16
 truck in, truck out, 16
 zooming, 16
Camera shots, 12-13
 Close-up, 13
 Extreme close-up, 13
 Extreme long-shot, 12
 Long shot, 12
 Medium shot, 13
Canted shot, 15
Cause and effect, 159

CC Radial Fast Blur, 82-83
CC Starburst, 83-84
CINEMA 4D, 256-300
 ambient occlusion, 296
 lighting, 294
 materials, 293-294
 modeling, 291
Cinematography, 10
CINEWARE, 297-300
Clean entrances and exits, 22, 161
Close-up, 13
Codec, 30
Comp panel, 47
Composition, 5
 3D animation, 275-280
 applying effects, 60-63
 creating, 43-44
 creating and animating type, 80-110
 handwriting simulation, StrokeText
 Illustrator artwork, 45-46
 keyframes, 50-58
 parenting layers, 219-220
Compression, 280–283
 codec and, 30
 lossless, 115
 lossy, 115
Content brief, 36
Constant bit rate (CBR), 308
Corner Pin effect, 188, 191, 229
Crosscut, 23
Current Time Indicator, 51
Cut on the action, 22

D

Data rate, 30
Design board, 39
Design principles, 4-5
Diachronic narrative, 234
Digital audio, 31
Direct manipulation, 158
Displacement Map effect, 64-65
Drop Shadow, 127-128
Dutch angle, 15

E

Easy Ease In keyframe assistant, 59
Easy Ease keyframe assistant, 59
Easy Ease Out keyframe assistant, 59
Effects & Presets panel, 60-62
Expressions, 220-222
Extreme close-up, 13
Extreme long-shot, 12
Eye-level shot, 14

F

First Margin property, 87
Foam effect, 60-62, 252-257
Follow-through, 8, 169
Font, 73-74
Footage, 44
 importing into After Effects, 44-47
 linked, 44
 organizing, 45, 306
Foundry, 262
Frame aspect ratio, 24-26
Frame rates, 27
Frame size, 26
Frames, 11

G

Graph Editor, 164-169

H

H.264 codec, 30, 69
Handwriting, simulating, 151–154
HD video, aspect ratio, 25
High-angle shot, 14
Horizontal Type tool, 78

I

Illustrator artwork, exporting, 117-118
Import Files dialog box, 44
Infographic, 196
Information architecture, 157
Interaction design, 157
Interpolation, 53

spatial, 55
temporal, 59

J

Joint Photographic Experts Group (JPEG), 115
Jump cut, 23

K

Kerning, 76
Keyframes
 assistants, 59
 interpolation and, 53
 setting, 50-59
 spatial interpolation and, 55
 temporal interpolation and, 59
Keying, 261
 in After Effects, 261-265
Keylight, 262
Kilohertz, 31
Kinetic typography, 77

L

Leading lines, 19-20, 250
Lens Flare effect, 84-85
Line of action, 21
Logos, 112-118
Long shot, 12
Lossless compression, 115
Lossy compression, 115
Low-angle shot, 14
Lower Third animation, 142-150

M

Match cut, 22
Masks, 120-121
Medium shot, 13
Motion Blur switch, 94, 279
Motion design, 2-4
Motion path, 52-53
Motion track, 223-226
MP3 (Motion Picture Expert Group), 31
MPEG files, 30
Multiplane camera, 238

N

Nesting compositions, 66
NTSC, 26

O

Open Type, 74
Ordered, categorical data, 197
Overlapping action, 8, 169
Overscan, 28
Overshoot, 134

P

PAL, 26
Pan camera movement, 16
Pan Behind Tool, 143, 185, 207
Paragraph Text, 79
Parallax scrolling, 238
Parenting, 219-220
Pen tool, 86, 152
Pitch, 34, 302-304
Point Text, 79
Position property, 50
Portable Network Graphic (PNG), 115
PostScript, 74
Preview panel, 53
Pre-visualization, 34
Project panel, 42, 45
Project workflow, 34-70
 applying effects, 60-62
 creating project, 41-49
 nesting compositions, 66-67
 rendering a project, 68-70
 setting keyframes, 50-59

Q

Qualitative data, 197
Quantitative data, 196
QuickTime Export Settings dialog box, 68-69

R

Radial Wipe effect, 201-204
Radio waves effect, 105-106

Raster images, 114-116
Render Queue, 68-70
Render Settings dialog box, 68-70
Rule of thirds, 17

S

Sampling rate, 31
Scale property, 56-57
Scene, 11
Screen Matte properties, 265
Screen Pre-blur property, 265
Scroll, UI design, 189
Serif, 73
Shape Layer, 123, 129-141
Shot, 11
Slideshow, 161
Slow-in and slow-out, 9, 166
Solid drawing, 7
Solid layer, 60, 192
Spatial interpolation, 55
Squash and stretch, 7
Staging, 10
Storyboard, 39
Stroke effect, 152-153
Style frame, 39
Synchronic narrative, 234

T

Tag Image File Format (TIFF), 115
Temporal interpolation, 59
Text
 animating, 80-110
 animating along a path, 85-88
 animating tracking, 101-106
 animation presets, 89-95
 animators, 95-110
Thumbnail board, 37
Timeline panel, 42, 48
Title Safe area, 28, 143
Track matte, 67, 123-124, 192-193, 212
Tracking, 16
Transform properties, 50
Truck in, truck out, 16

True Type, 74
Typeface, 72-73
Type tool, 78-79

U

Unordered, categorical data, 197
User-centered design, 156
User interface design, 157
Usability testing, 157

V

Value, 236
Variable bit rate (VBR), 308
Vector images, 114
Vertical Type tool, 78
Video
 aspect ratio, 24-26
 codecs, 30
 color management, 29
 compression, 30
 frame rates, 27
 frame sizes, 26
 importing, 66
 rendering, 68-69

W

Waveform Audio Format (WAV), 31
Web fonts, 74
Widescreen format, 25
Wiggly Selector, 106-110
Worm's-eye, 15

X

X-axis, 274
X-Y-Z coordinates, 274

Y

Y-axis, 274

Z

Z-axis, 274
Zooming, 16